TREASURES OF ASIA

COLLECTION PLANNED BY

ALBERT SKIRA

PERSIAN PAINTING

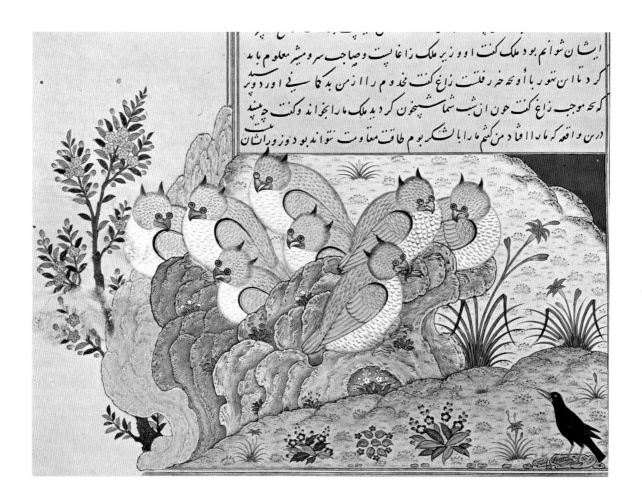

TEXT BY BASIL GRAY

Former Keeper of Oriental Antiquities at the British Museum

SKIRA

M

Colour plate on the title page:
Kalila wa Dimna of Baysunghur: The Owls and the Crow. Herat, 1430. (4⅝ × 7″)
Revan 1022, folio 66 recto, Topkapu Sarayi Library, Istanbul.

*

© 1977 by Editions d'Art Albert Skira S.A., Geneva
First edition © 1961 by Editions d'Art Albert Skira, Geneva

ISBN 0 333 22374 8

This edition published in Great Britain in 1977 by
MACMILLAN LONDON LTD
London and Basingstoke

Associated companies in New York, Toronto,
Dublin, Melbourne, Johannesburg and Delhi

PRINTED AND BOUND IN SWITZERLAND

9. 4N P

THIS book could not have achieved its representative character without the generous help of those who have the charge of the masterpieces of Persian painting now scattered throughout the world. We are especially indebted to Dr Mehdi Bayani, Director of the Gulistan Palace Library, Tehran, for access to the manuscripts under his charge and for obtaining the Royal permission to reproduce the miniatures selected. We are also grateful to Mr Haluk Bey, Director of the Topkapu Sarayi Library, and to Mr Kemal Çig, Director of the Museum of Turkish and Islamic Art, in Istanbul, for permission to reproduce works in their keeping. It is a special privilege to be allowed to include unpublished material from the Gulbenkian Foundation, Lisbon; from the Topkapu Sarayi Library and the University Library, Istanbul; and from the Berenson Collection at Settignano.

I wish to acknowledge the help of all my colleagues in different countries, especially Dr Richard Ettinghausen, Freer Gallery, Washington; Dr Maurice Dimand, Metropolitan Museum, New York; Dr Karl Kup, New York Public Library; Miss Dorothy Shepherd, Cleveland Museum of Art; Dr Dorothy Miner, Walters Art Gallery, Baltimore; Messrs Eric Schroeder and Cary Welch of the Fogg Art Museum, Harvard; and in the British Museum my friends Mr Kenneth Gardner, Keeper of Oriental Manuscripts, and his assistant Mr Glyn Meredith-Owens; Mr N.C. Sainsbury, Keeper of Oriental Manuscripts at the Bodleian Library, Oxford; Dr R. J. Hayes, Chester Beatty Library, Dublin; Professor David Talbot Rice, University of Edinburgh; and M. Jean Porcher, Conservateur des Manuscrits, Bibliothèque Nationale, Paris. I owe a special debt to Mr Ralph Pinder-Wilson for having read through the complete text and for giving me frequent help in my work. Finally my greatest debt is to my wife, Nicolete, who has supported me throughout the preparation of the book by her encouragement and an appreciation of its subject as keen as my own.

I dedicate this volume to the Persian people and to all those, living or dead, who have helped to reveal to the world the beauties of Persian painting.

BASIL GRAY

London, January 1961.

Contents

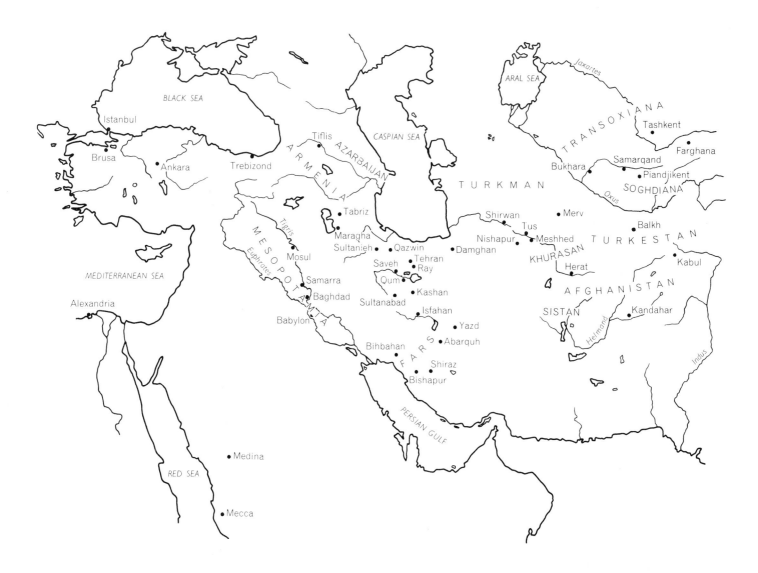

Introduction

1

PERSIA has a tradition which has been tenaciously held throughout the catastrophic course of a history imposed on her by her geographical situation. The heart of Persia is the Iranian plateau which has nourished her tough resistance in a land dependent for water on the trapping of the streams from the snow mountains which surround it. But this plateau is also a bridge over which many waves of invasion have passed since prehistoric times. When the plateau has been in the hands of a strong ruler, it has been the centre of an empire covering the better watered plains and valleys which lie to the south-west in Mesopotamia and to the north-east in the lands of the Oxus and the Jaxartes. The greatest of these empires was that of the Achaemenids, a succession of energetic and able rulers who in the sixth century B.C. established a provincial administration held together by its famous system of communications that has been substantially maintained throughout the succeeding centuries. The central administration has changed often enough from one foreign power to another since Alexander the Great destroyed the original empire; and at times the provinces have been virtually independent, or divided between other empires, but the memory has never been lost of the Achaemenid achievement; and it is this, with the language, which has given Persia her sense of national continuity. While inflicting immense damage the invasions have also brought many fructifying influences to Persia. The Macedonian conquest opened a long period of intense commercial relations with the Mediterranean world, already adumbrated by the dominance of the Persian coinage in the ancient world. The command of the overland route to China enriched her merchants materially while giving her access to the products of the greatest civilization in Asia in the first millennium of our era. Persia under her Parthian and Sassanian rulers long appeared as the protagonist of Asia against the power of the Roman and Byzantine empires, but her historic role is rather of a middle kingdom in which many traditions have fructified. The main route across the north formed part of the long trade route which brought Chinese silk to Rome or Byzantium. From Farghana, famed for its superior horses, the route passed by way of Samarqand and Bukhara across the Oxus into Khurasan, through Merv and Nishapur, or further to the east through Balkh and Herat, and then over the desert by Damghan to Ray, near the modern capital Tehran. The route then turns north-west through Sultanieh

and Tabriz to the pass into Armenia and the Black Sea. On the western edge of the desert there is another great road from Ray south to Qum, Isfahan and Shiraz, the capital of the southern province of Fars, which has given its name to the whole of Persia and to her language, Farsi.

The language, as has been remarked already, has been the sign of Persian continuity through her history, and yet there was a time when it seemed that it might be superseded for ever, at least as a literary and administrative tongue, by Arabic. The most profound and persistent change in Persia's history followed from the Arab conquest, so rapidly accomplished between 635 and 652, when not only the monarchy collapsed but also Arab governors replaced the native aristocracy. Even more fundamental perhaps was the wholesale conversion of the people to the religion of the conquerors, centred on the sacred book in the Arab tongue which thus became the language not only of government but also of all religious instruction and discussion. It was thus the only language of the learned and all history and science also were greatly enriched by its international use throughout the Moslem world. In these circumstances it is remarkable that the Persian people preserved their language, so that, as the power of the Caliphate began to decline in the ninth century, the native language revived with native rule. All the more was this remarkable because under the Sassanian rule literature had been practically equivalent to the religious texts of the national and royal religion of Zoroastrianism. A small minority had indeed clung to the old religion, but they were not an important element in the revived nationalism, and the Arabic script remained the universal medium for Persian as well as Arabic; and indeed this new Persian was permanently enriched with many Arabic words and forms of speech. The new language however was rooted in the popular oral tradition which had preserved the memories of the historic past and the native mythology, which has been shown to go back to the days when the Iranian ancestors were still living nomadic lives in the Central Asian steppe. These old traditions had been assimilated by the Zoroastrian priesthood to the official religion of dualism, and remained among the hymns incorporated into the Avesta. Now this rich national heritage could be written down in the new script, in the verse forms which developed directly from ballads sung by itinerant minstrels. It is by such oral descent that the stories which now make up the *Shah-nama*, or Book of the Kings, were preserved during the three hundred years which separated the fall of the Sassanian monarchy from the composition of the *Shah-nama* in the tenth century at the courts of the Samanid Nuh b. Mansur (976-997) and the Ghaznavid Mahmud (998-1030). Rudagi, the earliest Persian-writing poet whose work has survived, although very incompletely, was in fact a blind minstrel at the court of an earlier Samanid; and Daqiqi, who was commissioned by Nuh II to compose a *Shah-nama* in verse, seems at least to have had Zoroastrian sympathies. These early poets were expected to turn out a regular stream of panegyrics *(qasidas)*, and must have attained a ready virtuosity in composition, which stood them in good stead when required to compose a poem of the length of the national epic of the *Shah-nama*. This was the work of Firdawsi of Tus who composed, during a period of thirty-five years, a poem in about fifty thousand verses including the thousand couplets

which was all that Daqiqi had completed at the time of his death. This is the form of the national epic which is familiar to every Persian today, and it is this which is referred to in this book as the *Shah-nama*.

There is no doubt that Firdawsi was following closely accounts of the national story which were composed, in part at least, as early as the later part of the Sassanian period; and it is an interesting speculation whether there was an equally old tradition of painted illustrations of the main subjects which it treats. It has been pointed out that Firdawsi describes the ancient ceremonies of the Sassanian kings, which he cannot of course have seen, vividly and even pictorially; such for instance as the throne of Khusrau with the crown suspended over it by a gold chain to which it was attached whenever the king was about to take his seat. There seems to be a very ancient tradition of depicting such scenes from national history on palace walls in Persia. On the other hand it has been shown that Firdawsi was using written records, so closely does his version follow such earlier sources as are available to us for comparison. It therefore becomes a question whether any of these were illustrated books. In default of any surviving manuscripts, we can only remind ourselves that paper was introduced into Persia from China in 753 A.D. Sassanian painting survives only in fragmentary remains of wall-painting, mostly outside the present frontiers of Iran: the history of Persian painting before 1200 A.D. has to be pieced together from scraps of evidence, supported by literary references.

The view has been expressed by Dr R. Ghirshman, who is the best qualified to judge, that under the Sassanians the decoration of palace walls with figure subjects became usual from the middle of the fourth century, at first in a thoroughly Hellenized style as under the Parthians; but already by this date the superficially East Roman subjects, as in the floor-mosaics at Bishapur, have been given an oriental character.

This is not immediately apparent, he points out, because in the banquet scene, here symbolically depicted, the types of the nude dancing girls are those of Greek mythology. Moreover the small landscape elements are mere space-fillers, just as they were much later in the Islamic art of the ninth century throughout the Abbasid empire. So that we may see here at Bishapur already that revolt against naturalism and in favour of the conceptual which is significant for the future. At Bishapur no wall-paintings survive, but at a site in Afghanistan, in the valley of the Khulm river, at Dukhtar i-Nushirwan, there are the remains of a very large Sassanian painting on the rock-face, which seems to represent a governor seated on an official throne and under a white-winged crown with a pearl border and surmounted by a lion's head. The colouring is rich, lapis lazuli, yellow ochre and white, against a dull brown background. The throne and pose of the figure resemble a famous carved rock-crystal cup from the treasure of Saint-Denis, now in the Cabinet des Médailles in Paris, said to represent the Sassanian king Kavad I (488-532), seated on a similar throne with legs in the shape of winged horses. This same period may be given to the fragmentary wall-painting. Similar colouring is found in the late sixth century Buddhist wall-paintings of the Sui dynasty at Tun-huang, in the western edge of China, where Sassanian influence was especially marked at that time; standing as it does on the principal route by which this influence entered China.

The red background is found at Tun-huang in wall-paintings as early as the late fifth century, and in Persia itself at least as early as the fourth century, if the remains of a wall-painting discovered at Susa are to be given to the period of Shapur II (309-379), as its discoverer Dr Ghirshman believes from archaeological evidence. Although this picture had fallen from the wall soon after it was painted, the remains show a red or blue ground and one or more horsemen heavily outlined in dark brown and coloured in flat washes. The only indication of landscape is a pattern of small crescents, perhaps representing plants.

At Piandjikent in Soviet Khwarazmia, a site within the cultural orbit of Sassanian Persia, a Russian expedition has recently uncovered an extensive series of wall-paintings, part of which has been identified as illustrations to a cycle of exploits of the Persian hero Rustam. The best preserved part is a composition about fifteen metres long painted on a blue ground, against which a group of horsemen ride off to war, while the hero is engaged in combat with a monstrous snake. In another part his helpers are fighting against semi-human demons. The evidence of coins and remains of manuscripts from the site make it necessary to attribute these paintings to the early seventh century. Piandjikent, situated in Transoxiana, not very far from Samarqand, was one of the cities of Soghdiana, at this time inhabited by people of Aryan stock, mainly Zoroastrian in religion, under a dynasty of Ikhshid rulers. Before the end of the century they had been driven out by the Arabs, but not finally excluded until 728, by which date the Turks had spread all over the open country. Such a history gives a good idea of the variety of races and the transitoriness of political power in these lands; and on the other hand of the permanence and pervasiveness of Persian artistic and literary influence. Throughout the story which we shall be following these facts remain true, and it must be realized that many races contributed to the population of Iran, and many foreign dynasties commissioned the poems and their illustrations in manuscript or wall-painting.

The story of Rustam, so leading a theme in the *Shah-nama*, was not a part of the national legend as it was originally shaped; but the cycle of his exploits seems to belong to the mythology of Sistan, now in South Afghanistan, and outside the central Iranian area. It was only later incorporated into the main tradition of the Persian epic, which remained remarkably free from Moslem influence, and still imbued with ideas of the royal monarchy and the power of the great nobles much as they had been under the Sassanians. A national legend of the heroic wars between the Iranians and the Turanians was composed at a time when the Persians were actually under Turkish rule and it retained its great popularity throughout the centuries of Mongol and Timurid domination. Though full of vivid touches the *Shah-nama* is a cycle of romantic adventures in the struggle of the good heroes against the forces of darkness, which yet often appear to follow the same code of knightly conduct.

The central position of this cycle in the history of Persian painting follows from the aniconic character of the Islamic religion, which provided no opening for figural subjects. It is clear however that from the beginning secular painting was employed by the early Caliphs to decorate their palaces and bath-houses. In Syria and Mesopotamia

these followed the style of the Mediterranean, while in Persia the Sassanian tradition was continued. In the other arts the Arab conquest brought no stylistic break, but the painting of the eighth century can only be guessed at from the few literary references. An important text for the purpose occurs in the *Tanbih* or Compendium of Mas'udi, who in his eighth book recounts how, in the year 915, he saw in the house of one of the nobles of Fars a thick volume of Persian lore and traditions, in which were represented all the kings of Persia of the Sassanian line, each one portrayed on the day of his death. They were painted in the richest colouring, including gold and silver, and showed each king in some everyday action or attended by his courtiers. This book was copied, according to Mas'udi, from an earlier version, dated 781. Even from the ninth and tenth centuries there are no surviving book illustrations in Persia nor wall-paintings except the most meagre remains, but the Abbasid Caliphate, from its beginning in 750, was strongly Persian in character, both politically and in the arts. The seat of the Caliph at Baghdad was within the old frontiers of the former Sassanian empire and it is therefore not surprising that, in the words of Dr Ettinghausen, "the Persian character of Iraqian painting at the court of the Abbasids is beyond question."

This judgment rests on the evidence of the remains recovered from the site of the palace-city on the Tigris, Samarra, built by the Caliph Mu'tasim, and occupied only during the years 833 to 838. It was excavated by a German expedition in 1910-1914, and the finds published in a series of volumes, of which one by Ernst Herzfeld is devoted to wall-paintings. That they are formal figure paintings is not surprising in such a descendant from Sassanian court art; dancers and guards, huntsmen and attendants, they are rigidly presented in frontal and symmetrical poses within frame borders, generally pearled. The heads are large and the features heavily outlined, but the colouring was sumptuous with free use of gold. Generally there is little movement, but where there is, as in a well-known pair of dancers, the drapery forms a pattern of complicated folds. That this represents the old Sassanian style of flying draperies and pleated skirts as seen on some of the silver dishes and vessels decorated with hunting and feasting scenes, has been shown by Emmy Wellesz, in connection with the illustrations of the constellations in astronomical texts like the work of as-Sufi on the fixed stars, which are bound to be highly conservative. Though these are diagrams rather than miniatures, they do help to give an idea of the rather solemn but highly decorative repertory of the Abbasid period. It might be thought that the Persian tradition of this style was evident, but as a matter of fact attempts have been made to attribute the Samarra painting style to two other sources.

It has long been observed that the decorative wood and stucco at Samarra show the influence of the nomadic art of Central Asia, whose grammar is dominated by the play of light obtained by oblique cutting away of the surface. Such an art based on wood cutting is thought to have been introduced to Samarra by the Turkish guards who were so conspicuous in the court life of the Abbasids. If this is admitted it is further suggested that the painting style too may have been under similar Turkish influence, and this allegation is supported by a comparison with rather earlier wall-paintings of heavily

contoured, richly clad and frontally drawn friezes of knights discovered by a German archaeological expedition at Kutcha in Turkestan. The point is supposed to be clinched by pointing to similarities of ethnic type and costume or accoutrements, and of the sad-looking heavy faces. But all these points can be otherwise accounted for; this Central Asian school had long been, as has been pointed out already, under strong Sassanian influence; both it and the Abbasid school were thus descendants of the same Persian tradition. The most important wall-paintings at Samarra are not the figure paintings but the splendid frieze of floral scrolls enclosing animals and human figures, which was based on the Eastern Persian version of a late Roman theme. Like some of the Samarra stucco patterns this is developed from the Sassanian palmette.

On the other hand the Samarra painting style has been given a Syrian origin for its figure subjects by Herzfeld, who fancied that he had found Aramaean signatures of painters on a set of large decorative painted storage vessels, three feet tall, which were discovered in the palace. It has been proved by Dr D. S. Rice that these pretended signatures are wine labels, and the figures are in fact bordered by characteristic Sassanian pearl frames, while one is surmounted by that most typical design the ribboned duck. The Persian character of the Samarra painting is established beyond a doubt. But no book-paintings were found at Samarra and it is necessary to look to Turfan, on the northern trade route through Central Asia, where Le Coq's expedition discovered some precious remains of illuminated manuscripts of scriptures of a Manichaean community. They are assigned to the early ninth century, when this area was under the control of the Uighur Turks, who ruled from about 750 to 850. The Manichaeans were however refugees from the Arab invasion of Persia, and they had an ancient tradition of book-painting. For the founder of the Manichaean religion or heresy, Mani (d. 274), was always remembered in Persia as a painter of surpassing skill, even among those who persecuted his followers for their faith. There is evidence of the rich illumination of their books in a famous passage of St Augustine who writes of their fine manuscripts and exquisite bindings, if only as fit for the burning. Indeed their esoteric and anti-social teaching with their successful proselytizing in many lands led to their constant persecution. To this fact we owe another reference in which it is recorded that in 923 at Baghdad, when sackloads of Manichaean books were being burnt by order of the Caliph Muqtadir, streams of molten gold and silver ran out of the bonfire. The fragments of the few pages found by Le Coq are all that now remain of all the richly decorated Manichaean scriptures. They are unmistakably Iranian; the miniatures are closely associated with the text, either beside or above it, and with a solid blue background rectangular in shape. Other pigments employed are red, purple, white and gold, with two greens, one dark and the other pale. The figures are drawn in outline and coloured with flat washes on which simple dress-patterns of rosettes are added. The only landscape elements are stylized trees, but there are space-filling floral scrolls. The pages are painted on both sides, but are now extremely fragmentary after further adventures during the last war. But their importance is great for they are by far the oldest surviving Persian book-paintings, and all that we have to represent the style of the first millennium.

The metropolitan Abbasid style which can be studied at Samarra was widely influential throughout the empire, and even reached lands beyond it, such as Norman Sicily and Moslem Spain in the first half of the twelfth century, to which it was transmitted by the Fatimids of Egypt, who were more conservative in taste than the Arabs of Mesopotamia (Iraq). The fascinating series of panel paintings on the ceiling of the Cappella Palatina at Palermo belong however rather to the history of Arab than of Persian painting. But in East Persia also this tradition of palace wall-painting persisted, as can be seen from the scanty remains from Nishapur in Khurasan and among them the life-size figure of a horseman painted on the uncoloured wall, and other fragments showing that the heads were once emphasized by coloured haloes, just as in the contemporary ninth century Buddhist painting in the cave temples at Tun-huang. Although this was painted under a native Persian dynasty the Samanids, the costume of the rider is that of the steppe, long boots decorated with a flower pattern, and a leopard skin saddle-cloth; and he uses stirrups, a Central Asian invention. Three straps hang from the leather waist-belt, which is a Turkish dress fashion found again in the costume of the most important composition surviving from the mediaeval wall-painting of the Eastern Caliphate. This is the frieze of knights which once surrounded the audience chamber of the palace of the Ghaznavids at Lashkar i-Bazaar, on the Helmand river in Afghanistan. Here again we see the persistence of this old tradition of palace decoration with rows of impressive guards, each shown in the same military stance corresponding to the guard mounted for public audiences outside. Daniel Schlumberger who discovered and published this important frieze has correctly attributed the costume of these knights to a Sassanian fashion preserved in Turkestan, and has recalled the old Persian tradition going back to the Achaemenids of such a scheme of palace decoration, still kept alive by these Turkish invaders who burst in from Central Asia and established a transitory empire (995-1038) which covered the Punjab, Afghanistan, Sistan, Khurasan and much of Central Persia. As in the Abbasid paintings of Samarra, the free spaces between the figures are filled with flowers or fruits. In fact the style seems more old-fashioned and monumental, and less free than the horseman from Nishapur painted more than a hundred years earlier.

Such was the state of wall-painting in the time of Firdawsi, and such would have been the wall-paintings mentioned in the *Shah-nama*; where otherwise only portraits are mentioned, portable and therefore on panel presumably. There is no mention of the practice of book-painting in the epic, although we know from Istakhri and Hamzah Isfahani that pre-Islamic illuminated books were still treasured in old feudal families in the tenth century. On the other hand the Samanid ruler Nasr II (913-942) is said to have invited painters from China to illustrate the new translation of the Arabic story of *Kalila and Dimna* into Persian which he commissioned from the poet Rudagi; certainly a tribute to the reputation in Persia of Chinese art at this time. Not a trace of the translation nor of this alleged innovation now remains. So far as can be seen today no Chinese influence can be detected in Persian painting before the Mongol invasions of the early thirteenth century.

Until then Persia was ruled by another wave of Turkish conquerors from Central Asia, the Seljuq Turks, under the great Sultans from 1038 until 1157, and thereafter by *atabegs* who shared the empire between them. It was a period of great accomplishment in Persian poetry and letters, in which the greatest star was Nizami, whose *Khamsa* or Five Poems were to be so frequently illustrated by the illuminators of the subsequent centuries, but we know of no manuscript illustrated in Persia at this time. The only light which we have on figure drawing at this time is from decorated Persian pottery, particularly the two kinds, *mina'i* associated with Ray, and golden lustre associated with Kashan and Saveh. Both types were being produced in the last quarter of the twelfth century, and on both subjects have been identified from the *Shah-nama*, while poems round the rims serve also to connect these wares with literature. But the drawing hardly ever rises above artisan level in the figure subjects, in spite of the mastery of design applied to the traditional shaped vessels. In some rare instances however the vessel is treated as a vehicle for illustration, and the field divided into registers as on a page. A well-known example is the cup in the Freer Gallery on which the *Shah-nama* story of Bizhan and Manizha is shown in a succession of scenes in strip sequence divided between three registers. There is an extreme economy of representing the subject with the minimum of detail, but the interest is purely illustrative. Gone is the impressive art of the Sassanians and not yet arrived the romantic or lyrical art of the best miniature paintings of the fourteenth to sixteenth centuries. It is true that, throughout, innumerable illuminated manuscripts were produced, whose miniatures have interest solely as illustrations; but the qualities that render Persian miniature painting one of the great arts of the world and a unique expression of her genius do not lie in these. There is reason to suppose that Seljuq painting had not yet freed itself from this dependence on the subject, and that if we did have one of the first illustrated *Shah-nama* manuscripts, it would have the pedestrian character of these little scenes. Only when combined with the abstract art of arabesque or of inscriptions, as it often was at that time on pottery or inlaid metalwork, such figure subjects have themselves a formal beauty, transcending the accident of representation, by means of the very restrictions necessary to these media.

In Iraq under these Seljuq dynasties Persian influence diminished, and the democratic spirit of Islam prevailed so as to allow of the development of a humorous penmanship, while its scientific heritage from Hellenism appeared in economical illustrations more closely united to the text, as in the illustrations to the Arabic versions of Dioscorides or Galen. It is only in certain of the frontispieces to these volumes that the tradition of Sassanian Persia showed itself still powerful. Of this kind is a medical work ascribed to Galen and copied in 1199, probably in Mosul, the centre of a school under the *atabegs* of the Zengid house, one of whom, Nur ad-Din Arslanshah (1193-1210) just at this time was making his capital a famous centre for the production of engraved and inlaid metalwork. In 1210 Badr ad-Din Lu'lu, an Armenian slave captured in battle, became regent and from 1233 was recognized as a ruler in his own right, and so continued until his death in 1259. For him there was copied in twenty volumes the great Anthology of Arabic poetry known as *Kitab al-Aghani*, between 1217 and 1219, of which half is now preserved

in the libraries at Istanbul, Cairo and Copenhagen. Six of these have framed frontispieces in which the patron is depicted in occupations of the court and the hunt. The style is still splendid and monumental, rich in colour and hierarchic in feeling. The same style appears in the frontispiece of a splendid manuscript of Galen in the Vienna State Library which must be assigned to the same place and date. It happens that there also survives a Christian book, a Syriac Gospel Book, now in the Vatican Library, which was copied at Mar Mattei monastery in 1220 not far from Mosul. The basic style is the same though overlaid by Christian influence from Byzantium in iconography; and we find the same red background and the same dress patterns with floral designs as on the Seljuq work of the period. This evidence helps to tie the style to the Mosul region.

There is one manuscript which connects the school of Iraq of the early thirteenth century with that of the Persian Seljuqs, a romantic poem in Persian entitled *Varka va Gulshah*, now preserved in the Sarayi Library under the number Hazine 841. Many of the seventy small miniatures have coloured grounds, red, green, gold or blue, and all fill the intervals in the compositions with floral scrolls, stylized trees or birds in flight. The figure drawing resembles that on the Seljuq pottery of Persia, but the drapery folds are in the more naturalistic tradition of the Iraq school, rather than the flat arabesques of the pottery. Nearly all the heads of the human figures have round haloes, as on the Syrian enamel glass vessels of the period. The horses which occur in many of the pictures are particularly vigorous and well drawn. This unique book is obviously of the Seljuq period and it seems to fit best into an Iraqi milieu, but the poem is in Persian and copied by a scribe of Persian origin. In its illustrations one may see a reflection of the lost miniature art of Persia under the Seljuqs.

The paradox, which results from this survey of the history of painting in Persia before the Mongol invasions, is that it had not yet achieved the expressive and imaginative force, which was to give it its special and unique quality only after it had come in contact with Chinese drawing. This is the agent which seems to have freed the Persian genius from its subordination to the other arts of the book by a mysterious catalysis.

The Mongol Style under the Il-Khans

2

THE conquest of Persia by the Mongols was carried out by a succession of raids of devastating ferocity from 1220 to 1258, in which the population of the cities was reduced to a fraction and many of the leading centres of civilization were ruined. The aim of these methods was to reduce the country to a terrorized subservience, so that it could be held down by a comparatively small army of occupation, but the rule was so harsh that there were many revolts followed by new massacres. The loss of life and the material destruction are beyond calculation, and it is clear that the country never really recovered and that the irrigation of the land and the rebuilding of many cities was never fully accomplished. Destruction of libraries was so severe that it is no surprise that it is hard to find a single illustrated manuscript dating from before this cataclysm. But the Mongols found that they could not govern the land or gather the taxes without the help of some Persian ministers and officials. Even under Chingiz Khan himself merchants were a protected class as being of evident value to the whole economy. Moreover some parts, like Transoxiana, which provided grazing grounds not unlike the Central Asian home of the Mongols, were spared the worst destruction, which befell in particular Khurasan and Iraq. Indeed the Persian minister and historian Ala ad-Din Juvaini records that under Chaghatai "a woman with a golden vessel on her head might walk without fear" in Transoxiana. The Mongol rule brought as its first compensation security and law and order.

Moreover under the rule of the Great Khan Mangu, from 1251, reforms were introduced, and they were promulgated in the west by Hulagu who took up his rule at Samarqand in 1255. But even then the Mongols still led a nomadic life and their patronage of art would not have extended beyond a tent with embroidered pictures. It was not until the time of the Il-Khan Ahmad (1282-1284), that Persia had a Moslem ruler who could be really sympathetic to her culture. His predecessor Abaqa (1265-1282) had a Christian wife, Maria Palaeologos, and was in correspondence with several Western rulers: Christian influence is to be seen in the art of the Mongol court for long after this. Meanwhile Arghun (1284-1291) was a Buddhist, and this was no doubt one of the reasons that the country was open to artistic influences from Central Asia and China. The early capitals of the Il-Khans were cosmopolitan centres with, in general, wide tolerance of

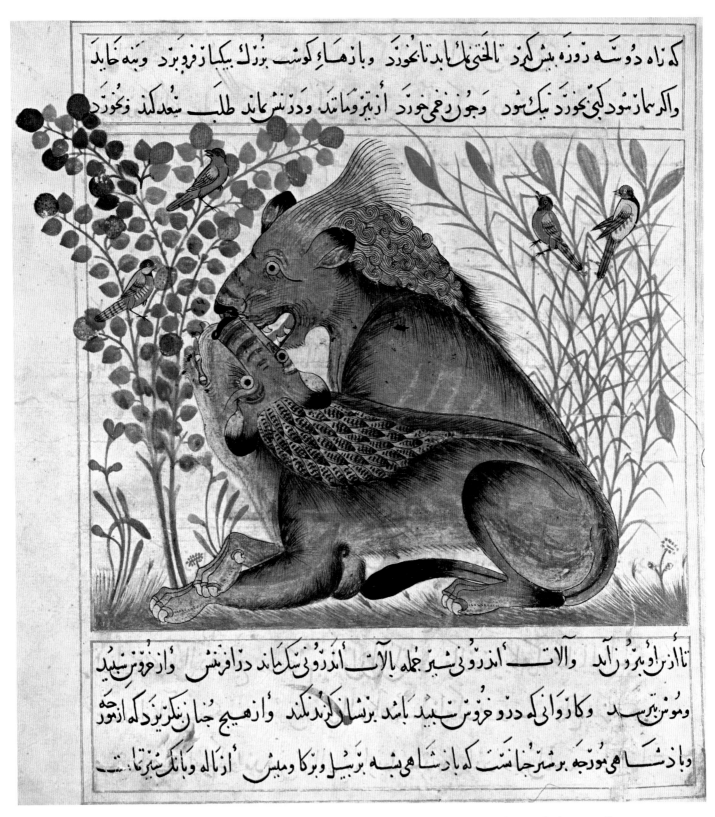

كه راه دوسه دوزه بيشكيرد الحتى لم ابد تانخورد وبازهاء كوش بزرك بيكازفروبرد وبنه خايد

والكر نماز شود دكبى نخورد نيك شود وجوز دحمى خورد ازتيزوماتد ودزنشرماند طلب سعدكذ نخورد

تاازراوبرورآيد والآت اندروى نشير جمله بالآت اندروى نيك ماند دزافرنش وازخروش نشيد

ومونن بترسد وكاروانى كه دزو خروش نشيد بايد برنشان كردندكند وازهيج جان زنكر بزدكه ازنور

دباد شاهى مونجه برشير خانت كه بادشاهى ببه برزبيل وبزكا وميش أزاله وبانكر نشيرتما بث

Bestiary (Manafi' al-Hayawan) of Ibn Bakhtishu: Lion and Lioness. Maragha, 1298. (13⅜×9⅝″)

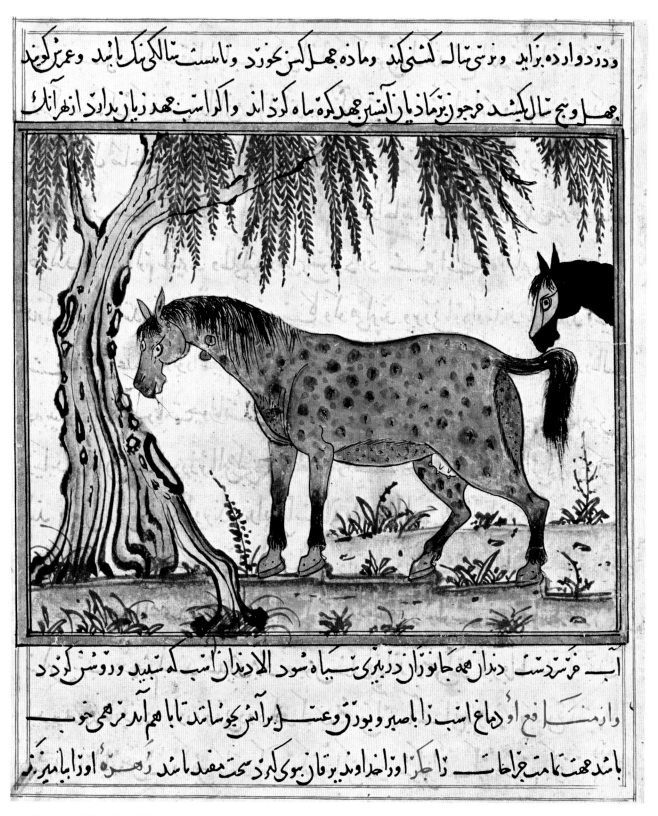

وددد دواده برايد ونرتى نال كشنى كند وماده مجر اكرن خورد وتاسست نال كى نك بابند وعمر بركوند
بجل وبج نال كيشند مر جون زبزماذ بار آتشتر مجهدكره ماه كرد اذ واكر اسب عهد زباز بدارد ازهر آنك

Bestiary (Manafi' al-Hayawan) of Ibn Bakhtishu: A Mare followed by a Stallion. Maragha, 1298. (13⅜×9⅝″)
M. 500, folio 28 recto, Courtesy The Pierpont Morgan Library, New York.

Illustrations pages 20-21

other religions. Even after Ghazan (1295-1304) had officially made Islam his state religion, his interest in scholarship ensured the presence in Tabriz of foreign scholars from many countries. From this time the Mongols settled in the cities and started to build fine and permanent quarters.

It is from the reign of Ghazan that the earliest surviving illuminated Persian manuscript has come down to us—a work on natural history, translated from the Arabic of a Christian doctor Ibn Bakhtishu, who was physician to the Caliph al-Muttaqi in Baghdad, for whom he compiled this work in the year 941. Ghazan had this well-known work translated into Persian by Abd al-Hadi, and it is probably the original copy which is preserved today in the Pierpont Morgan Library in New York under the number M. 500. The third figure of the date in the colophon is not clear, but it was probably written in 1298, and in any case at Maragha, an early Mongol capital in Azarbaijan, about seventy miles south of Tabriz. In its present state it contains 94 miniatures, but many of these are no bigger than an inch or two each way. Moreover unfortunately the manuscript illumination was never finished and there is also a good deal of later work on a number of the pages.

The original text was composed in Baghdad, and no doubt the copy used by the translator would have been a product of that same school, similar to the fable books which have been preserved from the thirteenth century, or the natural history manuscript now in the British Museum (Or. 2874). The style of these miniatures is unnaturalistic. They are flat diagrams, the animals being decoratively designed in a setting of conventionalized landscape elements. The outline is strong and there may be a touch of humour in the drawing of the expressions: trees and water are not derived from nature directly, but are generalized foliage arranged on the stems in a decorative pattern. A pool is a mosaic of ripples, the grass round it a repeated leaf symbol. When the sky is represented it is by an inverted arc in which a sun is placed like a jewel in a setting. The whole is displayed on the page like the illustrations to a Herbal without frame to separate it from the text. In contrast most, though not all, of the Morgan Library miniatures are framed, and the background vegetation is comparatively naturalistically rendered. Although Chinese elements are thus present in nearly all the miniatures, yet the Mesopotamian strand in the whole book is unmistakable. That is to say that there is an archaistic air about much of the work, which mixes awkwardly with the new naturalism of China. What does this mean? The animal world of the Morgan manuscript is seen from their own animal point of view: they inhabit the landscapes, and this is just as true of the first hand on the folios up to 20v. which drew the animals in their simple settings as of the impressionistic trees of the "magpies" on folio 60v. Behind these two styles are two different types of Chinese painting, one the handscroll or album-leaf with the minimum of tree or foliage to place or support an animal or bird, the other the landscape in ink and light colour from which the bestiary miniature could be a cut. Of course the Moslem painter could not avoid giving a more heraldic look to all his material. In order to combine on his page with the regular Arabic script, it needed to be formalized; but withal its quality of line differs from the firm outlining of the Baghdad

school. It retains the sensitivity to the fur or hide of the creature depicted usual in the Chinese school. The *Two Bears* of folio 24v. have no formal outline at all, but their coats are brushed in and then enhanced with gold, which is also used to point the eyes of all the early animals in this book. The *Lion and Lioness*, too, are outlined in pen only Illustration page 20 along the heads and backs, while the forequarters are drawn in red and the bellies are hatched. Even the more monumental *Elephants* and *Zebu* are drawn with a regard for the texture of the animals; the throat line of the zebu being delicately contoured to correspond to the folds in nature. The trunks of the elephants too have the softer undersides and the loose folds of the skin are recorded in contrast with the schematic rendering of the bodies: but in all these earlier pages the animals are generalized in a way appropriate to a Bestiary, while the more elaborate background landscapes for the later pages are better suited to larger pictures than the few inches of the book. Here for the first time the artists practise the cutting of the edge of the miniature with the frame, as had long been the custom in the bird and flower pictures in China. It will be seen in other work of the Mongol school in Persia how striking and effective this practice could be. But at this time the old tradition was too strong to allow of its being done very often. And the clouds are generally gold, edged with colour and entirely unnaturalistic in drawing. The splendour of these miniatures lies in the balance between the monumental and the naturalistic in the animal drawings. Even the most monumental pages which occur on the first twenty-four folios, give the animals a world to inhabit: however decorative the treatment of the trees and flowers, they are not mere symbols, but spread out into the margins because that is the way that they grow. So too they are not space-fillers but provide a setting for the beasts who move in and out among them, though they still seem a little artificial or contrived. The later pages show little vignettes calligraphically drawn in a much more Chinese manner, and therefore dependent on a far older tradition of landscape painting. Since the spectator is now looking through the paper into a world that opens out beyond it, it is no shock to allow the view to be cut off at any point that is convenient by the edge of the picture-space, even if that means dividing the body of the horse which is the ostensible subject of the miniature. This Illustration page 21 daring step is of the utmost importance for the future history of the school, for the concept of the window, setting the miniature behind the surface of the written page of the manuscript, allows all the later development of the composition. It is not denied by the frequent practice of allowing part of the scene to appear in the margin beyond the edge of the text and separated from it by half a page. Indeed the lances or tree-tops thus projecting vindicate the continuation of the imagined world beyond the narrow boundaries of the small miniature. Many brilliant devices were to result from this principle; though it was some time longer before the coloured background inherited from the old tradition of wall-painting ceased to be just a curtain before which the action took place, and became the limitless vista of the deep blue or burnished gold skies of the fifteenth century and later.

During most of the fourteenth century at least, the illustrator was rather awkwardly manipulating the landscape elements that he had received from China. The ways that

these were introduced suggest a quite imperfect acquaintance with Chinese painting, perhaps entirely known at first through the media of the decorative and applied arts, such as ceramics and textiles. The cloud-forms are those which were used in tapestry and embroidery and, above all, in costume. Gold-embroidered squares, though not perhaps precisely dragon-squares, are found in early fourteenth century Persian manuscripts, including the Edinburgh University Rashid al-Din of 1306 A.D., to be described below. They all appear to include cloud motifs in the design; and the dragon, the phoenix, and the crane also were no doubt found in Chinese woven and embroidered silks. Another element in the landscape which was a revivification of a convention in Chinese art was that used for water. Throughout the first half of the fourteenth century water is shown as a scale-like pattern, as curdled whirls or as crested waves, generally on a large scale in relation to the rest of the picture. All of these forms are found in Chinese painting of the time as well as much earlier, but not so conventionally rendered as in Persia except on the earliest blue and white porcelain with pictorial compositions. These however are now not believed to commence before the middle of the fourteenth century. It would therefore appear that these conventions must have been conveyed to Persia in some other manner. Possibly woven silks or carved lacquer may have been the media, but we know much less in detail of the history of these crafts than of porcelain before the Ming dynasty (1368-1644).

The most conspicuous of all the Chinese borrowings in the miniatures of this period are the trees and mountains. These can hardly have been derived from any source but actual paintings, access to which is likely to have been limited to court circles. We know

Jami' al-Tawarikh (Universal History) of Rashid al-Din: The Sacred Tree of Buddha. Tabriz, 1314. (4×9⅞")
Arabic MS 26, folio 36 verso, Royal Asiatic Society, London.

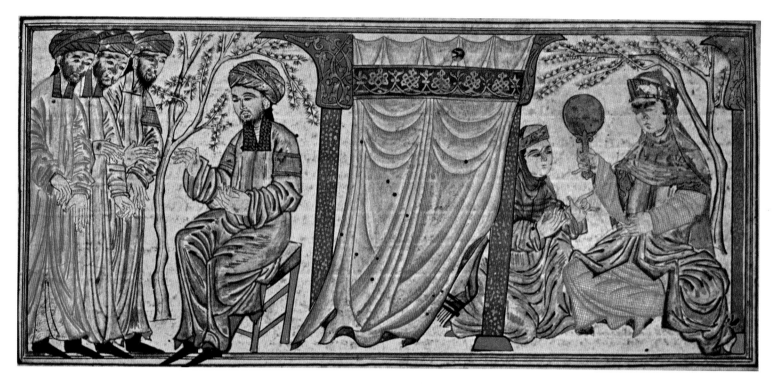

Jami' al-Tawarikh (Universal History) of Rashid al-Din: Abraham receiving the Three Strangers and Sarah in the Tent. Tabriz, 1314. (4¼×9⅝") Arabic MS 26, folio 47 verso, Royal Asiatic Society, London.

that there were Chinese scholars at the capital Tabriz, and that the wazir, Rashid al-Din, had Chinese helpers in compiling his universal history. It is in the Tabriz manuscripts that the Chinese landscapes occur in their purest form; that is, in the Morgan *Bestiary* and the two surviving portions of the *Jami' al-Tawarikh*, dating from the lifetime of this author, Rashid al-Din, and now preserved in the libraries of the Royal Asiatic Society and the University of Edinburgh. These last are dated respectively 1314 and 1306. In the *Bestiary*, the trees are conspicuously naturalistic and calligraphic, while the indications of ground are limited to crags and hillocks outlined by double contoured borders. Possibly these represent the Chinese heavy brushstroke made with the side of the brush, but they might be referred more naturally to the imitation of embroidery or tapestry weaving. The shading within these contours is much richer in the other manuscripts of the group, especially the *Jami' al-Tawarikh* and the *History of Ancient Peoples* by al-Biruni, also in the library of Edinburgh University (Arab 161). We find the same jagged contours but enriched by strong colour, in earthy tints, chocolate brown, slate blue, and brown ochre, often strongest near the summits and enclosing curious bubble-like reserves which are perhaps intended to represent stones; or filled with internal contour systems which may indeed be used to convey the same information as the contours in a modern map. If so, this would be a useful indication of the fundamentally symbolic character even of this most naturalistic sort of Persian book-painting. So that although in the *Jami' al-Tawarikh* the colouring is much more subdued and limited, the basic

concept is usually nearer to the Persian conceptual picture. Scale relationship is habitually disregarded and the landscape elements become space-fillers in these compositions. Although the frame still cuts the composition, where it is required, for effect of balance or drama, miniatures are tied to the text by the device of prolonging the lances of the mounted troops as it were behind the lines of the text, to reappear in the margins beyond them.

A curious feature of this manuscript is the free and almost indiscriminate use of silver paint, not only for the enhancement of the blue of water, where it might seem appropriate, but also for dress-folds and even on the faces of bearded men. It is possible that this strange custom was derived from the illuminated manuscripts of the east Christian churches, especially the Jacobites. It is obvious that there were at Rashidiyya, the library centre established by Rashid al-Din, Christian scholars to help in the universal history, and the influence of the schools of Syria and Mesopotamia is to be seen not only in these particulars but also in the drapery folds, especially in the al-Biruni in which the Chinese influence is less strong. But it is only to touch on externals to seek to disentangle the several influences in these manuscripts; their most striking characteristic is dramatic power achieved with a minimum of means. Instead of being strung across the page, avoiding overlapping, as in the school of Baghdad, here the figures are arranged in tight groups, on two or three planes, with a preference for asymmetry; and so as to emphasize the main action by spacing as well as gesture. Apart from some Biblical *Illustration page 25* history scenes, and a series of portraits of the Chinese emperors, the compositions are likely to have been invented for these volumes, and the many other copies, now alas all vanished, which Rashid al-Din arranged to have made every year in this library for the great libraries of the Islamic world. The choice of subject is therefore significant and sometimes daring. For instance, there is a pure landscape without any figures, to represent *Illustration page 24* the *Sacred Tree of Buddha* (which is incidentally quite unlike any Indian representation of this subject), and another of the *Mountains of India*, both of them highly imaginative and romantic, in spite of a certain childish incompetence in the use of the sophisticated Chinese terms for mountains, trees and water.

Illustration page 27 Although there can be no doubt that the al-Biruni history book (Arab 161, in Edinburgh University) is a product of the Il-Khanid school and presumably from Tabriz, and that it is dated between the two volumes of Rashid al-Din, in 1307-1308, it stands rather apart from them in its greater dependence on the Mesopotamian school. There is no opening up of vistas, but the horizon is closed not far behind the picture plane so that it rather resembles the Morgan *Bestiary*, as it does also in its richer colour range. But the most significant difference lies in the new conventions for drapery folds. Instead of the flowing, open folds of the Rashidiyya library, we find the enclosed spirals and curls which characterize the Mesopotamian manuscripts. As in Mesopotamia many of the heads are haloed in gold with a double rim simply for emphasis, and they crowd the foreground in an old-fashioned way. There is nothing in this manuscript to compare with the expanse shown in the *Drowning of the Egyptians in the Red Sea* or in the *Swallowing of Qarun by the Earth* in the other Edinburgh manuscript. But one striking feature of the al-Biruni

History of Ancient Peoples (al-Athar al-Baqiyah) of al-Biruni: Destruction of the Temple of Jerusalem. Tabriz, 1307-1308. (3×5⅝) Arab 161, folio 158 verso, University Library, Edinburgh.

is significant for the future, the coloured skies shading gradually from deep blue at the top to the plain paper below, and the elaborately convoluted clouds in blue with white linings. From this time on this kind of cloud convention was frequently used, though not so prominently, in Persian miniatures. As if to emphasize the picture openings on these pages, several of the miniatures are framed not only with gold rules but with patterned borders. These borders are Islamic, but the clouds and the similar conventions for fire and smoke are of Chinese origin and are frequently found in Buddhist paintings.

With their richer colouring these miniatures are more decorative than the *Jami' al-Tawarikh*, but less effective as illustrations owing to their timid gestures which contrast with the dramatic movement of these latter. In one miniature only, in the al-Biruni, is there considerable dramatic force: that representing the destruction of a Illustration page 27 domed building, which achieves a powerful effect just in the same way as the rather similar subject in the *Jami' al-Tawarikh* illustration of the end of Samson and the fall of the Philistine temple (reproduced in *Persian Miniature Painting*, pl. xviii B). In both the action is crowded into the front of the picture-space. But that here reproduced is much the richer of the two.

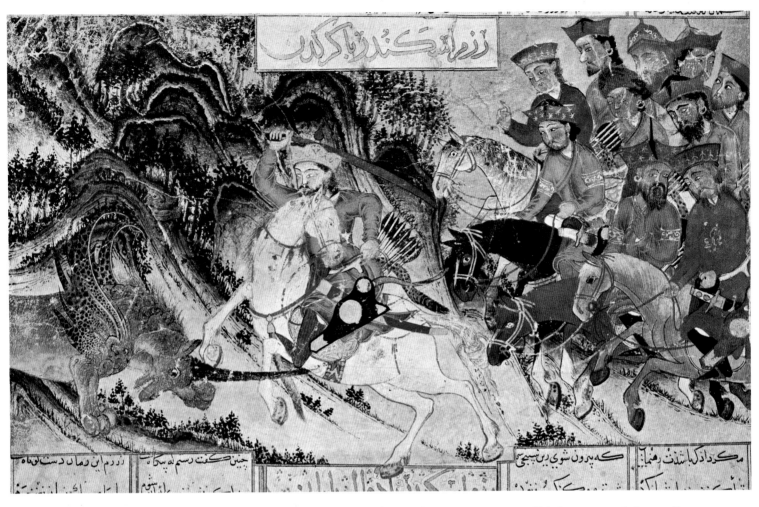

Shah-nama (Demotte) of Firdawsi: Battle of Iskandar with the Dragon. Tabriz, 1330-1336. (7×11½″)
No. 30.105, Courtesy of The Museum of Fine Arts, Boston.

One of the most striking features of the *Jami' al-Tawarikh* manuscripts is the great size of the page, about 17 by 12 inches. And this we know to have been a special feature of the production at Rashidiyya: even the theological works of the master were written on paper of this size. Not again until the first half of the fifteenth century, in the historical recensions of Shah Rukh which will be discussed later, was this large page used in any illustrated manuscripts, except in two cases with which we must now concern ourselves. A manuscript of the *Shah-nama*, now called after its former owner Demotte, which is known to survive in only about sixty folios carrying miniatures, and a very few with text alone, has a page measuring about 16 by 11½ inches; and a copy of *Kalila wa Dimna*, of which the fragmentary remains are mounted in an album preserved in the library of the University of Istanbul, must have measured at least 13 by 9¼ inches. And both these fragmentary manuscripts devote a much larger area of their pages to miniatures, so that their actual scale is considerably larger than any in the *Jami' al-Tawarikh*. They are generally agreed to be the most remarkable and impressive of all the work of the

fourteenth century. In particular the *Shah-nama* pictures sum up and transcend all that can be found of drama and decorative richness in the earlier Tabriz books. The colouring of the al-Biruni is combined with the movement of the *Jami' al-Tawarikh*; while the role of landscape has increased, and it is brought into closer relation with the figures.

Shah-nama (Demotte) of Firdawsi: The Indian Army fleeing before the Iron Warriors of Iskandar. Tabriz, 1330-1336. (10⅝×11⅜″) No. 1955.167, Courtesy of the Fogg Art Museum, Harvard University.

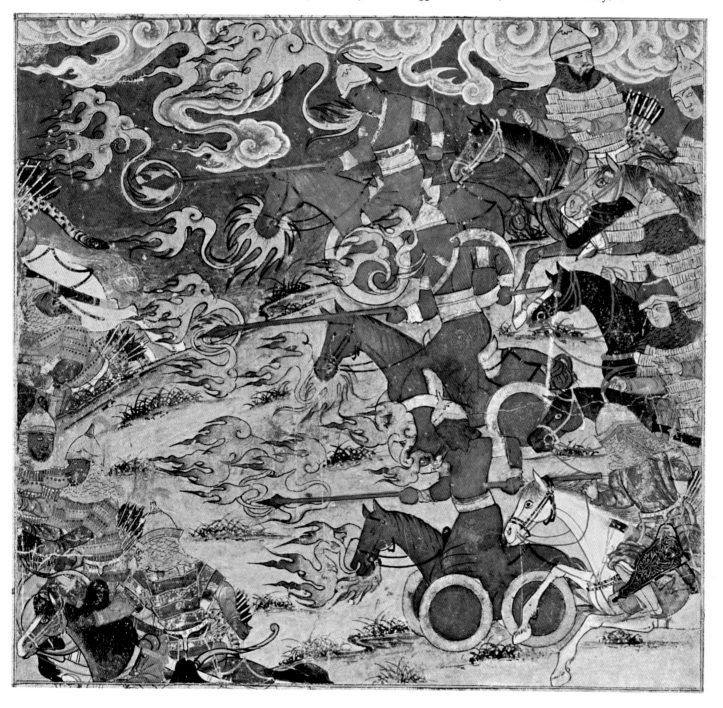

The dragon slain by Bahram Gur winds itself round the great tree-trunk, in the Cleveland Museum page; the tree which speaks to Alexander through the many heads on its branches, on the Freer Gallery page, is rooted in the ground at his horse's feet. On the Fogg Art Museum page showing *Bahram Gur shooting the gazelle and trampling on Azada*, the deer really run along the hill slopes, up or down, but the conventional patch of maize filling the corner and the cloud-patterns remain as they were in the earlier books. For earlier they certainly are. The question still debated is, "how much earlier?" Historical consideration suggests that important books like this are not likely to have been produced during the period of disturbance and fighting which followed upon the break up of the Il-Khanid power in 1336. From that date until 1360 there was no ruler powerful enough to support a library staff competent for such a task. In style the miniatures are nearer to what precedes than what follows this interval, but it is rash to attempt to evaluate this stylistic development in terms of temporal interval.

If we now turn back, or rather on to the Demotte *Shah-nama*, we can understand what has been accomplished. The often rather exaggerated size of the mask-like faces preserves the essential of the heroic dignity that we must suppose native in the Persian school, while the artists were now able to compose their scenes in free space. The backgrounds may not be in close relation of scale with the main action, but they are all that is required to give the figures a scale suited to the illustration of the national epic. The main figures are still placed near the front of the picture, but are now turned in every direction, quite often inwards, so as to present their backs to the spectator. While the vista is never closed, skies of deep blue or gold have become the rule; and, as has already been remarked, the cutting off of the action by the edge of the "frame" to the miniature has been developed to a fine art. The result is a unique combination of drama with a grand concept of nature suited to romance. The world is sympathetic rather than engulfing as it later became, when the beauty of the natural world became the real theme of so much Persian painting. It is strange that the influence of China should have been so effective in bringing out this sense of drama; and the pathetic or heroic which was native in Persian poetry of the epic kind; whereas in China itself themes of this kind were never treated in superior painting. It seems that the very tension between the native tradition and the newly learnt science of picture-making brought forth this vigorous style of inspired illustration.

Because of its connection with the school of Tabriz, most critics have inclined in recent years to place the Demotte *Shah-nama* about 1330, although they hardly ever fail to suggest it must have taken a considerable time to produce. The most recent datings are those of Dr Ettinghausen, to 1330-1350; of Dr E. Kuehnel to 1330-1340; and of M. Ivan Stchoukine to between 1330 and about 1375. It does not seem that the fall of the house of Rashid al-Din in 1336 can have immediately put an end to the practice of the style, but the political state of Persia between that year and 1360, when the Jala'ir established themselves, would have provided no patron with enough resources to produce so ambitious a book as this was. From what survives it can be estimated that the whole poem would have been illustrated by about a hundred and twenty miniatures.

Attempts have been made to distribute the miniatures among several different hands, and even to allocate their production to different decades of the fourteenth century. It is indeed obvious that a number of artists worked on this book; but the stylistic variety, or the varying degrees of Chinese influence, do not really require that it need have been in production for several decades; but, on the contrary, given that it was a revolutionary book, such differences are just what would be expected. Each artist might be assumed to have executed at least twelve of such miniatures during a year, so that if there were six painters employed on it, the illumination would have been completed in about one year and eight months. Even if allowance is made for interruption and other urgent commissions, three years would be a sufficient allowance; and, even if there were only three painters engaged, a total of six years would have sufficed. The period 1330 to 1336 seems to me the most likely. The two most striking advances on the early fourteenth century miniatures are the greatly enriched colour-range, and devices to open out the structure of the composition, frequently by use of a *repoussoir*, a figure in the extreme foreground, sometimes even with his back turned towards the spectator, or even seeming to come forward out of the picture, as in the *Battle of Bahram Gur with the Dragon*. The whole sky is now filled with a solid ground of gold or blue, often with no clouds; flowering trees are frequent, and the pine is now allowed to show red-tipped needles. This *Bahram Gur* picture has a fully developed landscape background, but in some of the other pages such as the *Bahram Gur trampling Azada* stalks of maize and scalloped swirls are still used for fields and cloud, as symbols.

As has already been remarked two themes were treated with outstanding success in this manuscript, the heroic and the pathetic. Never again in Persian painting do we find this powerful sense of destiny which dominates and inspires these few memorable pages. And of the heroic subjects it is rather those concerned with the struggle against the forces of evil which predominate than those of mere personal prowess. On a page, now unfortunately missing since an exhibition in 1937, the Iranian king Kay Ka'us is shown at the outset of his disastrous campaign against the magicians of Mazanderan and their devilish helpers; the knotted trunks of two trees are leafy only on the side away from the sinister horned devils, some of whom are being trampled under foot by the king. The impression is well given of a desperate fight in a wild country. No pages are more striking than those depicting the exploits of the heroes Bahram Gur, Rustam, and Alexander; and especially their combats with dragons. These are very different from Illustration page 28 the decorative creatures which are depicted in the miniatures of the fifteenth and sixteenth centuries. Bahram's dragon is indeed closely derived from a Chinese prototype, but is all the more formidable for that reason. But the subject is of course inconceivable for a Chinese for whom the dragon typifies the cosmic force; so that the painter has completely changed the character of the creature in showing it prostrate with its huge scaly tail coiled round a bare tree on a mountain side, its great jaws open, not to emit fire and smoke, but its last gasp. Bahram Gur with his sword drawn turns his back to finish off the dragon, and faces the landscape which is thus involved in the heroic scene. The creature which Iskandar (Alexander) attacks is not so formidable, but in combining

Illustration page 28 the fangs of a wolf with the horn of a rhinoceros and the wings of an eagle, and the claws of a lion, it effectively typifies all natural animal strength, from which, realistically, the king's horse turns away its head. The smaller scale of the monster here is set in a nearer and therefore more formidable landscape; which is again made up of Chinese

Shah-nama (Demotte) of Firdawsi: The Bier of the Great Iskandar. Tabriz, 1330-1336. (9¹³/₁₆ × 11")
No. 38.3, Courtesy of the Smithsonian Institution, Freer Gallery of Art, Washington, D.C.

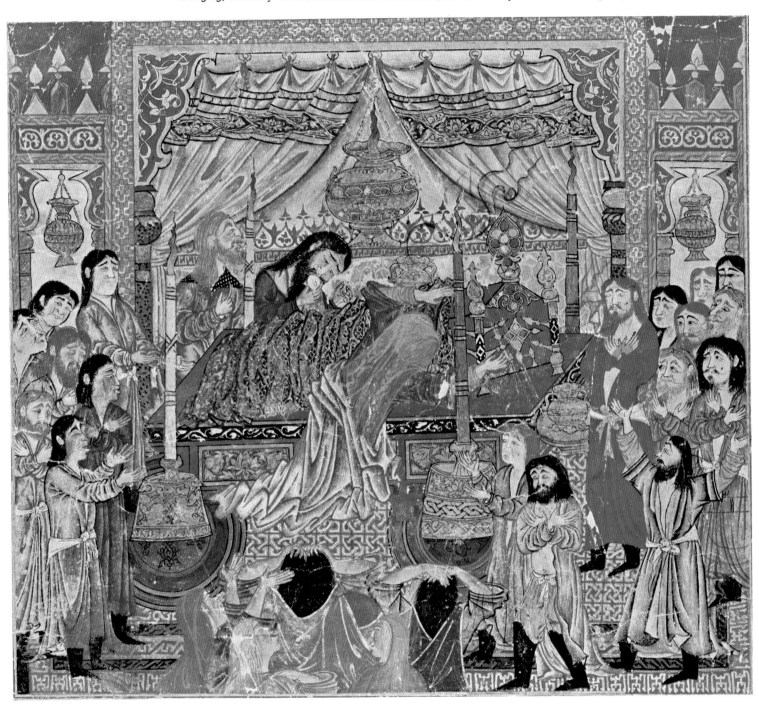

elements, better understood and co-ordinated, and brought into relation with the figures of Alexander and his warriors. But the human figures still dominate the picture as they do throughout this manuscript.

Even more striking are the "pathetic scenes," as they have been named by a French critic, the late Eustache de Lorey. Scenes of mourning are among the finest in the series; and, in all, the human figures crowd the whole picture. The most moving and accomplished of these scenes of mourning is that showing *The Bier of the Great Iskandar*. In the Illustration page 32 version of the Alexander legend followed by Firdawsi, Iskandar died at Babylon and his coffin was carried to Iskandaryyah after the echoing cliff of Khulm had been consulted. There, on the plain, it was surrounded by ten thousand mourners of his army and of the Persians. At dusk he was buried. Once more the artist (certainly not the same hand as the last) has altered the setting of the scene; which he has chosen to depict as a palace in which the coffin of the dead king has been placed on a platform like a Chinese emperor, with carved panels of Chinese floral subjects round the sides, but it is surrounded by four tall candles set in candlesticks of Islamic shape; and the whole stands on a carpet with an interlace centre and border of stylized Kufic. Above the bier and on either side hang glass lamps, as used in a mosque, while richly embroidered curtains hang behind in what seems to be a niche. The mourners stand on either side, bare-headed and having let their hair and beards grow; their hands either crossed on their breasts or stretched out in supplication. Behind the coffin and next to it stands a bearded figure, Aristotle, the tutor of the dead king; but the drama is concentrated in the women in the centre foreground, all seen from the back or in half profile, with their hands stretched above their heads, the fingers wonderfully expressive of grief. Beyond them and falling across the bier itself is the distraught figure of the mother of Iskandar, her robe hanging in tortured folds, which are the focal point of the whole picture; the only strongly accented lines in it. The composition is held together and given stability by the architectural structure, with its emphatic verticals, and the symmetrical plan. Such symmetry had been an Iranian contribution to the school of Mesopotamia in the previous century, and its persistence here and in other pages of this manuscript shows that the Chinese innovations were fitted into an Iranian conception of the picture.

These subjects do not end the pathetic line so often preferred in this manuscript. One other striking example only can be mentioned here. The captured king Ardawan, last of the Parthians, is brought before his captor Ardashir, just before his execution. He is a pathetic sight, his hands tied behind his back, a halter round his neck, his face white in strong contrast to the sanguine cheeks of his tough jailers.

The resourcefulness of the artists of the book is not exhausted: for there are other manners for the court scenes and the scenes of battle, in one of which for instance the title has been taken into the field of the picture, while the lances of the horsemen are raised up between the columns of the text of the epic. None of these battle scenes is richer in colour than the charge of Iskandar's iron horsemen at the battle of Hydaspes Illustration page 29 against the army of King Fur. Gold and silver have been used to depict the polished steel of these naphtha-filled engines of war, and the fire from their nostrils and spear-points

colours the underside of the clouds with red and gold lights. The landscape is here as simple as in the Morgan Library *Bestiary*: no further setting is required for this subject, which is the best example of the effective cutting by the margins of what might be taken from a narrative handscroll of the Far East. The terrified Indians glancing backwards have already almost fled out of the picture. This composition must surely have been seen by the illustrator of the Sarayi Library *Garshaspnama* (Hazine 574) which, as Dr Ettinghausen remarked, dates this Demotte page before 1354, the date of that manuscript. Evidence of the workshop practice at this time is provided by the condition of the double margins of this miniature. Between the ruled lines is still to be seen the continuation of the underdrawing of the miniature, with only tints added. It follows that the strong colouring within the margins must have been added subsequently, and may not be by the same hand; though it is certainly of the same period. Even so simple a subject as *Darab sleeping beneath the ruined arch under which he had taken refuge from a storm*, and from which a mysterious voice designates him as king and son of a king; even this is made memorable by the height of the arch set in a perfectly symmetrical building which entirely fills the picture-space. The dreaming king has been given the crown which was not to be his until some time later, but his solitude is thereby emphasized. Moreover this miniature is prophetic in another sense; for in it is to be seen the exemplar of the fifteenth century style in which too great damage is not done to the unity of the page by closing the horizon with a building or a high hill-side, and keeping the figures within the coulisses of the one on the other. The Demotte *Shah-nama* is in fact the first of the modern books of Persia as well as the highest point in the development of the Mongol school under the Il-Khanids. It was rightly said by a sixteenth century Persian critic, Dust Muhammad, that the modern style of painting as it was known in his time took its rise under Abu Sa'id (1317-1335).

This writer was a calligrapher and painter who was ordered by the Safavi prince Abu'l Fath Bahram Mirza to form an album of his collection of paintings and calligraphic specimens in 1544, and to prefix to it an account of the past masters of these crafts. This album is now preserved in the Topkapu Sarayi Library in Istanbul. All that precedes the time of Abu Sa'id in this account is legendary, but from that point the story is coherent and in its main lines entirely convincing. For he gives the succession of patronage of the leading schools as passing from the last of the Il-Khanids to the Jala'ir, who we shall see to have been the patrons of the most impressive books which survive from the later part of the fourteenth century. Then the school is represented as having been transplanted to Samarqand by Timur on the fall of Baghdad in 1393; and so as having passed to his descendants, of whom he mentions especially Baysunghur, Ulugh Beg and Sultan Husayn Mirza. This important document will be referred to again for these later periods; now we are only concerned to note that he states that it was *Ustad* (master) Ahmad Musa who "withdrew the covering from the face of painting and invented the kind of painting which is current at the present time. An *Abu Sa'id-nama*, a *Kalila wa Dimna* and a *Mi'raj-nama*, copied by Maulana 'Abdullah, were illustrated by this painter; and also a *History of Chingiz*, afterwards in the library of Sultan Husayn Mirza."

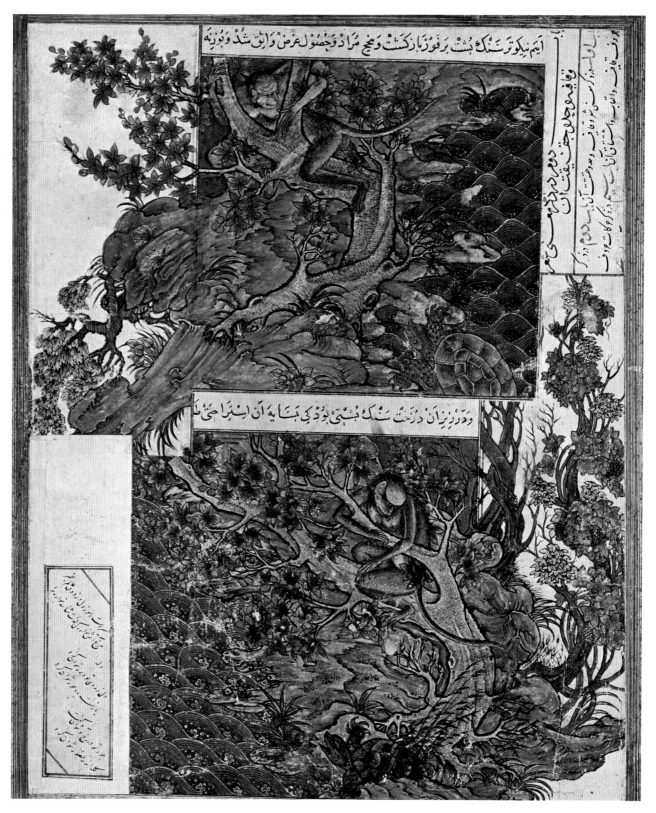

Kalila wa Dimna (Album from the Imperial Palace of Yildiz): The Deposed King of the Monkeys throwing Figs to the Tortoise. Tabriz, 1360-1374. (13¼×10⅛″) F. 1422, folio 19 verso, University Library, Istanbul.

It has been suggested that the *Kalila wa Dimna* here mentioned should be identified with the series of miniatures cut from a manuscript and now preserved in a very large album which was formerly in the Ottoman Imperial Palace of Yildiz, and is now in the library of the University of Istanbul. They are indeed among the most remarkable work of the whole century, and have already been mentioned as having preserved the same sort of scale as the Tabriz books of the first quarter of it. But they are considerably more advanced, especially in the landscape. There is greater variety of tree, more freedom in composing, and more advanced perspective. A striking and highly successful innovation is the extension of the miniatures into the margin. This is not at first sight so obvious since they are now mounted several on one album page; nearly all the text having been cut away, and the miniatures fitted together, sometimes even overlapping. But study reveals that almost every one follows the same plan of an extension into the margin, and then a development upwards of plants or trees which seem often to have extended to the full height of the page. In at least one case there is an architectural extension into the margin, but the demarcation line is always preserved; in this case by showing an open balcony in which plants are growing. In fact in each case the white paper of the background stands for the open air, but by an odd convention this is left blank as in a Chinese picture, whereas in the marginated area the sky is coloured blue or gold, just as it is in the Demotte *Shah-nama*.

On one page of the *Kalila wa Dimna* (now mounted on folio 18 r. of the album) thick white clouds are drawn on the upper margin of the page and blue seems to have been added later by someone who was perhaps worried by the unusual effect. On other

Illustration page 35 pages, such as the *Monkey throwing Figs to the Tortoise*, here reproduced, the landscape also extends into the margin in each of the two miniatures here mounted together, and is evidently conceived as projecting into free space. In the court scenes, of which there are several, the margin represents the "outside." There is only one later example of this concept of the page, and this is a volume of poems prepared for the last Jala'ir ruler, Sultan Ahmad, in about 1405. The effect there is quite different, and the colouring is limited to pale blue and gold instead of the rich and strong colouring of the *Kalila wa Dimna* pages; which in this resemble the Demotte pages. In fact, it seems quite inconceivable that the former could be the earlier of the two, as has been suggested; or indeed that they are not considerably later. However, there are enough points in common to convince one that they belong to the same family descent. For instance, in one of the throne scenes, there is an unexplained valance across the top, just as in several of the Demotte pages of similar subjects. Architecture is still depicted as a straight wall forming the background, and carpet or tiling is shown extended below it as though it were continuing in the same plane. The animals are however, very suitably, far superior in liveliness and naturalism in the Fable book. In fact they were never surpassed in the Persian school in these respects. Although so well observed, they nevertheless lack the sympathy found in the fifteenth century miniatures, and consequently do not touch that lyrical height which is then the special quality of the school. But the compositions are more complex, and have greater depth. For instance the old king of the monkeys who

has retired to live a life of contemplation, seated in the fig tree, whose fruit he has been Illustration page 35 idly throwing into the water because he enjoyed the sound of its falling, is not only realistically represented, but the tree grows in free space, and twists in a most naturalistic way on the bank. There are several varieties of tree in these pages, so that it is not possible to dismiss them as copies of half-understood Chinese conventions. The stylization is in fact no greater than is often found in Chinese paintings. But the water is regularly represented as a pattern of scallops, inside each of which is a swirl of spray, thus uniting two conventional patterns found on Chinese fourteenth century blue and white porcelain. Something approximating to this had already been found in use in the Rashidiyya *Jami' al-Tawarikh*. But here its greater regularity does strongly suggest a direct borrowing from Chinese porcelain, and, if so, of a date not before 1350. Indeed this would give a useful confirmation of the date to be suggested for them on historical grounds: between 1360 and 1374.

No piece of blue and white porcelain is however represented in this manuscript; they are all of gold, silver or a bluish-green all-over glazed ware that might be intended as celadon, or less plausibly for the pale-bluish glaze of the Chinese porcelain known as *ch'ing-pai* or *ying-ch'ing*; but the shapes are more like those of celadon. The tiles and carpets are naturally of Persian types, and seem to belong to a period nearer to the end than the beginning of the fourteenth century. Of great interest is the transitional character of these pages as instanced by the representation of interiors in the two bedroom Illustrations pages 38-39 scenes reproduced. Although both have the same flat back wall, in one the open door marks a significant step towards the opening of a second plane, which was to become the normal device in the Timurid style of the next century. Indeed this page is much more advanced than the other, in its handling of spatial relations. As we have seen the best Il-Khanid painters had used the inward turned figure in the foreground as a *repoussoir*, but now in the third quarter of the century mastery of perspective and of foreshortening has gone far enough for the best artists to do without this kind of aid. What is still unresolved is the inconsistency of free space of the natural world in the background, now relegated to the margin, and the controlled perspective of the interiors. The Chinese heritage gives these pages a unique cosmic feeling among the Persian illustrations of these fables, which are after all directed to pointing the morals of the folly, deceitfulness and inconstancy of man in the allegories of the animal world, and are of great antiquity and universal application. The wild rocky settings of many of the pictures, the more emphasized by the patches of exotic vegetation, are ideal for the purpose; while the stories of men are mainly court scenes, or in the houses of the rich whose wealth attracts the robber and the murderer. This page is also the only one which has remained intact and still shows both the relation of text to illustration and also the relation of the marginated page to the border. The size of the page within the margins, which on the unillustrated pages would have been filled with script, is 11¾ inches by 6¼ inches. The width of the margin at the top is 2¾ inches and at the side 3 inches. It appears that the miniature never extended into the lower margin which thus always formed the base line of the composition.

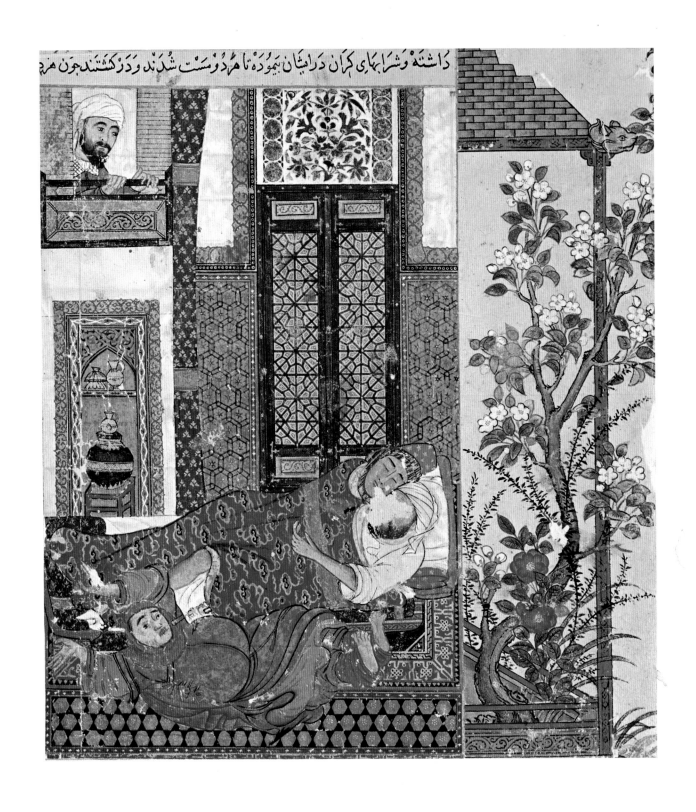

Kalila wa Dimna (Album from the Imperial Palace of Yildiz): An Attempted Murder Frustrated. Tabriz, 1360-1374.
(9×8″) F. 1422, folio 11 verso, University Library, Istanbul.

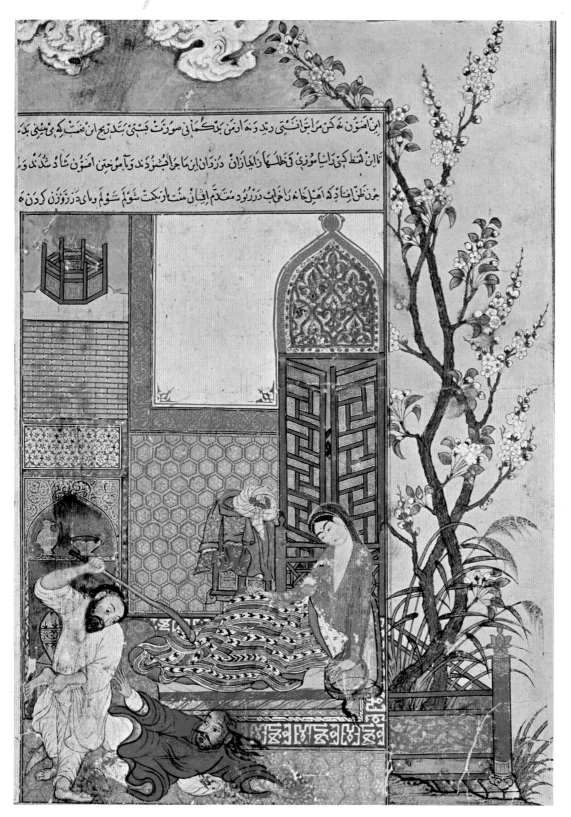

Kalila wa Dimna (Album from the Imperial Palace of Yildiz): The Thief discovered in the Bedchamber.
Tabriz, 1360-1374. (12⅞×8¾″) F. 1422, folio 24 recto, University Library, Istanbul.

In the same album in the Sarayi Library which contains the account of Persian miniature painting by Dust Muhammad, are to be found another series of large-scale miniatures cut from a manuscript which must have measured at least 13¾ by 10 inches, very near to the dimensions of the *Kalila wa Dimna* pages. These miniatures illustrate the *Mi'raj* or night ride of the Prophet.

Illustrations pages 41-43
These also must be later in date than the Demotte pages; but they are in their different ways of nearly as fine quality. Could they mark the return of patronage to Tabriz in the person of Sultan Uways? That would put them in the 1360s or 1370s, which are otherwise at present a blank in the history. How far the school had developed by about this time is indicated by some other pages which are all that remain of another monumental *Shah-nama* preserved in yet another album in Istanbul (2153). In them the landscape plays a much greater role than any miniatures which we have so far considered. The action in fact takes place in the landscape, and not against a landscape background. The elements are still recognizably Chinese, but they are used to build up that romantic listening world which was to be so characteristic of the Timurid age. There is some stiffness and awkwardness in the placing of the figures, but not more so than is found for instance in a well-known manuscript of the *Mi'raj-nama* in the Bibliothèque Nationale of the period of Shah Rukh in Herat, where it was copied, in the year 1436. Many of the Persian miniatures mounted in this album 2153 and its three fellows in the Sarayi Library, 2154, 2150, and 2160, have been convincingly attributed to this early fifteenth century school by Dr Ettinghausen; but he does not include in his summary account of the contents of these albums any mention of this group of *Shah-nama* pictures. And of some of the others he does remark that they appear to be the work of a school in which there is a not fully consolidated union of Far Eastern and Persian elements. While he seems undoubtedly correct in his attribution of many of these paintings to the school of Herat under the Timurids of the early fifteenth century, some seem to the present writer to belong to an earlier period before this style had developed so far. It will not be sufficient to point to the large scale of the page nor to the Mongol features found in some details, since it will be shown that both these are features of the atelier of Shah Rukh, who deliberately revived the style of historical illustration which had been characteristic of the Rashidiyya school. In these pages however it is not a question of revival or survival, but of a further development of the style that has been seen in the Istanbul *Kalila wa Dimna* pages. The same strong colouring is there, deep blue skies with tufts of white cloud, similar water conventions, but above all the dramatic tension which was never recaptured in later times. In the beginning of the fifteenth century there were fresh contacts with China through the frequent interchange of embassies between the Ming court and the Timurids in Samarqand and Herat, and these are clearly reflected in the rich clothing with floating scarves depicted in a number of paintings now mounted in these Istanbul albums. But the pages illustrated here in three examples, are unlike these. To a unique extent in Persian miniatures they are dominated by the landscape. Unlike that in the earlier fourteenth century manuscripts previously discussed, these are no mere backgrounds, but have swallowed and engulfed the figures.

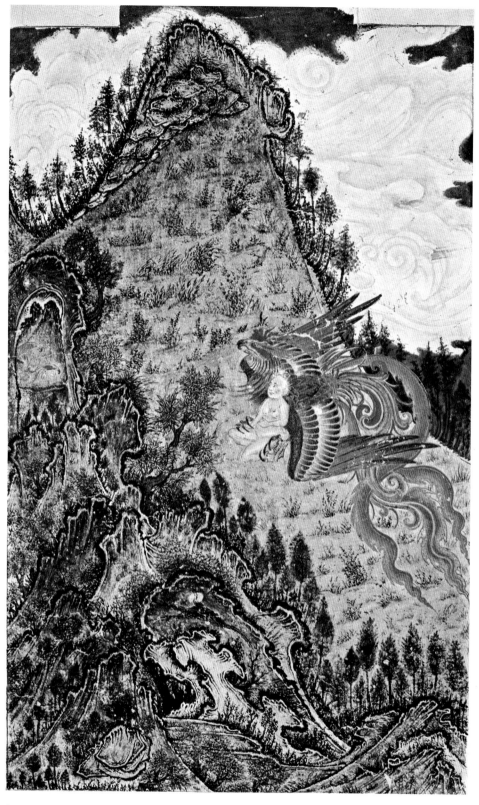

Shah-nama fragment mounted in an Album: The Simurgh carrying Zal to his Nest in the Elburz Mountains.
Tabriz, c. 1370. (12½×7⅝″) Hazine 2153, folio 23a, Topkapu Sarayi Library, Istanbul.

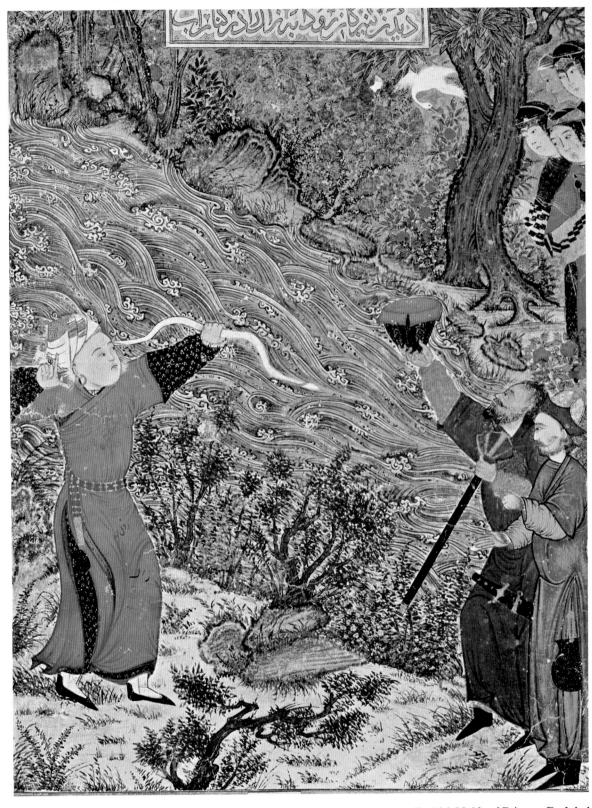

Shah-nama fragment mounted in an Album: Zal shooting a Waterbird before the Turkish Maids of Princess Rudabeh.
Tabriz, c. 1370. (10×7¾″) Hazine 2153, folio 65b, Topkapu Sarayi Library, Istanbul.

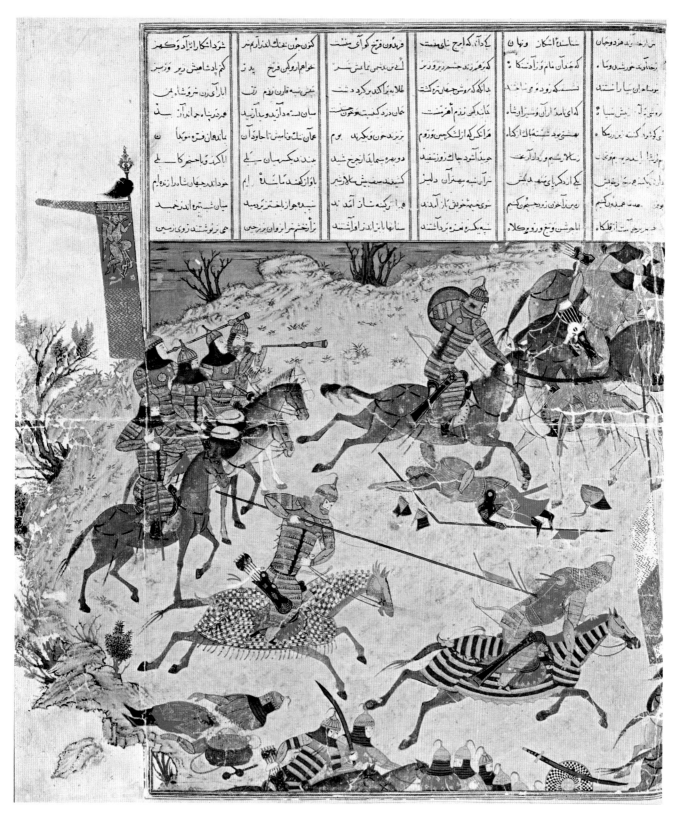

Shah-nama fragment mounted in an Album: King Minuchihr of Iran defeats Tur. Tabriz, c. 1370.
(15¼ × 13⅜″) Hazine 2153, folio 102a, Topkapu Sarayi Library, Istanbul.

Illustration page 41

Illustration page 42

Illustration page 43

In the *Shah-nama* pages composition in free space has been achieved, and landscape and figures are coherently related. Of the three examples reproduced, *The Zal carried by the Simurgh to its Nest in the Elburz Mountains* still preserves the old tree-fringed crags, much as in the Demotte book; but the billowing white clouds in the deep blue sky make a vaulted heaven; while the incident of the shooting down of the water bird by Zal to give an excuse for sending a message across the river to the servants of Princess Rudabeh, is set in as realistic a landscape as is found in Persian painting. Yet this new science serves the purpose of an imaginative illustration of two dramatic scenes in the epic; the moment of action which was to have great consequences in the national story. Both are built up on a diagonal from left to right, and in both the bird is the centre. The enthusiasm of the attendant has led him to take off his hat in salute to his master's prowess and his outstretched arm and Zal's both point to the bird. The old water convention, of Chinese origin, is employed with such variation in line as to produce the effect of a boiling torrent.

The battle scene is at first less striking, but analysis shows a most skilful composition, making use of the Jala'ir practice of extension into the margin to launch a twofold attack towards the right edge of the picture. In this movement the vital line is that of the lance with which Minuchihr is thrusting at the fleeing Tur. This part of the composition was repeated by another hand in a miniature mounted in another of this same series of albums No. 2152, which was lent to the exhibition of Islamic art at Munich in 1910, and has thus become well-known through reproductions. It has been correctly dated by Dr Kuehnel about 1400, for it is certainly later than our miniature, and omits much significant detail, such as the sword falling from the grasp of Tur. The drawing also is much less vigorous and betrays the copy. The scale and placing of this big page in the 2153 album clearly leads on from the Jala'ir school to the Timurid, which was thus prefigured thirty years before the first Timurid manuscript. There are at least seven more of these great miniatures preserved in this same album, of which one only has ever been reproduced. Several are throne scenes nearer in style to the *Kalila wa Dimna* scenes, and there cannot be much time between the dates of their production.

There is no doubt that the house of Jala'ir were the successors to the Il-Khans in patronage of the arts of the book in fourteenth century Persia. This is established, not only on the testimony of Dust Muhammad, writing in 1544, but more convincingly on surviving material. The dated manuscripts do not begin before the reign of Sultan Ahmad (1382-1410), but it is known from the late fifteenth century Persian critic and historian of letters Dawlatshah that Sultan Uways was a highly skilled figure draughtsman and he even credits him with having instructed in the art Abd al-Hayy, the greatest master painter of the age. However according to Dust Muhammad there was at Sultan Uways' court the master Shams al-Din who had been a pupil of Ahmad Musa, already mentioned as the leading miniature painter under Abu Sa'id. It is here suggested that the fragmentary miniatures of the *Kalila wa Dimna* and the *Shah-nama* now preserved in the two albums in Istanbul described above may be the work of the school of Shams al-Din for Sultan Uways and have been produced between 1360 and 1374 when the Sultan died.

The earliest manuscript with illustrations surviving from the library of Sultan Ahmad is the *Book of the Marvels of the World* (now Supplément Persan 332 at the Bibliothèque Nationale, Paris) written at Baghdad in 1388. The numerous miniatures in this book are in a far simpler style than those which we have been considering, and perhaps disappointing as the products of this royal atelier, but allowance must be made for the precarious hold which Sultan Ahmad had of power in the troubled times during Timur's successive invasions and the incursions of the Turkmans. The manuscript is written in

Book of the Marvels of the World (Aja'ib al-Makhluqat): Gathering of Fruit from the Lubya Tree. Baghdad, 1388. (9⅛×8⅝″) Sup. Pers. 332, folio 158 verso, Bibliothèque Nationale, Paris.

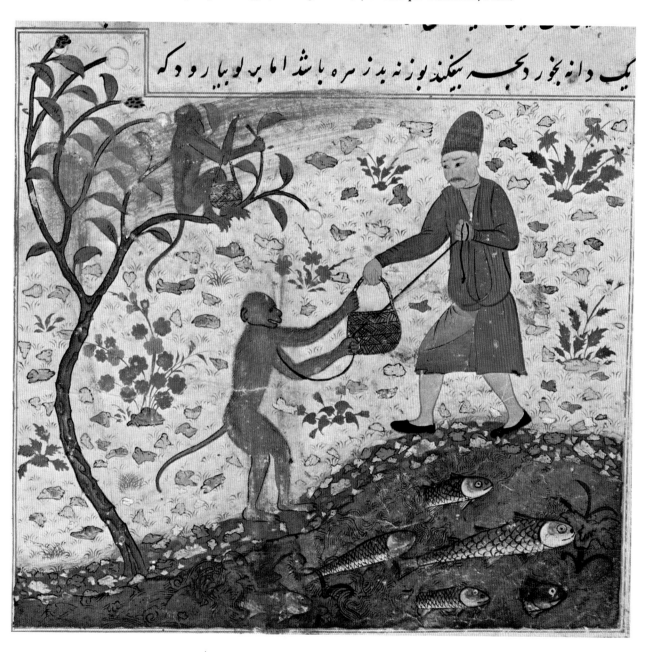

Diwan of Khwaju Kirmani: Prince Humay at the Gate of Humayun's Castle. Baghdad, 1396, painted by Junayd.
(12¾×9½") Add. 18 113, folio 26 verso, British Museum, London.

Diwan of Khwaju Kirmani: Combat of Humay and Humayun. Baghdad, 1396, painted by Junayd. (12¾×9½″)
Add. 18 113, folio 31 recto, British Museum, London.

Illustration page 45

Illustrations pages 82-83

Illustrations pages 46-47

the new *nastal'iq* hand, and the lay-out of the miniatures also is new. They are essentially coloured drawings and the background is left uncoloured. There is a far stronger tendency to pattern than in the earlier fourteenth century miniatures, especially in the treatment of trees and plants. Figures of men and animals are lively in scenes like the *Gathering of Fruit from the Lubya Tree*, while the astronomical subjects are in an old-fashioned style, decorative and flat. The silver water was to become the normal convention in the Timurid period, and the pattern of large plants which cover the ground in many of the miniatures was also to be a normal form of background. It has been suggested that these miniatures are at least mainly later than the date of the manuscript, but in a book of this kind there would be little point in text without pictures, and the colour scheme is in line with the bright colouring of the previous decades at Tabriz, which was the principal Jala'ir capital. These people were one of the Mongol tribes and must have gathered up what remained of the Il-Khanid artists of the book. As has been suggested, the main interest of this manuscript is that it looks forward to the early Timurid work like the *Kalila wa Dimna* manuscript of the Royal Library at Tehran. For it shows in some of its miniatures the same delight in the world of nature, if more naively, and with less lyrical feeling. The simple compositions are illusionist in that they have solved the problem of the relation of figures to landscape within the margins of a smallish page. The horizon is carried right up to the top margination, thereby keeping the idea of the back curtain without losing the sense of space.

Still they do not prepare us for the superb quality of the illustrations of the *Diwan* of Khwaju Kirmani which is dated only eight years later and is one of the great monuments of Persian painting. This manuscript, now preserved in the British Museum under the number Add. 18113, was completed in Baghdad in the year 1396, by the famous scribe Mir Ali Tabrizi, who is credited with the invention of the new script *nastal'iq* employed in it. Of the nine miniatures, all but one completely enclose the small area left for the text, which is in one case reduced to a single couplet. All appear to be contemporary with the date in the colophon and all with this exception seem to be by one hand, or at least under one direction. This can only be the master *(Ustad)* Junayd, whose signature is to be found in the design of the sixth miniature on folio 45 v., representing the marriage of Humay and Humayun, introduced into the window framework above the throne of the princess. This artist's name, which is the first to be found on the field of a miniature, is known to us from the account of the painters of previous ages prefixed to the album of Bahram Mirza in 1544, to which we have already referred, where he is said to have been a pupil of Shams al-Din and to have worked at Baghdad; in the inscription on the miniature his name is followed by the suffix *al-Sultani* which would be correct for the court painter of Sultan Ahmad. It is to be noted too that this manuscript was once in the collection of this same prince Bahram; and may well therefore have been known to Dust Muhammad.

The three court scenes are the richest in the book: each of them filling the page with a single architectural construction, crowned by a Kufic inscription in white on a decorative floral ground. In two of them the numerous figures are divided into groups

عاشقان نوروز وصف خط و خالش کرده اند بیدلان از صبح تا شام تماشایش کرده اند

کثره ورق از نقش و عشق جنت خوانند و فنردو دیوان عالم را مشتر کرده اند

چون ز روی مهرت زجانم تابوت کرک اند مهر مهرت را برروی دل مصور کرده اند

ثانیا که کعبه معنی دل نهاده اند را چون حلقه بر در کرده اند

وله خلد الله تعالی خلافه و سلطانه

زدوست عین درما زی می توان یاف زجورت ما به نی جان می توان یاف

غم عشق کزآن سرمایه مات عجب دائم که آسان می توان یاف

درین دل لب یاقوت رنگت نشان آب حیوان می توان یاف

اگر بر بام قصر آهی شتاب دار شعاع مهر رخشان می توان یاف

سکوب بت کازبت عاشقانت تمات عیش رضوان می توان یاف

محبوبیش اشکارا برنیا بد پنهانی که پنهان می توان یاف

هر آنکو دین ندارد همچو زر لف کفرش ایمان می توان یاف

وله خلد الله تعالی خلافه و سلطانه

Diwan of Sultan Ahmad: Pastoral Border. Baghdad, c. 1405, painted by Junayd. (11⅝ × 7¹⁵⁄₁₆″)
No. 32.35, Courtesy of the Smithsonian Institution, Freer Gallery of Art, Washington, D.C.

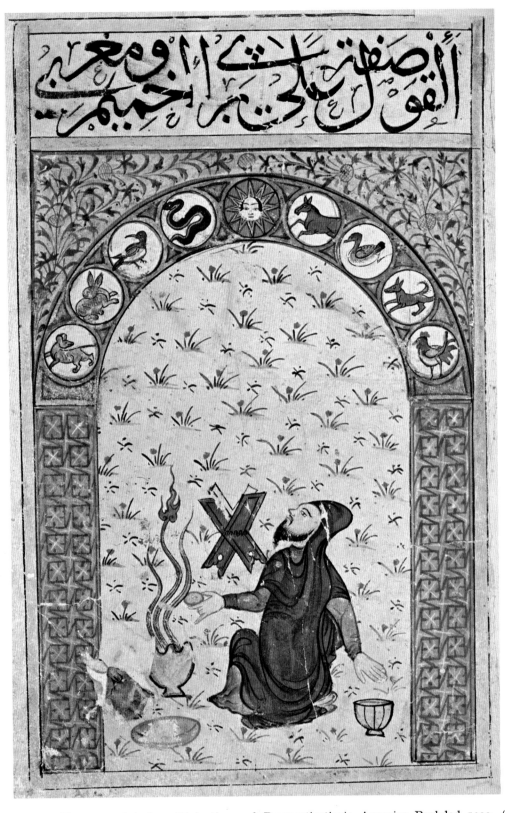

Kitab al-Bulhan (Tracts on Astrology, Divination and Prognostication): Aquarius. Baghdad, 1399. (9½×6¼")
Or. 133, folio 29 recto, Bodleian Library, Oxford.

by strong vertical lines which produce two narrow panels, of unequal width, in one of which recession is given by an arch and in the other by a receding wall. In the third where there are fewer figures to control, the whole is enclosed by a single arch under which a gold semi-dome provides the recess for the royal throne. In all three also there are magnificent carpets and rich tilework and the effect is sumptuous. In the two more elaborate scenes an open window, through which girls' heads look out, continues a device noted in the Istanbul *Kalila wa Dimna* pages. This is required by the subject of one, in which Humay on a visit to the court of China thus catches his first sight of Humayun looking down from a window. It is a device often used by painters of later periods to aid the construction of their composition. In these two miniatures too, there are figures of servants holding open doors and so increasing the sense of the enclosure of the scene, which does not seem to suffer from the lack of perspective in the flat elevation. This is not quite so successfully managed in the third interior; but the boldness and simplicity of the device of placing the angle of vision high above the picture-space carries conviction of the intended transitions from floor to platform and then to wall; and the figures are tall and elegant, very different from the red-faced men of the first half of the century. But perhaps the most fundamental change is that the movement is entirely internal to the composition with a strong circular tendency. The open-air scenes here reproduced make this even clearer by their circular horizons, twice sweeping into the margins in the fashion already found in the Istanbul *Kalila wa Dimna* pages. Now however the overlapping trees and rocks are in the farther distance, instead of the foreground, and the sense of free air is made more sensible by the presence of many birds in flight beyond the edge of the painting, which is thus released from the two-dimensional page. In one, prince Humay rides up to the gate of the castle of Humayun, where he sees Illustration page 46 her on the terrace of a tower enclosed in a walled garden full of flowering trees. Here the left edge of the miniature forms the flanking wall of the tall tower, on which the composition forms a half circle. The second situation is, if possible, even more romantic: as they seek one another Humay encounters her in male disguise and wearing armour Illustration page 47 and visor; they fight without recognizing one another until she takes off her helmet. This is the moment of the painter's choice, and again the action is surrounded by trees and birds in flight. In both there is a stream winding across the foreground, bordered by flowering plants, but on the near side the circle of rocks comes right round to lap along the lower margin edge. These trees are the native Persian cypress and juniper, the chenar and the tamarisk, quite unlike the exotic Chinese trees of the Demotte *Shah-nama* and the *Kalila wa Dimna*.

The hillside of the duel is bare and rocky, but two other miniatures are set in gardens: the feast at which the lovers plight their troth in the jasmine garden, where, under a golden sky, the courtiers pick roses and play on the pipe and the tambourine; and the earlier and more intimate scene when Humay faints with emotion when he finds himself face to face with his beloved in the moonlight in a garden of flowering trees. The artist has attuned his art to the melody of Persian lyric poetry and found the perfect proportion of text and figure subject. At the same time the spaciousness of the Il-Khanid compo-

sition has not been wholly lost. But, if criticism is to be made, it would be that the range is rather small, and the figures a little stiff and doll-like. In colour the contrasts are harsh compared with the mastery in the fifteenth century of subtler combinations than the bitter greens and harsh reds of these experimental pictures. But the way was open for all the developments of the next century.

The basis of Junayd's work was an accomplished draughtsmanship, most clearly seen in the duel scene; and this is even more apparent in another royal manuscript of Sultan Ahmad, his own poetical works, finely written on pages with wide margins. The Illustration page 49 only pictorial decoration of this manuscript, which is now in the Freer Gallery, Washington, is to be found on the eight last pages, of which the margins are filled with pastoral drawings of the most exquisite quality, enhanced with gold and light blue, which stand almost alone in the whole œuvre of the Persian school. Careful analysis of the elements of the drawings does however show that the landscape is built up in the same way as that in the Khwaju, and this kind of tinted drawing is to be seen in the margins of some of the pages of the accomplished little *vade mecum* prepared for the Timurid prince Iskandar in 1410, which will be described below when we come to speak of the early Timurid school. There are also two somewhat similar whole pages of gold-enhanced drawings at the end of the *Shah-nama* of Sultan Ibrahim prepared for this other Timurid Illustrations pages 98-100 prince in about 1435, also reproduced below. There can be no question, as we shall see, that these drawings are contemporary with the two royal volumes, and they thus support the dating of the *Diwan* of Sultan Ahmad and its decoration to the early fifteenth century, which some critics have denied. It is true that these margin drawings are in some ways unique: for instance in their conception as forming a plane behind that of the text page, and continuing behind the central area. This is the reverse of the older convention by which the text was enclosed by the miniature as described above. Miniatures they are not, but only decoration, although elaborate. Stylistically they combine features taken over from Chinese models, especially noticeable in the animals and birds; the new Persian tree and rock conventions; and some European touches, practically confined to the faces of some of the figures. Comparable influence in another manuscript of the same school will be considered very shortly. The convolute and forked clouds can be paralleled in the 1435 end-papers already referred to, in which also are to be seen some ducks in flight and swimming, as on some of the other pages of Sultan Ahmad's *Diwan*. It is therefore possible to regard these pages both as the last evidence of the naturalism of the Mongol period, and as prefiguring, in their scale and fine drawing, the best work of the Timurid school.

Compared with these the miniatures in a composite volume in the Bodleian Library are rough and vernacular, but thereby probably more typical of the state of painting at the end of the fourteenth century in the Jala'ir kingdom. The volume (Or. 133) contains miscellaneous tracts on astrology, divination, and prognostication; and includes fifty-four full-page miniatures symbolical of the seasons, the climes, the signs of the zodiac and various demons and supernatural beings. It was composed by a native of Baghdad, but of Isfahani origin, in the year 1399, according to Professor D. S. Rice

who has made a close study of it. In the page showing Aquarius, reproduced, the spandrels Illustration page 50 of the arch are filled with a naturalistic design of lilies, which contrasts with the repeated conventional plant inside the arch and recalls the similar arch in the Khwaju manuscript. In the small pictures of the four seasons the lesser trees are more impressionistically rendered. The framing of the subjects in roundels or panels suggests that they may be derived from metalwork, and if so they represent an old Persian tradition. This is a more elegant one than that to be discussed in the next chapter under the heading of the "school of Shiraz."

Tabriz under the Jala'ir was still an entrepot for international trade, though restricted by the unsettled times. Professor Rice has referred to the trading privileges granted by Sultan Uways to the Venetians and the Genoese, to account for the persistence of European or at least Mediterranean influences in these pages. As Dr H. Stern has pointed out, the iconography of the months seems to derive rather from a Byzantine than a Latin prototype, and the most immediate Christian influence at Tabriz until the extinction of the Eastern Empire was from Byzantium. It continued after the capture of the city by the Turkmans, as we shall see. The old Persian influence in these astrological pages is shown in the symbol of the sun which forms the centre of the arch. In the centre of the rayed twelve-pointed disc is a full face, with strongly marked eyebrows, and black hair parted in the middle. This same face, but without the rayed halo, is found in a similar position in the centre of the arch above the throne of Anushirwan, the King of Kings, in a miniature in the Khwaju manuscript of 1396 in the British Museum, thus connecting these otherwise dissimilar manuscripts, just as we have already noted the floral designs in the spandrels of this same arch as similar to those in the signed *Wedding Scene* in the Khwaju. This particular feature is still found in the decoration of the Gulbenkian Foundation (Lisbon) *Anthology* of Iskandar, a Shiraz manuscript of 1410 (frontispiece to the second part). Considering the scientific character of this book the miniatures show a remarkable degree of naturalism in the handling of both figures and landscape.

Tabriz had a troubled history in the time of Sultan Ahmad. It was captured by Timur in 1386 and remained in Timurid hands until 1406, when it was seized by the Black Sheep Turkman Qara Yusuf, at least nominally a feudatory of the Jala'ir house. Sultan Ahmad's capital during these years was at Baghdad, but he then for a time returned to Tabriz, and it was in attempting to assert his claim to rule in this city that he met his death at the hands of Qara Yusuf in 1410. He seems always to have received a welcome from the citizens when he was able to reside at Tabriz, where he patronized the arts. Consequently it is to his atelier that we should attribute a beautiful manuscript of the *Khusrau and Shirin* of Nizami, now in the Freer Gallery in Washington, which Illustration page 54 was copied according to the colophon "in the capital of the kingdom Tabriz by Ali Hasan al-Sultani." The date is no longer preserved and it has been attributed to about 1420 by M. Stchoukine. The rule of the Black Sheep Turkman continued in Azarbaijan until 1437, but there is no evidence either in literature or from surviving manuscripts that they were patrons of the book. Their capital was generally at Shirwan, but the

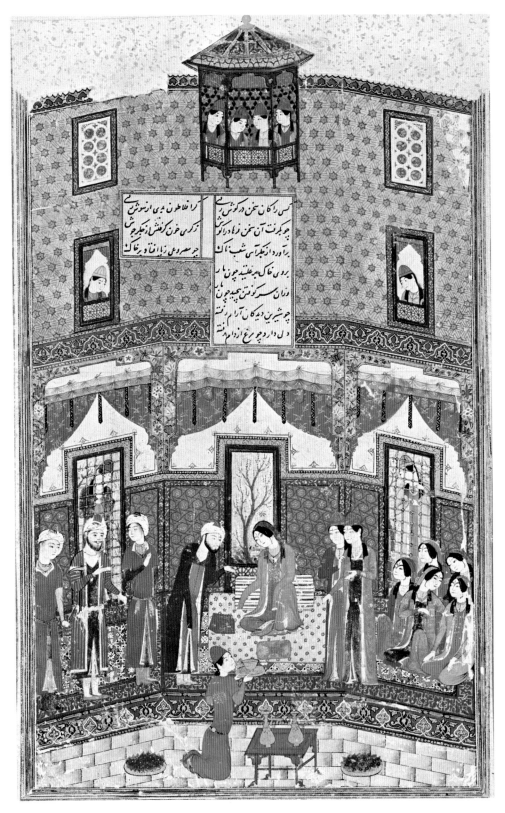

Khusrau and Shirin of Nizami: Farhad brought before Shirin. Tabriz, 1405-1410. (10¾×6½″)
No. 31.34, third miniature, Courtesy of the Smithsonian Institution, Freer Gallery of Art, Washington, D.C.

library staff of the Jala'ir seems to have remained at Tabriz, because when the Timurid prince Baysunghur was sent by his father Shah Rukh to govern this city he found there the greatest calligrapher of the age, Ja'far al-Tabrizi.

The five miniatures in the *Khusrau and Shirin* are in any case nearer in style and colouring to the Khwaju manuscript of 1396 than to any fifteenth century miniatures In the *Farhad at work carving the Channel through Rock*, a delicately drawn tree in the margin recalls the trees which surround the *Duel Scene* of the 1396 Khwaju; and the Illustration page 47 looped-up curtains in the *Farhad brought before Shirin* are exactly those of the interiors Illustration page 54 in this book. Moreover the text is still enclosed within the field of the miniature in this page just as it was in 1396, but is not in the whole-page Timurid miniatures. The spatial conception is however already changing from the still plastic design of the fourteenth century with recession clearly implied, to a purely conventional scheme which does not bear analysis, but consists of little more than a screen bent like the two wings of a stage background. This was to be the convention in the fifteenth century. Here we still see however the exquisite draughtsmanship and the sensibility in gesture of the otherwise rather stiff figures, of the Jala'ir school. Before considering the succession of this school we must now turn back to the other main stream of Persian painting in the fourteenth century, which was not only vigorous and effective but was to contribute something permanent to the later development of the whole school.

Shiraz and the Iranian Tradition in the Fourteenth Century

3

THE story of the fourteenth century which we have followed so far is that of the impact of the Chinese style and its gradual absorption into the main stream of Persian painting, which was possible because the Il-Khans built on the older culture of the country. But away from the court and its immediate environment in Azarbaijan, things worked out rather differently. Chinese influence was clearly less strong, and probably only second-hand, through the industrial arts, especially the costume of the invaders. The older traditions of Persian painting could persist more vigorously under these conditions; a main centre seems to have been Shiraz, capital of the southern province of Fars which had been the heart of the Achaemenid empire.

Shiraz itself was a creation of the Saffarid (867-900) and Buwayhid (933-1056) dynasties, and under the Mongols was a prosperous city with a great cultural tradition, having been the home of the poet Sa'di, who died there in 1294, and then of Hafiz, who survived to see the conquest of Timur and died in 1389. But in politics it suffered many violent changes during the century. The house of Inju, descended from the last governor under the Il-Khans, who became independent after the death of Abu Sa'id in 1335, ruled Fars from that date until 1353, when they were ousted by the house of Muzaffar, who had been the rulers of Yazd meanwhile. They had a greater dominion over all south-west Persia until they were finally extirpated by Timur in 1393. Both Abu Ishaq the Inju and Shah Shuja' the Muzaffarid were patrons of Hafiz and might have been expected to have employed skilled artists of the book. In fact the volumes which can with certainty be assigned to Shiraz at this period all fall within the Inju domination. It is not until the eve of the fall of the city to Timur that there is a book which can be given without doubt to the Muzaffarids; but we shall try to bridge this gap. For there appears to have been a continuous tradition of book illustration at Shiraz, which is important just because of that continuity.

Four dated manuscripts of the *Shah-nama* (two of them are now dispersed) form a fairly close group, ranging in date between 1330 and 1352, and located at Shiraz by the dedication of one of them to the wazir Qawam al-Din Hasan, the patron of Hafiz, Illustration page 58 who died in April 1353, twelve years after its completion. Others are scattered in American and European collections. The majority of the miniatures have all-over coloured

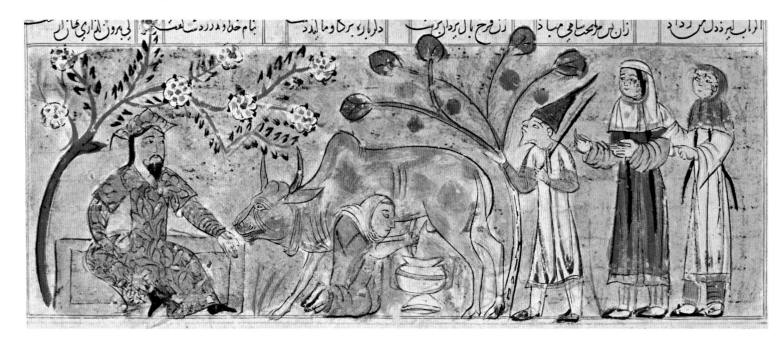

Shah-nama of the Wazir Qawam al-Din Hasan: Bahram Gur in the Peasant's House.
Shiraz, 1341. (4×9⅜″) w. 677a, The Walters Art Gallery, Baltimore.

backgrounds, in red, yellow-ochre or gold; but a few are plain without colour. It has been authoritatively suggested that these backgrounds derive from a tradition of wall-paintings, going back to Sassanian times. The existence of the tradition is now seen to be well-founded, but it must be admitted that there is a long gap in the tradition which is not at present covered in any way. However it can be seen that these miniatures reflect a style which was current in Iran before the Mongol invasions, exemplified in the lustre-painted pottery, tiles, and vessels, dated examples of which go back to the second half of the twelfth century. They have in common especially the heavy outline to the features and the filling of the background with trees or foliage, even in cases where it does not well suit the subject represented. The conventional types of trees also tend to be similar, with feathery foliage and large blossoms on thin and sinuous trunks. But there are equally new features in these miniatures and those in the other manuscripts of this Shiraz school; some, like the lotus dress-patterns and large peony flowers, importations of the Mongols from China; others like the strange coloured conical mountains in conventional colours, red, blue, purple and yellow, can be paralleled in much earlier paintings on walls in the Buddhist shrines of Central Asia, but may be of quite independent origin. For there are, on Sassanian silver vessels and dishes, indications of conventional landscape which show clusters of cones as symbols of mountain, and it seems quite possible that this convention, like the coloured background, may have survived as a living tradition in Iran down to the fourteenth century. The outstanding element in these miniatures is the animal drawing, firm, lively and sympathetic; such as might be expected of an old Iranian tradition.

The large peony flowers used as space-fillers in a *Kalila wa Dimna* of 1333 remind one of the common background to Sultanabad pottery. Another manuscript in which these flowers are found is the unique text of the Persian novel by Sadaqa b. Abu'l Qasim of Shiraz entitled *Kitab i Samak 'Ayyar*, now in the Bodleian library (Ouseley 379-381). The numerous miniatures in these three volumes are nearly all on a yellow or red ground, but are the roughest of all the work of the Shiraz school at this time. Movement is stiff and architecture and landscape extremely summary, but the conventions employed are the same as those in the *Shah-nama* manuscripts especially the two dated 1330 and 1333 in the libraries of Topkapu at Istanbul and the State Library at Leningrad. The colour range also is similar, with the stress on purple, blue (or the two combined in a peculiar violet), and yellow. Every scene in this whole Shiraz group is dominated by figures and always the other elements in the composition are subordinated and used mainly as decoration, to fill completely the rest of the picture-space. This is rectangular and generally occupies from a third to a half of the page within the margination, which it very seldom passes by a lance point or a banner. A special feature of the manuscripts of 1330 and 1341 is the stepped miniatures, rising in the centre like a pyramid, a device which emphasizes the symmetry of the compositions and so the traditional Iranian qualities of frontality and hierarchy. Possibly the steps derive from architectural murals. The "rouged" cheeks of the men and their strongly marked beards and eyebrows are also old Iranian characteristics reflected in the post-Sassanian painting of Central Asia.

Shah-nama: Gayumart, First King, in the Mountains. Isfahan, 1325-1335. (3¾×4¹¹/₁₆″)
No. 29.24, Courtesy of the Smithsonian Institution, Freer Gallery of Art, Washington, D.C.

Mu'nis al-Ahrar (Scientific Anthology) of Muhammad b. Badr Jajarni: Weapons, Animals, Precious Stones and Musical Instruments. Shiraz, 1341. (7½×5″) No. 45.385, J.H. Wade Collection, The Cleveland Museum of Art. (Slightly enlarged)

Mu'nis al-Ahrar (Scientific Anthology) of Muhammad b. Badr Jajarni: The Planets. Shiraz, 1341. (7½×5″)
No. 57-51-25, Courtesy of The Metropolitan Museum of Art, New York. Bequest of Cora Timken Burnett, 1957.
(Slightly enlarged)

A different type of illustrated manuscript which must be attributed to Shiraz is represented by a scientific anthology or dictionary entitled *Mu'nis al-Ahrar*, preserved in the autograph of the author, Muhammad b. Badr Jajarni, dated 1341. This manuscript, formerly in the Kevorkian Collection, is now divided and pages from it are in the Museums at Princeton, Cleveland, the Metropolitan and the Freer Gallery. The illustra-

Illustrations pages 60-61

tions are in three or four panels, the full width of the page, generally on a red ground but occasionally plain, with floral decorations and consist of separate images as in the well-known Larousse dictionary. They are of much finer draughtsmanship than anything which we have so far considered from this Shiraz school, and the rapidly drawn foliage sometimes recalls that in the Morgan Library *Manafi'* manuscript. Generally however it is only used as a decorative space-filler, as on the page at Cleveland, and on a larger

Illustration page 61

scale on the fine drawing of the Planets in the Metropolitan; and the figure drawing is also nearer to the Shiraz group. By 1341 presumably many of the court artists from Tabriz may have sought employment elsewhere, and this may account for the superior execution of these pages. It is possible however that there was a closely allied school of book illustrators working at Isfahan, whose political fate followed that of Shiraz. The greater elegance of these drawings and the finer quality of line in the animal subjects serve to connect them with a group of *Shah-nama* illustrations on a much smaller scale than those which we have been considering, but which are universally attributed to the first half of the fourteenth century, but have been diversely given to the schools of Tabriz and Shiraz. Two at least of these small manuscripts have been broken up and divided among many western collections, and a slightly larger volume is preserved in

Illustration page 59

the Freer Gallery, but none is apparently dated. An attribution to Isfahan of this last has been suggested to the author by Dr Ettinghausen and is acceptable for the whole group. The other manuscripts are of a smaller format and may be slightly earlier in date. Whereas they include only a minimum of landscape, generally no more than a strip of grass and some straggling trees, the Freer book shows on several pages contoured peaks not unlike those in the Shiraz miniatures, but in a different colour range, in which slate-grey, blue and silver take the place of the cruder red and yellow of Shiraz. In fact the rich use of silver and of gold is one of the features of this book. But the smaller pages are only slightly less rich and many are painted on a gold ground. In fact stylistically they must stand together, and form a single group. They are remarkable for the fine and sensitive draughtsmanship, and the admirable movement of the animals especially of the horses. Clothes and armour are completely Mongol, but in spirit as far as can be from the Il-Khanid miniatures of the Demotte *Shah-nama*, being as gay and narrative as these are pathetic or heroic. In fact they seem to reflect the older national tradition but with a greater debt to the refined mastery of Chinese brushwork than is ever seen in the Shiraz manuscripts. The pages from the *Mu'nis al-Ahrar* manuscript of 1341 seem to form a link between the two, especially in the animal drawing. Their very economy allows of a concentration on the dramatic moment of gesture; and they are therefore well suited to accompany the text which is written in an old-fashioned hand. These simple compositions recall those on the pre-Mongol pottery of the twelfth century.

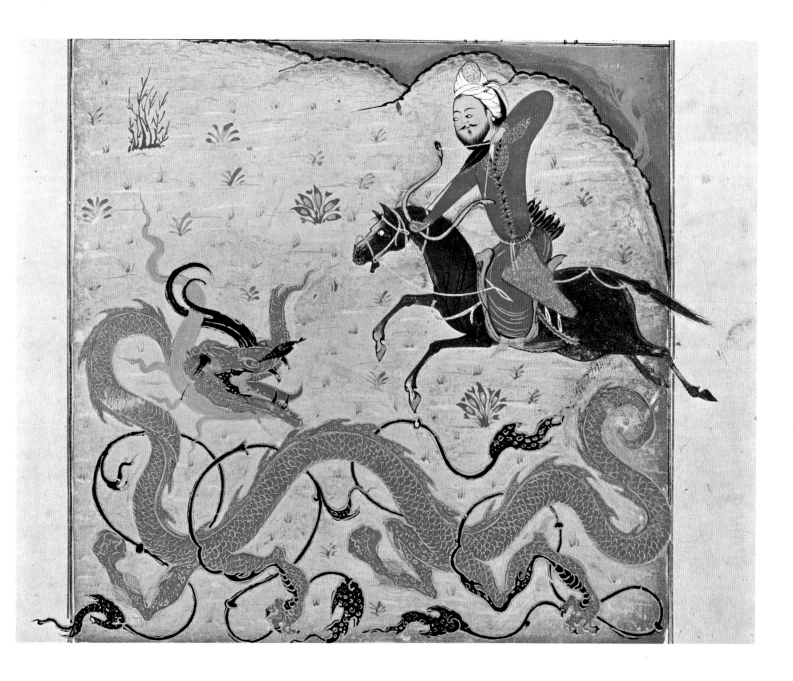

Shah-nama: Bahram Gur killing the Dragon. Shiraz, 1370. $(6^5/_{16} \times 4^7/_8'')$
Hazine 1511, folio 203 verso, Topkapu Sarayi Library, Istanbul. (Enlarged miniature)

With the *Shah-nama* of 1370 (Sarayi Library, Hazine 1511) we have completely left Illustration page 63
behind the natural landscape of the first half of the century and entered a conceptual
world in which Persian painting was to excel during the next two hundred and fifty years.
A few naturalistic trees survive, incongruously beside the formal tufts and stumps, but
the imaginative concept holds the whole in a closed picture. The elements are to be seen
as symbols rather than decoration; three men represent an army, two rounded peaks
a range of hills, and a round circle the mouth of a well. It is important to consider this

development in sequence of the whole history of the school, as a step towards the search for a satisfactory relation of miniature and text. Hitherto the conventions had been too much under the influence of the archetypes in Chinese scroll-painting or in large scale wall-painting to fit easily into the pages of a book. Consequently there had been too great a tension between the action and the landscape setting, each claiming more than its due; and often requiring to be viewed from a greater distance than is convenient with a book. This situation is clearly shown by the background treatment, which had hitherto been used to suggest infinite recession through the plane of the page unless this was directly negatived by a curtain or wall. Now such a visual approach is abandoned in favour of an illusionary world in which the spectator participates as he does in a stage production. In this book of 1370, for instance, the wild country in which Bizhan has been imprisoned is represented by a series of blue segments arranged in a scale pattern and

Illustration page 63 enhanced with gold sprays to indicate vegetation. The dragon which Bahram is attacking is no longer the loathly bleeding monster of the Demotte *Shah-nama* but a cerulean apparition formidable because unearthly, as dynamic as a coiled spring; and still sinister with its black mane. Colour is now used for its formal qualities rather than representationally. So, by different routes the miniature art at Tabriz and Shiraz had arrived at solutions of the problem of the book painting.

Painting under the Timurids (1400-1450)

4

AT the end of the fourteenth century Persia again suffered the terrible experience of repeated invasion by a ruthless ruler of boundless personal ambition from the confines of Central Asia. The fact that Timur and his clan, the Barlas, were Muslims made no difference to the savagery of their conduct. Part of the Chaghatai Turks who still retained a form of nomad life, they were bound by the traditions of the Mongol Rule rather than by the law of Islam. Gradually during their occupation of Transoxiana they absorbed Muslim culture; though Timur himself remained illiterate all his life, he spoke Persian as well as Turkish and he took the decisive step towards settled city life of fortifying Samarqand in 1370; thus, Barthold has pointed out, breaking the testament of Chingiz Khan, from whom he was proud to claim descent through the female line. He was a great builder and laid out notable gardens outside Samarqand in which he liked to live in the intervals of his campaigns. Many craftsmen were transplanted hither from the captured cities of Persia, including Shiraz and Baghdad in the same year 1393. But he was probably not himself a patron of the arts of the book. In spite of the fact that Abd al-Hayy, one of the leading masters of the Jala'irid school, was transported to Samarqand, there is no mention of any manuscript prepared there under his supervision.

Instead the literary evidence mentions several series of wall-paintings executed in the garden pavilions at Samarqand, celebrating Timur's conquests and recording the features of his children and generals. This is the kind of painting preferred by the successful man of affairs and its significance in this history may be that it introduced, for the first time since the Sassanian period, the art of portraiture into Iran. Not many portraits exist which can be attributed to the Timurid period, but enough to suggest that it may have had a certain vogue. Some of the wall-paintings were on the walls of the garden palace of his grand-daughter Beghifi Sultan, who may perhaps have preferred other subjects, such as the fragment of landscape discovered in the mausoleum of his sister Shirin Beg Aqa, built in 1385. No other trace remains of these wall-paintings, nor of any others in the palaces of Persia up to the time of Shah Abbas I. That paintings in other media were in fact carried out at the court of Timur is suggested by a story recorded by the Mughal emperor Jahangir, of his receipt from Shah Abbas of a battle picture of

Epic of Timur (Shahanshah-nama): Warrior in the Mountains. Shiraz, 1397. (10×6½″)
Or. 2780, folio 213 verso, British Museum, London.

one of Timur's campaigns in Central Asia signed by the master Khalil, who is recorded as one of the four ornaments of the court of Shah Rukh, Timur's son and successor in the government of Khurasan and Transoxiana, and therefore heir to much of his establishment. Whether or not this gift was an original old master or not, the story does suggest that there may have been paintings on cloth or silk at the beginning of the fifteenth century, and this was large enough for the names of the principal commanders of the army to be written beside their figures in the picture. One is reminded too of the celebrated painting on stuff of the princes of the house of Timur in the British Museum, made for Timur's descendant, the emperor Humayun about 1555, of which more will be said below. When the Spanish embassy of Ruy Clavijo reached Samarqand in the summer of 1405, the ambassadors were received in a succession of garden palaces or pavilions, tent-like structures lined with silk, which was woven or embroidered with patterns. Inside the roofs of some of these falcons and eagles had been "figured"; in action, with wings spread, or as about to pounce. Otherwise the decoration of all these tents, carefully described by Clavijo, seems to have consisted only of hanging silks embroidered with arabesque patterns and appliqués. There is no mention at all of painted decoration, yet the descriptions are very full and careful. The only figured decoration was in enamel-work on silver, looted by Timur from the Turks at Brusa, and Greek work no doubt. It is to the memoirs of Babur that we owe the reference to the representation of the Indian victories of Timur on the walls of one of his pavilions at Samarqand. These have vanished, but there fortunately survive several Timurid manuscripts with miniatures which were executed in the lifetime of Timur and within his dominions. The earliest are from Shiraz, which had bought off the keenest rage of the Conqueror. They are twin volumes of *Epics* in the Chester Beatty Library and the British Museum, which date Illustration page 66 from 1397 and are stylistically so closely descended from the Shiraz manuscripts which have been described, from the last decades of Muzaffarid rule, that they must be given to Shiraz. This has been disputed on the grounds that their quality is so superior, but that is mainly a matter of better materials, a change to be expected from the change of rule. Gold is indeed lavishly used and the blue is a real lapis. The paper is especially thin and smooth, and it has suffered damage so as to affect several of the miniatures, of which there are sixteen in all. The theatrical device of the coulisse and the army hidden behind rocky hills continues, and so does the vigour of action and the dramatic use of the strong diagonal line (the steps of a pulpit, the lines of arrows strung on the bow or quivering in the flesh of Faramurz); while the walls of pumice-like rock are quite unlike anything to be found in the Jala'irid school. A beautiful tree in the margin of one miniature in the Chester Beatty book does recall the Tabriz school, and it may be that one or more of the painters from that city might have found his way to the south by this time. If so he had adopted the larger scale of the figures in relation to the page, and the plain golden skies of Shiraz. The high horizon, as has already been noted, is characteristic of these pages; but the rocky barriers are sometimes awkwardly handled, as in the *Camp Scene* in the *Shahanshah-nama* in the British Museum, where horsemen seem to be sinking down into crevasses from which horses and mules are scrambling out. The caravan

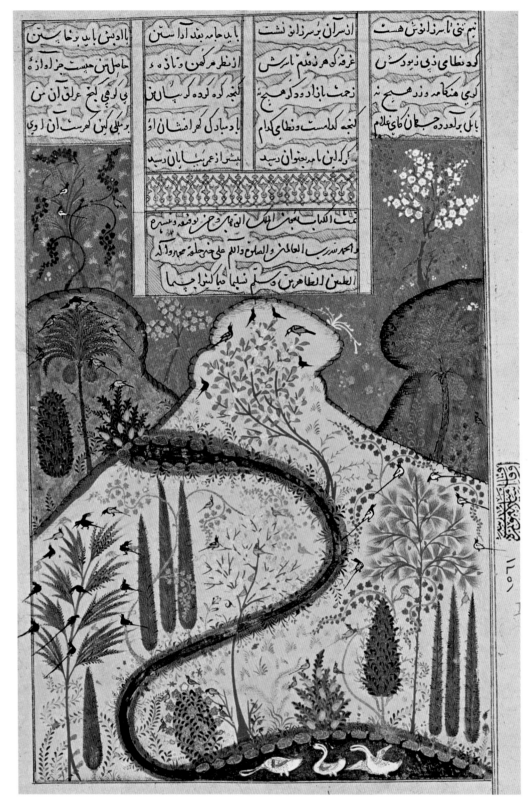

Anthology: Mountains and Streams. Bihbahan (Fars), 1398. (6¾×5″)
No. 1950, folio 26 recto, Museum of Turkish and Islamic Art, Istanbul.

silhouetted against the sky of this miniature is however particularly effective. In the *Wars of Chingiz Khan* in the same volume, the cleft in the background mountains, which we have seen to be a Shiraz characteristic, is exploited to dramatize a battle scene; but this is a far more important feature of another manuscript of this period, the *Anthology* of poems by seven poets copied by a scribe of Bihbahan in Fars, and now Illustration page 68 preserved in the Museum of Turkish and Islamic Art in Istanbul (No. 1950). It is dated 1398, and contains twelve miniatures, of which eleven are pure landscapes; but all, including a hunting scene at the end, show the same rounded pattern of hills, non-representational in colour; in contrasting tones, purple, yellow, salmon-pink and orange; or the same river making a sinuous loop in the centre of the composition which is strongly symmetrical. These pages are unique in the whole history of the Persian school; and in their stylization rather recall the Indian painting of Rajputana of two hundred years later. The drawing however shows a fineness and sensibility which presupposes the long development of the art in Iran.

These are the most conceptual of all known Persian miniatures, but the only element that could not be matched elsewhere is the gold scrollwork which is scarcely noticeable at first sight, but which is to be seen on almost all of the pages. The Chinese conventions for water and clouds are used in some of the pages, but nothing could well be further from Chinese landscape painting. Dr Mehmet Aga Oglu, who first published these miniatures attributed them to the hand of a Mazdean devotee who had, he thought, attempted to symbolize the glory of the energy of the continuing creation of the world, known as "khvarnah" in the holy book called *The Bundahishn*. Such beliefs survived more in a tendency towards pantheism found in Sufism, which is an unorthodox but widespread way of thought in Persia. Manifestly these pages depict the splendour of creation, which has often been implicit in Persian miniatures but is here uniquely the explicit theme of the painter.

Although no other manuscript is illustrated exclusively with such pure landscapes, the same concentration on the world of nature is shown in the decoration of two anthologies prepared for Iskandar Sultan, son of Umar Shaykh and grandson of Timur, in 1410-1411, no doubt at Shiraz. For he was Governor of Fars from 1409 to 1414, and did not occupy Isfahan until 1412, but from that date he made it his home and was occupied in adorning it with fine buildings. He is said to have married one of the daughters of Sultan Ahmad Jala'ir, who had been taken after the defeat of Sultan Bayazid the Ottoman at the battle of Ankara in 1402, and he certainly inherited one of the leading calligraphers from the Jala'ir court at Baghdad, Maulana Ma'ruf, and he was surrounded by Mongol emirs. But his taste in art and poetry was Persian, although he also patronized a poet who wrote in Turki, Mir Haydar. All this means that there would have been no great change at Shiraz, and no break in the artistic life of the city. The two anthologies, which are now in the Gulbenkian Foundation at Lisbon and the British Museum (Add. 27 261), differ in size and script but are clearly the work of the same school of painters and illuminators. In particular they share one feature which is unique to them, the decorative thumb pieces in the centre of each page at the side of the folio nearest to Illustration page 71

the edge. Triangular in shape they are filled with finely drawn flowers and animals, gilt in the smaller book in the British Museum, and delicately tinted in pale blue, pale rose, and with touches of gold in the Gulbenkian volume. Here most of the themes are hares, deer, birds (especially ducks at rest and in flight) and cloud forms, all in Chinese taste as it had been transmitted to the soil of Persia. This kind of *chinoiserie* is developed in the British Museum book from folio 403 to 420 and from folio 433 to the end of the book, filling first whole margins and then whole pages. The Gulbenkian book is in two parts, originally two volumes, and in the first are included, on folios 125 and 126 and on 175, whole pages of decoration in pale blue and pink similar to those in the British Museum; but less pictorial than these, with greater arabesque character. The opening title-pages in both volumes are in normal Persian arabesque, and particularly fine, and of course strictly symmetrical. The plants and trees drawn in the margins of Add. 27 261 have the grace and naturalism that we have noted in some of the work at the court of Sultan Ahmad. Technically they are connected with the larger margin paintings in the Freer Gallery *Diwan* of Sultan Ahmad. These more elaborate margins in Iskandar

Illustration page 71

Sultan's book all occur in the section dealing with astrology, a subject in which he took an especial interest, probably nourished by his father's well-known scientific work on astronomy at his observatory at Samarqand. It has also been pointed out that this book contains the Shi'ite law written on a gold ground and that, like so many of this persuasion, he was a mystic and affected by Sufism. No wonder then that these drawings show an intensity of feeling for natural life which makes the line vibrant. This intensity also informs the best of the miniature paintings in this small volume, such as the *Battle of the Clans watched by Majnun* and the *Majnun and the Animals*. Even more romantic is the landscape in the two miniatures, *Shirin looking at the Portrait of Khusrau* and *Iskandar visiting a Hermit*. Several of these subjects are closely paralleled in the Gulbenkian book, which is probably the earlier of the two. There are twenty-four miniatures in the first part of the manuscript; only fourteen in the second, but these are the more original, especially the double-page compositions. Here the colour is most fully developed, and the use of different tints of gold the most lavish; the effect is thus much richer than in the Jala'ir manuscripts. Sometimes one feels that too much has been sacrificed to richness, so that the miniature becomes a mere pattern without feeling, as in the case

Illustration page 74

of the *Darab (Darius) taken prisoner by Iskandar (Alexander)*, where the arabesque border increases the jejune effect. Still the subordination of the landscape to the figures here forecasts the style of the Timurid school of the mid century. It is easier to enjoy

Illustration page 76

the romance of the *Iskandar peeping at the Sirens as they sport by a Lake*, where the margin painting has mercifully been left undone. The curious texture of both water and rocks makes a perfect setting for the charming naivety of the girls' gestures; whose apparent innocence is conveyed by the same leaf skirts as are worn by Adam and Eve. There is still however a stiffness in the figure drawing which reminds us that these are the first beginnings of a new art, the style which was to become the classic Persian book style.

Illustration page 75

On the other hand the *Bahram introduced into the Hall of Seven Images* is an accomplished work in the rather old-fashioned style of the Jala'ir school. Architecture and perspective

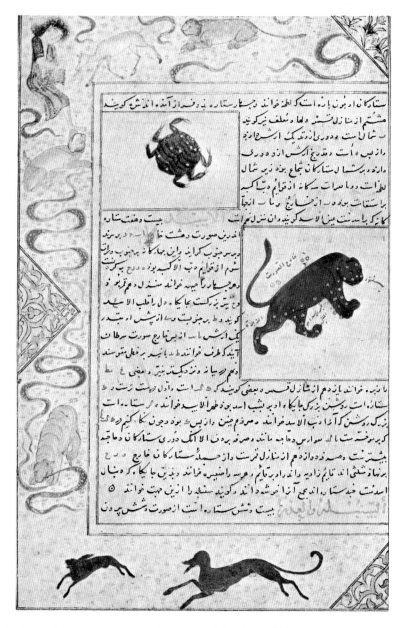

Anthology of Iskandar Sultan: Astrological Subjects. Shiraz, 1410-1411. (6⅛×3⅞")
Add. 27 261, folio 539, British Museum, London.

are skilfully managed and the colour-scheme cool and attractive. A quite new influence
is seen at work in the *Adam and Eve in Paradise*, where the figures are on the larger
scale which we have seen to have been characteristic of Shiraz before 1400.

Miniatures occupying the whole of a double-page opening are rare in Persian
manuscripts, apart from frontispieces which show only stereotype subjects such as hunting
and feasting scenes, or Solomon judging men and demons or surrounded by the whole
animal creation. In the early Timurid manuscripts they are relatively frequent, and
there are four in the big Iskandar *Anthology*, and one in the small *Anthology* which is

Illustration page 73

Illustration page 77

Illustration page 79

here reproduced. The panorama of the city of Mecca with the holy place and the Ka'ba in the centre surrounded by crowds of the faithful pilgrims, is a wholly conceptual picture, the city being laid out schematically without a single view-point; while golden clouds form a conventional frame cutting off the field of vision where it suits the subject. The first double page in the Gulbenkian book contrasts the enthroned king Khusrau with his courtiers and the prisoners awaiting execution on the page facing. Here is found one of the earliest examples of the combination of gold ground and blue sky which is one of the most striking inventions of the Persian school. So much of Persia is desert that it might be thought that this was a piece of naturalism, born of the sight of the burning sun on the bare ground, in which for a brief period in the spring flowers show with brilliant effect. But it seems more in accord with the spirit of the court of Iskandar, who was an extreme Shi'ite, as is indicated by literary sources and also by the resplendent double-page illustration in the second part of the book, showing the Shi'a Imams in Paradise and their opponents in hell (pp. 523-524). Two shades of gold are employed in the clouds of glory surrounding the Imams, through which can be seen a green curtain. A group of eight of their followers below show that they are far above them in the sky. On the facing page are eleven figures writhing in flames, against a blue ground; their faces being far more expressive than is usual in Islamic painting, and perhaps indicating some Western influence. This is followed by another version of the panorama of the Ka'ba, similar to the British Museum composition except that here the architecture does not continue from one page into the other; and the pilgrims' camp here occupies the left side with a variety of different animals in lively action; two donkeys braying, a horse and two camels instead of the small group of three camels in the other book. And it must be remarked that the smaller volume still encloses some text in the field of the miniature, as had been the custom in the Jala'ir school. The last double page shows the catapulting of the patriarch Abraham into the fire by the pagan king Nimrod. Here again the two sides are contrasted; on the right the king is seated among his courtiers with the catapult conspicuously tied by a white rope which makes an amusing S-design with the machine, under a gold sky. Only the pattern of flowers on the blue ground carries across to the left-hand page, in the centre of which is the intensely realized scene of the Patriarch seated on a bed of flowers in the middle of the bonfire; remarkable for the realism of the flames licking the faggots. Again one wonders whether there might be any Western influence here, perhaps from some Italian book or panel painting brought by a Venetian trader to Tabriz. If at first sight the most conspicuous feature of the Gulbenkian *Anthology* is its sumptuous use of gold and silver beyond any which had preceded it, the truly significant thing is the uniting of the Shiraz vigour and dramatic power with the tradition of craftsmanship and grasp of the principles of perspective of the Jala'ir school of Baghdad and Tabriz. There is no doubt that, in his brief *floruit*, Iskandar inspired the finest work that was then produced in Persia; whether by his personal taste and enthusiasm or by a greater generosity to his artists. His reign was short, for his ambition outran his discretion; so that his uncle, Shah Rukh, who was trying to keep the Timurid empire together, was exasperated by the insubordination of

Anthology of Iskandar Sultan: View of Mecca with the Holy Place and the Ka'ba. Shiraz, 1410-1411.
(Each page 6⅛×3⅞") Add. 27 261, folios 362 verso and 363 recto, British Museum, London.

his nephews and their struggle with one another. After pardoning Iskandar's rash and impetuous actions several times he finally authorized his deposition from the government of Fars; and when he resisted the royal army, he was captured and blinded in July 1414, which at least put an end to his patronage of the arts, whatever may be the exact date of his death, which is a matter of dispute. He had thus a bare two years of rule at Isfahan. No illuminated manuscript can be proved to have been produced for him there, but Mr Eric Schroeder has attributed to this period of his career a manuscript of the *Kalila wa Dimna* in the Gulistan Library in Tehran which is one of the most beautiful of all Illustrations pages 82-83 Timurid illuminated books. Certainly the thirty miniatures in it show stylistic features which point to the date of about 1410 to 1420. Such are the tree forms, which commonly resemble the flat sinuous kind with few leaves seen in a 1388 *Kalila wa Dimna* of the Bibliothèque Nationale (Sup. Pers. 332), or the bare and windswept kind with modelled trunks to be found in the earlier fourteenth century miniatures of the Il-Khanid school.

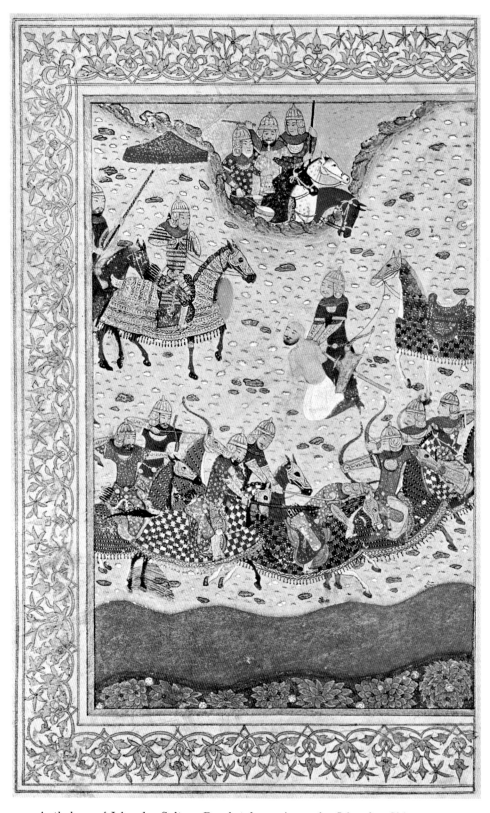

Anthology of Iskandar Sultan: Darab taken prisoner by Iskandar. Shiraz, 1410.
(9½×5⅞″) Page 166, Gulbenkian Foundation, Lisbon.

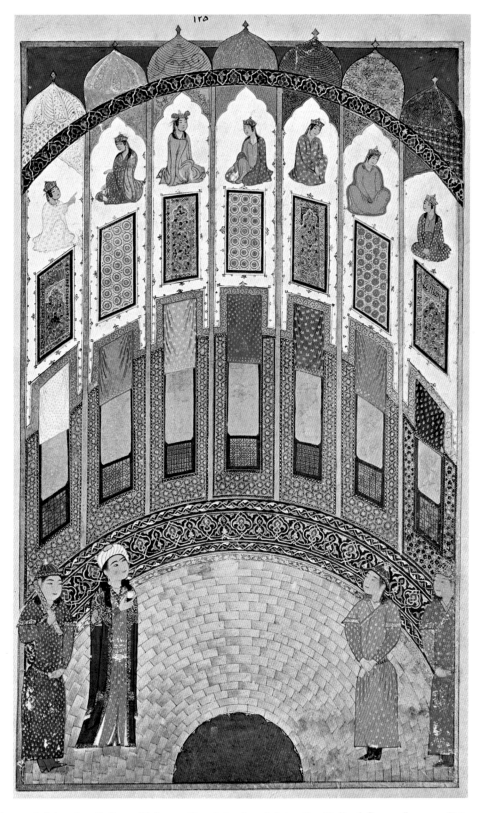

Anthology of Iskandar Sultan: Bahram Gur introduced into the Hall of Seven Images. Shiraz, 1410.
(9½×5⅞″) Page 125, Gulbenkian Foundation, Lisbon.

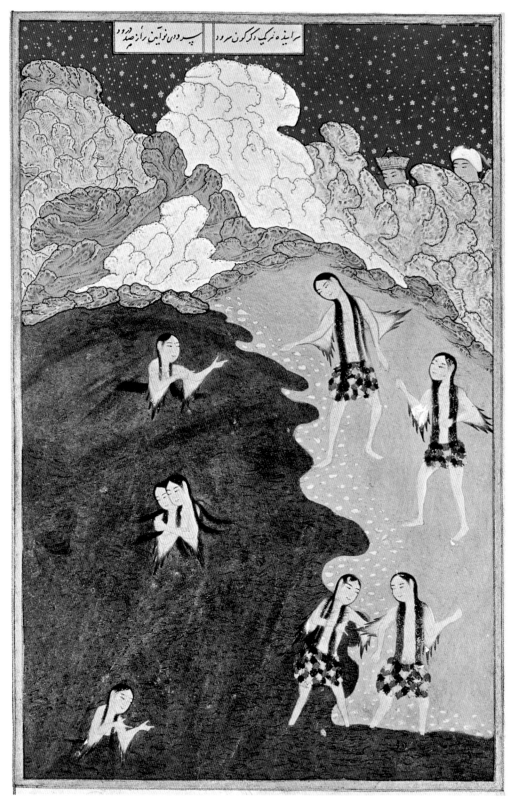

Anthology of Iskandar Sultan: Iskandar peeping at the Sirens as they sport by a Lake. Shiraz, 1410. (9¼×5¾")
Page 215, Gulbenkian Foundation, Lisbon.

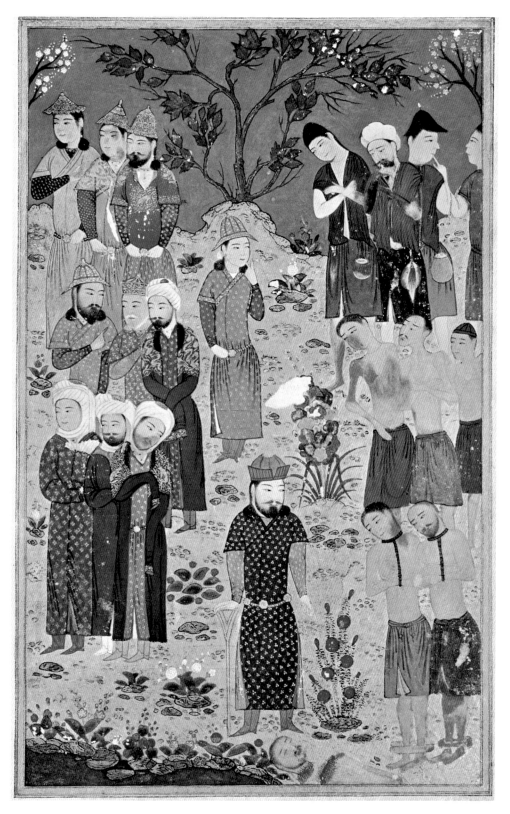

Anthology of Iskandar Sultan: Prisoners before Khusrau. Shiraz, 1410. (9⅛×5¾")
Half of a double-page composition. Page 47, Gulbenkian Foundation, Lisbon.

At the same time the style is further developed than in any manuscript that we have so far discussed, in the just relationship of the animals and the landscape. There is a great advance in subtlety of characterization of the animals, as for instance in the scene in which the rat has to choose how to act when surrounded by three different perils, and quickly makes a compact with a cat which is caught in a trap. Here is an immediately convincing animal world with all in scale to their range of vision.

Illustration page 84

In a second illuminated manuscript of the *Kalila wa Dimna*, preserved in the Topkapu Sarayi Library in Istanbul (Revan 1022), there are a number of miniatures which closely resemble those in the Tehran copy, but the characterization of animals is handled in an entirely different and much less moving way. Of the subjects treated, less than half are common to both manuscripts; but when they are, as in the case of the *Thief discovered in the Bedchamber*, there are details which show decisively that the artist of the Istanbul book must have derived it from the Tehran version or from one very much like it; for he has reversed the figures and thus shown the husband who jumped out of bed to deal with the intruder, holding his stick with a left-handed action instead of the natural position in the other manuscript. Now the Istanbul book was completed in 1430 for Baysunghur Mirza in Herat. For anyone who has handled both these manuscripts, there can be no doubt that the Tehran book must be the earlier. Schroeder's suggestion that it was produced in Isfahan for Iskandar is therefore to be preferred to that of Mr B. W. Robinson that it is a much later version, of about 1460 to 1470. The book opens with a double-page composition of a young prince enthroned in a garden, with flowering trees beyond the fence that encloses a paved courtyard on which are grouped the courtiers and musicians. Birds and clouds fill much of the gold sky and ducks swim in a pool in the foreground. All this is the conventional scene proper to an opening, though here a good deal damaged and retouched in places, especially the faces. The composition was used again in an *Anthology* of 1468 in the British Museum (Add. 16561), reduced and simplified to such an extent that the horses held by a groom are now forced backwards through the bars of the fence, and the prince is offered a cup of wine instead of the volume which should represent the manuscript itself. We shall see that the inventions of the earlier Timurid period were repeatedly used again in later manuscripts, even as late as the beginning of the seventeenth century.

Illustration page 82

With the miniature on folio 18 r. we reach one of the animal subjects which so greatly distinguish the *Kalila wa Dimna* of Tehran. This shows the solitary bull, Shanzaba, which so alarmed and impressed the other animals by its bellowing that it was taken into an uneasy partnership by the lion-king, at large in a flowery meadow. The sensibility of the drawing is enhanced by the richness of the colour; the vivid green of the bamboo on the left, contrasting with the dark and light greens, the brown and yellow of the other vegetation, so that the whole makes a heightened and daring harmony, with a range greater than was usual in later periods. It is however the draughtsmanship that sets this manuscript apart from even the other royal books of the early fifteenth

Illustration page 83

century. The delightful scene illustrated on folio 61 v., in which the monkey inadvertently wins the friendship of the tortoise which catches the figs he throws into the water,

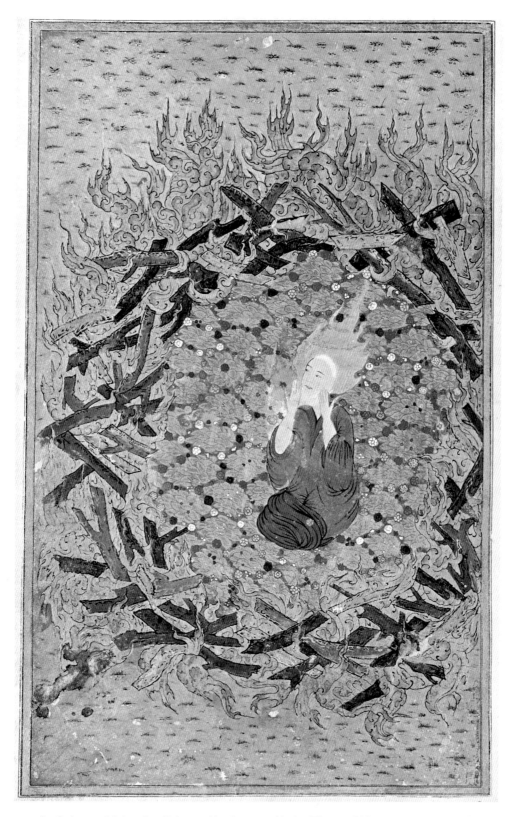

Anthology of Iskandar Sultan: Abraham amid the Flames. Shiraz, 1410. (9¾×5⅞″)
Half of a double-page composition. Page 646, Gulbenkian Foundation, Lisbon.

because he likes the splashing sound they make, is rendered with the most loving care for natural detail. The water, as throughout this book, is rendered by grey on silver, with curling ripples ending in spray, as in early Chinese blue and white porcelain of the fourteenth century. On the shore exquisitely formed conical shells are surrounded by coloured pebbles, some even golden in the next miniature, which shows the monkey being carried on the back of the tortoise through the water. This (folio 61 v.) is the finest naturalism of all the illustrations; and yet the composition is dominated or controlled by a rhythmical repeated accent of the scalloped shore's outline and the tufts of green which lean all towards the left.

Illustration page 84

This quality is completely absent from the Istanbul copy of the same work (Topkapu Sarayi Library, Revan 1022), in which the drawing is hard and crisp, without feeling; the figures often arranged in straight lines, birds and animals frozen even when in action, and the landscape a mere decorative background, however splendid the colouring of rocks or clouds. In these respects the manuscript is at one with the famous *Shah-nama* copied for the same patron, Baysunghur, son of Shah Rukh, at Herat in the same year, 833 A.H. (1430 A.D.). We must now turn to the history of the school of painting at this centre which was the capital of the province of Khurasan and the seat of Shah Rukh who was recognized as head of the Timurid house after the death of its founder, and maintained some kind of control over all the princes until his own end in 1447. Shah Rukh had won this ascendancy by 1409, when he established himself in the capital of his father, Samarqand, in the mainly Turki-speaking lands beyond the Oxus where he was still most at home, rather than in the heart of Persia at Shiraz or Isfahan, where his nephews had their governorships. For most of the rest of his life he lived at Herat when not campaigning, another centre where he had been governor since 1397, and to which he may have led back some of the artists and craftsmen removed to Samarqand by Timur. He was a man of very different character, who combined a liberal patronage of learning with strict adhesion to the code and spirit of Islam. Far from joining in the drinking bouts in which so many members of his father's house indulged, he was a teetotaller who poured down the drain all the wine that he could find in Herat, including that in the house of his own son Juki. It seems likely that this same severity may have led him to command the preparation only of improving books, rather than poetry or romances. Certainly judging from the surviving manuscripts, he seems not to have attracted to his library the best artists of the book who were working in Herat or elsewhere in his time. On the other hand he was a notable patron of scholars, especially the historians Hafiz Abru and Abdul Razzaq. He is known to have sought out the few surviving manuscripts of the universal history by Rashid al-Din, so as to establish the text and prevent it from perishing. Consequently his library seems to have been fully occupied with work of this kind, demanding accuracy of copying rather than originality, and speed of production rather than quality of the work produced. Three of the few surviving contemporary manuscripts of Rashid al-Din's history carry Shah Rukh's library seal, including the fragment in the possession of the Royal Asiatic Society from

Illustrations pages 24-25

which two miniatures have been here reproduced; while another in the Topkapu Sarayi

Library in Istanbul is of special interest to us because it contains some miniatures added at this time in places still unfilled in the original atelier at Rashidiyya. This historical school hardly ever rises above the pedestrian.

The most famous historical manuscript which must be assigned to this school is the richly illustrated volume in the Bibliothèque Nationale (Sup. Pers. 1113), which has Illustration page 81 few direct echoes of the style of Rashid al-Din, but preserves the same simple grouping of figures and bright colour-scheme as the Herat books made for Shah Rukh about 1425. It may be that this volume was completed ten or fifteen years later, for it shows that liking for symmetry which becomes commoner towards the middle of the century. The pigments are good and gold is freely used, so that it is not likely to be a provincial work. At the same time the colouring is less rich and decorative than in that other manuscript in the same collection (Sup. Turc 190), the *Miraj-nama*, recounting the night journey of the Prophet Muhammad to heaven and hell, written in Eastern Turki for Shah Rukh according to the colophon, at Herat in 1436. This is a sumptuous quarto volume, in which the deep blue of the night sky is a dominant, and several shades of gold are

Jami' al-Tawarikh (Universal History) of Rashid al-Din: Marghu Buyinrah nailed to a Donkey. Copy made for Shah Rukh, Herat, c. 1435. (4⅞×7¾″) Sup. Pers. 1113, folio 61 verso, Bibliothèque Nationale, Paris.

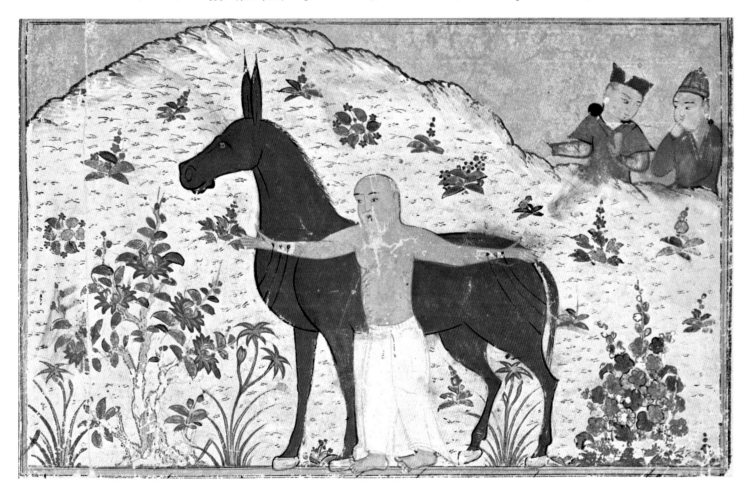

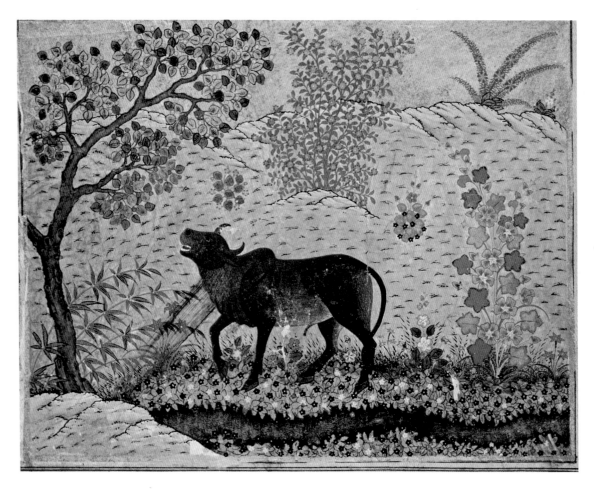

Kalila wa Dimna: The Bull Shanzaba in a Flowery Meadow. Timurid School, 1410-1420. (4⅝×5⅞″)
Folio 18 recto, Gulistan Palace Library, Tehran.

employed in many of the miniatures. The subject makes the pictures rather monotonous, but there is great dignity as well as decorative value in the mosaic-like scenes in which the angel Gabriel guides the Prophet through the courts of heaven and hell, here represented as among gold cloud swirls; and once more the artists have responded to the opportunity in the two scenes in which the blessed are shown arriving in the flowering land of paradise, which are as fresh as anything in the earlier Shiraz volumes.

Turki was the native language of Shah Rukh and of the other Timurids, and this book is claimed sometimes as a masterpiece of Turkish art. It belongs however to the main stream of the development of Persian miniature-painting, to which no doubt the "Turkish" Timurids contributed by their patronage. What is most difficult to assess is the influence of this violent and accomplished family in supporting Persian culture in which most of them were at home. It is not to be doubted that the Persians regarded them as foreign lords. It has been well said, by Jean Aubin, that Iranian culture in the early fifteenth century could certainly alter the taste of its conquerors to its canons, but not their character or spirit. In the struggle for power their taste for Persian letters or art

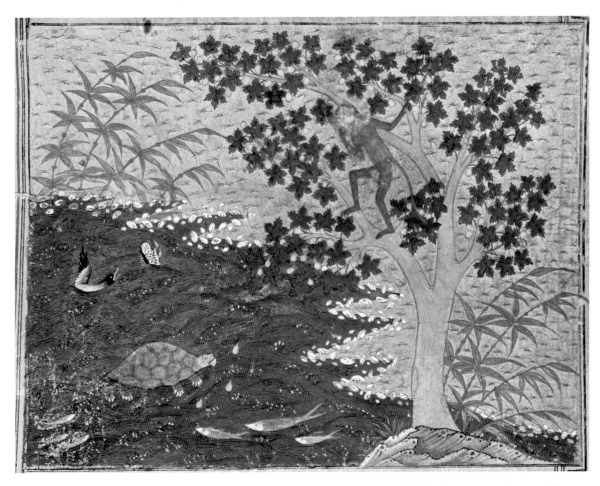

Kalila wa Dimna: Fable of the Monkey and the Tortoise. Timurid School, 1410-1420. (4⅝×5⅞")
Folio 61 verso, Gulistan Palace Library, Tehran.

counted for nothing, and they were never able to trust one another. In one respect the position for the Persians was worse than it had been under the Il-Khans, for power was now in the hands of the Turkish Amirs instead of the Persian Wazir. On the other hand most of these princes were proud of their personal accomplishments, and liked to pose as patrons of learning and art. The sons of Shah Rukh, Baysunghur and Ibrahim, were lovers of Persian literature, and their elder brother Ulugh Beg was a learned man and a patron of scientific studies, geometry, astronomy and music. Baysunghur was a good calligrapher and he prepared a new edition of the *Shah-nama*. Ibrahim corresponded with him on literary subjects. All three sons were given to feasting and concerts, unlike their strict father. There was therefore to be expected a difference in quality between the work produced at Herat for Baysunghur and for Shah Rukh.

The reputed date of the foundation of Baysunghur's library is 1420, when he was sent as commander of a force to recover Tabriz from the Turkmans, and returned bringing with him the master Ja'far, a pupil, either direct or at one remove, of the inventor of *nastal'iq* writing, who became the head of the most famous scriptorium of

the day. In a manuscript of 1421, now in the Academy of Sciences in Leningrad, of the *Khusrau and Shirin* he already signs himself al-Baysunghuri. In 1427 a second master calligrapher, Muhammad b. Husam called Shams al-Din, who taught Baysunghur himself calligraphy, produced for his master two beautiful small books, an *Anthology* and the *Gulistan* of Sa'di. They are both of great distinction for their illumination and writing, and also for the colouring of the miniatures of which there are eight in the *Gulistan*, now in the Chester Beatty Library in Dublin; and seven in the *Anthology*, preserved in the Berenson Collection at I Tatti near Florence. The compositions are not complex but subtle in their rich plane surfaces and glimpses of wider prospects. There are

Illustration page 87
Illustration page 86

Kalila wa Dimna of Baysunghur: Lion killing a Bull. Herat, 1430. (6×6⅞″)
Revan 1022, folio 46 verso, Topkapu Sarayi Library, Istanbul.

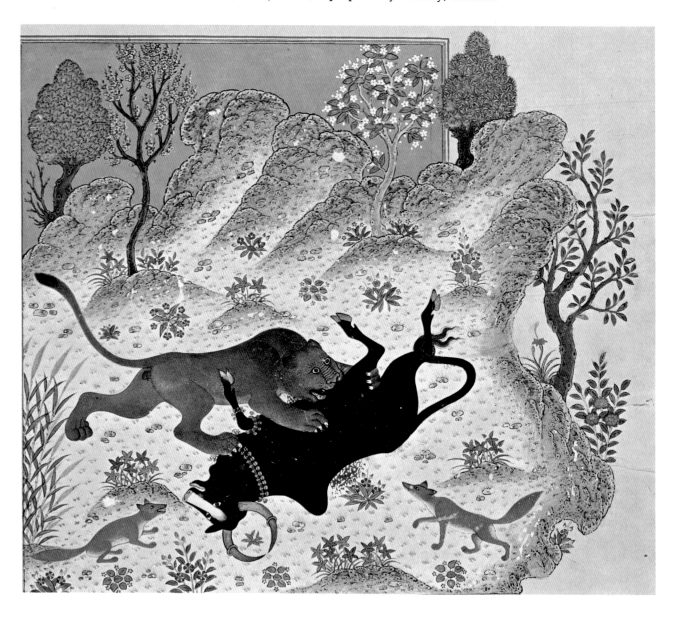

obvious links with the Jala'irid manuscripts, for instance in the continuation of the compositions into the margins into which mountains rise in the two sea scenes in the *Gulistan*, and trees both with and without foliage in the *Anthology*. But it is the colouring which is the distinctive mark of these early products of Baysunghur's atelier, especially the various reds and orange, brilliant but never harsh. Gold skies are discreetly introduced in the corner, above a rose-pink tower, or as a foil to two magpies, or to flowering trees, all to be standard devices in later Timurid painting, though they were never again used with such purity. There is a kind of cool splendour about these two books which is unmatched. It is interesting to compare the *Scene from a Love Story* in the Illustration page 86 Baysunghur *Anthology* with the similar subject in the Khwaju of 1396 (thirty years earlier); the composition has been greatly simplified, and instead of the symbolism of the garden wall, there is only the expressive intensity of the colour. It is for this reason that the openings of door and windows are so emphatic in these two manuscripts of 1427, marking the communication between the inside of the palace and the outer world. The significance of every gesture is enhanced by the economy of the means of expression.

By far the most sumptuous of the manuscripts produced in Prince Baysunghur's library and known today is the copy of the *Shah-nama* in the Imperial Library of the Gulistan Palace in Tehran. It is comparatively well-known in the West, since it has been shown at exhibitions in London, Leningrad, Paris and Rome, and miniatures from it were reproduced in the Unesco World Art Series volume on Iran. It has twenty-two well-preserved miniatures and a dedication to Baysunghur, and was copied by Ja'far Baysunghuri in 1430. Next after the brilliance of the colouring one is struck by the extreme clarity of the compositions, and the sharp silhouette of the figures, who are nevertheless stiff and expressionless. A similar stiffness is to be seen, though not so conspicuously, in the earlier Baysunghuri books, in which sensibility is not so completely absent as from this too dazzling book. It opens with a double-page royal hunt, watched by the young patron. The stance of every figure is varied, the gestures are far from being monotonous, but the forms are stiff none the less. This hard, almost metallic quality, especially conspicuous in the tree trunks, and in the rock pattern, has stultified the attempt at a rugged profusion of coral-like boulders. It is indeed in the architecture that the artists have been most successful, where the brilliance of the tilework is not negated by the stage-property structures as elsewhere.

The question must be asked whether this manuscript is the original fair copy of the new text of the epic prepared under the personal patronage of Baysunghur, the preface of which he prepared in 1426, four years earlier than the date in the colophon. It may be argued that it would have taken a long time to write, illuminate and illustrate a volume of this quality, and wherever we have evidence from dated miniatures or from dated sections in a volume of a poet's works, one or two years are regularly shown between the earlier and the latest dates in the same volume. On the other hand it seems very likely that Baysunghur might have commissioned more than one copy of a work to which his personal name was attached, and there have been reports of the survival in Persia of other equally fine examples of this new recension dated between 1426 and Baysunghur's death

Anthology of Baysunghur: Scene from a Love Story. Copied by Shams al-Din, Herat, 1427. (7¾×4⅞″)
Folio 26 verso, Berenson Collection, I Tatti, Settignano (Florence).

Gulistan of Sa'di: Wazir as a Dervish begging in front of the King's Palace. Copied by Shams al-Din for Baysunghur, Herat, 1427. (9¾×6″) P. 119, folio 9, Chester Beatty Library, Dublin.

in 1433. One reason for assuming that there was another and even more richly illustrated copy appears to follow from the existence of a *Shah-nama* manuscript prepared for Shah Abbas I in 1614, which is obviously derived from some early fifteenth century original more fully illustrated than the Gulistan Palace manuscript, since it contains thirty-nine miniatures as against twenty-two in the latter. This manuscript, now part of the Spencer Collection in the New York Public Library, is discussed below, and it is sufficient to note here that of these additional miniatures some at least are completely different from anything in the Tehran book, while the remainder show so thorough a dependence on the Timurid originals as to make it quite unlikely that the artists concerned were capable of the invention required for an entirely new composition. It is most Illustration page 164 curious to detect how the artist who was set to illustrate the *Coronation of Luhrasp by Kay Khusrau* lifted the whole framework of his composition from the scene of *Faramurz mourning for Rustam*, in the 1430 book, and simply added the figure of Luhrasp and the crown in Kay Khusrau's hands and the throne behind in the place of the coffin of Rustam! A new polo picture is supplied by ingeniously rearranging the figures of the hunters in the right half of the frontispiece! Others, like the *Bizhan in the Well*, are entirely new, but in the same pseudo-Timurid style. Surely they must also be derived from some fuller, even more richly illustrated volume.

The other well-known manuscript produced for Baysunghur in this same year, the Illustration page 84 *Kalila wa Dimna* which is now Revan 1022 in the Topkapu Sarayi Library, seems to have the same status, for its twenty-two miniatures only partly correspond with the thirty in the earlier manuscript already discussed and assigned to about 1415. The figures are stiffer and grouped more rigidly in phalanxes instead of the easier grouping of the Tehran book. Everything in it is shown in the harshest light as realistically as in any early Persian work, or to put it more sympathetically, it shows the firm drawing and rich jewel-like pigments with every detail picked out in the strongest colouring. The combination of gold ground and blue sky is again found in this manuscript and the spongy rock forms are particularly richly coloured. The trees have the same smooth trunks with eyes like palms as in the *Shah-nama*, and a routine way of rendering each species seems to have been worked out. In fact what we have here is first-class craftsmanship, too seldom enlightened by the touch of imagination which had been so conspicuous in the earlier volume. In this respect Baysunghur's workshop resembles that of his father Shah Rukh. Only the effects are more brilliant, the pigments richer, and the compositions more sophisticated. A scale of figure drawing and relationship had now been arrived at which satisfied Persian taste for a long time to come, so that this may be considered to be the beginning of the "classic" period of Persian miniature painting. From this time the background to every subject depicted is the paradise, the garden originally set aside as the hunting park of the ruler, but endowed with all that glory of the perpetual spring which is attributed to the walled garden watered by a never-failing stream, only to be understood against the background of a land that is two-thirds desert; and in a culture permeated by the Sufi sense of the immanence of the divine in the world of nature seen as the mirror of the divine.

Shah-nama of Muhammad Juki: The Battle between Gav and Talhand who swoons on his Elephant. Herat, c. 1440.
(9×5¼″) MS 239, folio 430 verso, Royal Asiatic Society, London.

Shah-nama of Muhammad Juki: The Div Akwan throws Rustam into the Sea. Herat, c. 1440. (9×8½″)
MS 239, folio 165 verso, Royal Asiatic Society, London.

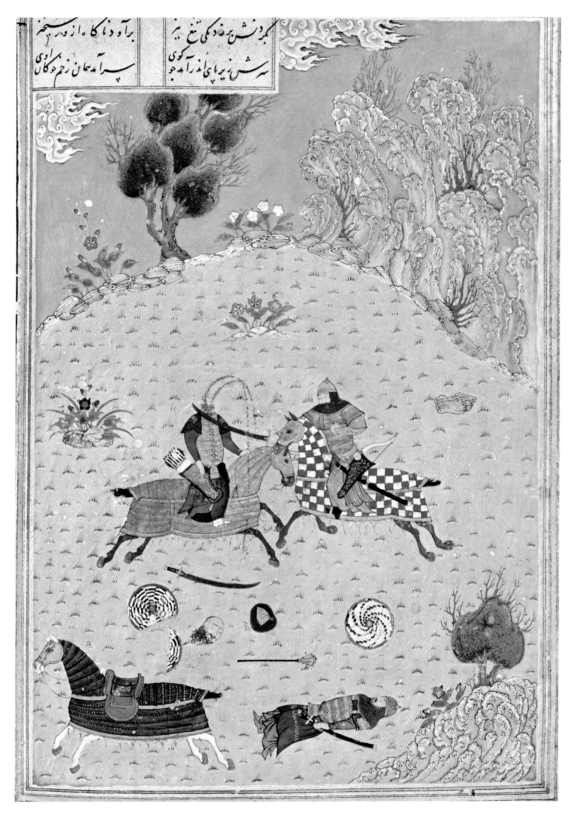

Shah-nama of Muhammad Juki: Gustaham beheading Farshidward. Herat, c. 1440. (9×5¼″)
MS 239, folio 206 verso, Royal Asiatic Society, London.

Baysunghur, who was considered the best connoisseur of his generation, died of dissipation in 1433, but Herat remained the centre of the arts of the book for some time longer. First, according to the report of Dust Muhammad, under the patronage of his son, prince Ala al-Dawla, who survived until 1447, and not only retained his father's artists but also attracted to Herat Ghiyath al-Din, a painter who had accompanied the embassy of Shah Rukh to China in 1419 to 1422, as the envoy of his son Baysunghur, and had made vivid notes of what he saw there and on the way, which had been incorporated by Abdul Razzaq in his *History*. He came now from Tabriz, where he had presumably been employed by another son of Shah Rukh, Ulugh Beg, who patronized the arts and learning there in spite of the opposition of the local dervishes, who tried to impose the prohibitions of orthodox Islam, instead of the lax or free-thinking principles of the Persian Sufis. Unfortunately at present it has not been possible to attribute anything to this artist or his school, either at Tabriz or Herat. Prince Babur Mirza is recorded by his namesake the Mughal to have built a pleasure house of two storeys with wall-paintings which he, surely mistakenly, thought to be later additions by Abu Sa'id. But Ala al-Dawla's uncle, Muhammad Juki, was another patron

Illustrations pages 89-91

of the arts; and a finely illustrated manuscript of the *Shah-nama* made for him survives in the library of the Royal Asiatic Society of London. He was not trusted by his father with any important political appointment and he also was given to dissipation, perhaps on that account; as is suggested by the story that in 1440 Shah Rukh personally ordered the throwing away of all the wine found in his son's house in Herat. At any rate he is said to have led an invalid life until his early death in 1445. This *Shah-nama* is generally attributed to about 1440, and naturally to Herat, although some influence has been noted in its miniatures from the school of Shiraz, which we shall see to have pursued a different course after the death of Sultan Iskandar.

The miniatures are all on a much smaller scale than those in the Baysunghur manuscripts, painted with great skill in enamel colours, the figures dwarfed by the brilliance of the landscape. The artists show far greater interest in the natural world, so that it takes over the function of dramatic setting and the action of the figures is quite subservient to it. There is a tendency to elaboration, in such features as the rocks, which now often form great sponge-like masses in unreal colouring; trees are more windswept and clouds more conspicuous, with pink shading to the white swirls. The painters knew how to heighten the romantic feeling by poising castles or palaces precariously among crags and precipices, or by giving the rocks themselves a kind of architectural quality; so organized are they in towering or jutting needles or wall circles as to make an amphitheatre for the action. In the 1430 *Shah-nama* the star-filled sky has an all-over sameness which is simply rich in effect, while in the Royal Asiatic Society manuscript of 1440 stars seem to burst across the sky in clusters of intensity. Human figures are no less stiff, generally, especially when on horseback, but there is less monotony in stance or movement; and, in some, a definitive advance towards more complex compositions, especially

Illustration page 89

in the great battle scene here reproduced, *The Battle between Gav and Talhand*, where the central mêlée has more energy in the counterpoint of involved movement than anything

in the 1430 book. No doubt the drawing in this manuscript is not so sure as in the books from Baysunghur's workshop, but it is not a repetition of old formulae that we find here; rather the stir of new advances towards the more open composing of the second half of the fifteenth century.

Before the decade was over the sway of the Timurid house was shattered and the days of their patronage of Persian art and letters finished, at least for a season, and never to be as pervasive as it had been during the first half of the century. Muhammad Juki died in 1445, Shah Rukh in 1447, and his remaining son Ulugh Beg in 1449. A certain Abu Sa'id, of dubious origin, set himself up as heir of the Timurids, and inaugurated twenty years of philistine rule under the influence of the orthodox dervishes of Samarqand, who, as Barthold puts it, were "hostile to any form of culture." An *Anthology* in the Chester Beatty Library is said to have been his. He was killed fighting against the Turkmans in 1468, and was succeeded in Herat by Sultan Husayn Bayqara, who ruled Khurasan for about forty years and inaugurated a second age of Timurid patronage there, as splendid as the first, but confined to that north-eastern province of Persia. Before entering on an account of that period attention must be paid to what had been happening in other parts of the country, which gradually passed from the control of the house of Timur. Since the main centre seems to have lain in Shiraz, it may be best to start with what we know of the schools of painting in that city.

5

WE have followed the development of the Timurid school in Shiraz up to the defeat and blinding of prince Iskandar in 1414. His cousin prince Ibrahim, another son of Shah Rukh, and also a man of literary and artistic tastes, was the governor for the twenty years from 1414 to 1434. He was noted as a calligrapher and himself wrote the monumental inscriptions on his two religious endowments in that city, which were reproduced in the glazed tiles. He continued the patronage of writers and artists, but the finest painters seem to have migrated to Herat after Iskandar's death, for no Shiraz work after 1414 keeps the lyrical note of the earlier school. There appears indeed to be a return to the rougher, more vigorous style of late fourteenth century Shiraz in the earliest surviving manuscript which can be attributed to the library of Ibrahim, an *Anthology* finished in 1420 for his brother Baysunghur (Berlin Museum).

The best known work composed in Shiraz in his time was the *Zafar-nama* or life of Timur by Sharaf al-Din Ali Yazdi, which was finished in 1425. Some large-scale miniatures survive from an early manuscript of this history, of which the finest is in the Freer Gallery, while others are in Montreal. The date is said to be 1434, and this cannot be far out. The page in Washington represents the triumphal entry of Timur into Samarqand; the balconies being covered with coloured silks hung out, and spectators looking down fearfully at the conqueror riding by under a state umbrella. Although this miniature occupies a regular rectangle the great height in proportion to the width gives it a special feeling of nobility. It is a finer historical style than that of his father Shah Rukh at Herat at this time.

Illustration page 97

A richly illustrated copy of the *Shah-nama*, dedicated to Sultan Ibrahim, is in the Bodleian Library at Oxford (Ouseley, Add. 176), and is datable to about 1435. The colophon is missing, and it is possible that it was unfinished at the date of his death, which probably occurred in that year. It retains in its illustration many of the features of the 1420 book, such as the simple landscape background, the high horizon, and the vigorous action; and the colouring remains mainly in a low key. Indeed the free use of green has proved fatal to some of the miniatures which show holes where the paper has been burnt by this arsenical pigment. Rough and homely compared with the miniatures of the Baysunghur *Shah-nama*, these show an economy of composition which can

Illustrations pages 98-100

be highly decorative and compensates for some clumsiness in such matters as architectural perspective. Many have a tendency towards symmetry, and some achieve a largeness, just because of the simplicity of the composition. Several double-page court and hunting scenes are richer in complexity and colour; but this exuberance is rather more than these artists can manage, so that they tend to be incoherent. Scenes like the Illustration page 98 *Rustam catching his Horse Rakhsh from the Wild Herd* are more typical of the virtues of this manuscript, in the skilful use of colour contrast.

Illustration page 100

Illustrations pages 71-79
A very different feature of this book is the presence on the reverses of five pages of "capriccios," drawn in gold and silver only, with motifs of a kind of *chinoiserie* which clearly continue the tradition of the decoration of the two Iskandar *Anthologies* described above: indicating the continued presence in Shiraz of one artist, at least, who had been trained in the library of that patron. These drawings are deliciously free, but they derive, either directly or indirectly, from Chinese decorative art in porcelain or textiles, the vogue for which is also attested by the presence in the miniatures of this book of representations of blue-and-white vases of Chinese porcelain, which are most frequently found in Persian manuscripts of the first half of the fifteenth century. The animal drawing on these pages helps to authenticate the contemporaneity of the drawings in the same Illustration page 49 colour-scheme in the *Diwan* of Sultan Ahmad. Pure pen and ink *chinoiserie* drawings occur in several mixed albums in the Topkapu Sarayi Library, and should be attributed to this period, rather than to the earlier or later dates sometimes proposed for them.

Clearly related to the Bodleian *Shah-nama* of Sultan Ibrahim, and therefore to be assigned to the school of Shiraz while it was still a Timurid city, are several other groups of vigorous miniatures, dated in the colophons of the manuscripts for which they were prepared to the years 1438 and 1444, or lacking now any date. Timurid rule in the province of Fars and in its capital, Shiraz, continued until 1452. In the Bibliothèque Nationale (Sup. Pers. 494) is another *Shah-nama* manuscript, dated 1444, and copied by Muhammad al-Sultani, the typical Timurid suffix, with a much larger page (14¾ by 10¾ in.) and seventeen miniatures. The action is bold and spacious, and the colouring wonderfully rich in range and intensity. Figure drawing, cloud forms and foliage connect them with the Shiraz school, and all the particulars, as well as the size, confirm B. W. Illustrations pages 102-103 Robinson's guess that the pair of well-known frontispiece pages from the Goloubev Collection, now in the Cleveland Museum of Art, belong to this manuscript. The right-hand page bears on the reverse an illuminated *shams*, unfortunately without the name of the prince for whom it was prepared, filled in; and on the reverse of the left-hand page is the beginning of the Baysunghur preface to the Epic with a good illuminated heading. Although it might be thought that the subject, a royal feast in a garden, would not lend itself to movement, the forceful gesture of a single figure in each half of the double composition and the leaning stance of many of the figures do in fact give a sense of great energy to these pages. Figures and carpets almost float over the ground, while the rich vegetation and the sumptuous textiles, in which gold and silver are not spared, make the background like a tapestry. Certainly the Timurid school of Shiraz showed no sign of decline in vigour in its last decade.

Zafar-nama (Life of Timur) of Sharaf al-Din Ali Yazdi: Triumphal Entry of Timur into Samarqand. Shiraz, c. 1434. (10¹³/₁₆×6¾″) No. 48.18, Courtesy of the Smithsonian Institution, Freer Gallery of Art, Washington, D.C.

Shah-nama of Sultan Ibrahim: Rustam catching his Horse Rakhsh from the Wild Herd. Shiraz, c. 1435. (4⅝ × 7⅛")
Ouseley, Add. 176, folio 62a, Bodleian Library, Oxford.

Exactly contemporary with this manuscript is a Nizami in the library of Princeton University (Garrett 77 G), copied at Abarquh, an ancient city of Fars north-east of Shiraz, with colophon to the *Makhzan al-Asrar* dated 1443, and nine miniatures, which Robinson has claimed as the earliest dated miniatures of his Turkman school, which we must now consider. In the fourteenth century two groups of Turkman tribes led a still largely nomadic life, which had from time immemorial been their habit in Central Asia, in a wide area between the Timurids and the Ottoman Turks, stretching between Mosul and the Syrian border. They had been feudatories of the Jala'irid Uways (1341-1374), who kept his court at Baghdad and, although a Mongol, was thoroughly Iranicized and himself a calligrapher and draughtsman of merit. Within little more than a generation the Black Sheep Turkmans (Qara Qoyunlu) had supplanted their overlords, and under Shah Muhammad, son of Qara Yusuf, ruled in Baghdad from 1411 to 1433. His younger brother, Jahan Shah, ruled in Tabriz from 1436, before eventually succeeding to the throne and transferring the capital there. He was a poet in his native Turki language but with a thorough mastery of the Persian poetical technique. His son Pir Budaq, who had actually been adopted by the last Jala'ir ruler, Sultan Ahmad, was installed as governor in Shiraz in 1453, but was deposed for plotting in 1459 and put to death for rebellion in 1465. He too was known as a patron of the book arts and of Persian culture. Beautifully illuminated manuscripts of the *Diwans* of the poets Katibi, who was patronized by the Qara Qoyunlu house, and Qasimi, are preserved in Istanbul. We do not have any illustrated manuscripts from the court of Jahan Shah himself at Tabriz which he adorned with fine buildings between 1436 and 1467, when he died. After this date the other branch of the Turkmans, the White Sheep (Aq Qoyunlu), under their head Uzun Hasan (1453-1477), ruled from Tabriz for a decade, during which he was courted by the Venetians as an ally against the Ottoman Turks, who however soundly defeated him in 1473. His wife was a princess of the last Byzantine house, the Comnenes of Trebizond (as had been those of two of his predecessors), and this brought him into close connection with several leading Venetian families, with whom the Comnenes were related. In the Treasury of St Mark's is a marvellous carved rock-turquoise cup bearing his name. Certainly he must have had opportunities for seeing and acquiring examples of Italian painting and prints, and probably also manuscripts. Several embassies from Venice visited him in Tabriz, and their accounts survive.

From the time of Uzun Hasan we do have some manuscripts to show the kind of miniatures preferred by the Turkman rulers; the earliest being an *Anthology* (British Museum, Add. 16 561) dated 1468, written in the city of Shirwan, or Shamakha, on the west side of the Caspian Sea. The style is much quieter than the mid-century work of Shiraz or Herat. But the book does include one remarkable composition, a miniature of the city of Baghdad in flood, a schematic aerial perspective view of considerable skill.

Uzun Hasan made his capital at Tabriz, not Shiraz, and there could have been a more advanced style there, possibly represented by some of the figure drawings in the Istanbul albums which are associated with the name of Mehmet the Conqueror (Fatih). These show the eclecticism to be expected of that cosmopolitan court, including Christian

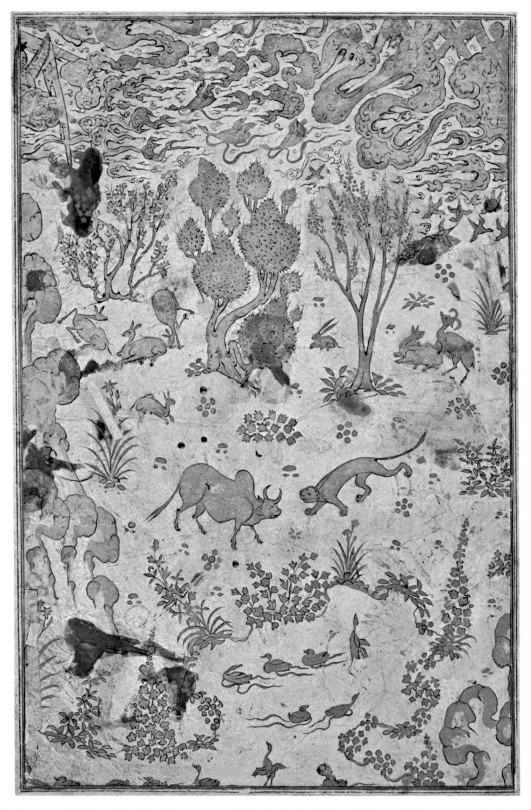

Shah-nama of Sultan Ibrahim: Landscape with Animals in Gold and Silver. Shiraz, c. 1435. (10½×6⅞″)
Ouseley, Add. 176, folio 3a, Bodleian Library, Oxford.

influence. There is Chinese influence also; and, judging from both style and costume, of the Ming dynasty rather than the Yüan. One or two pieces of early fifteenth century blue and white porcelain are introduced, and there are even direct copies of Chinese paintings as well as some originals, by artisans rather than by the painters whose work is considered by historians of Chinese painting. A difficulty in sorting out the contents of these mixed albums is that work of quite different periods has been indiscriminately put together and attributions to various names added by connoisseurs of the later sixteenth century or even more recently. Reference has already been made to miniatures from a fourteenth century *Shah-nama* (Hazine 2153) of large scale and remarkable force and Illustrations pages 41-43 invention, and there are also large drawings in almost pure line and very much in Chinese taste which must be attributed to the late Jala'ir time about 1400. Everything in fact suggests that these albums represent the salvaged relics of the royal collection from Tabriz, gathered over a century at least, first by the Jala'ir rulers and then by their successors at Tabriz, the Turkmans of the Qara Qoyunlu and then of the Aq Qoyunlu. Tabriz was in fact one of the clearing places of all the currents which were running across the Middle East in the hundred and fifty years of the greatest mutual influence of the Iranian world and the Chinese from about 1300 to 1450. In spite of the distrust of the Timurids for the new and nationalistic Ming dynasty which succeeded the Mongol Yüan in 1368, annual presents were exchanged between Timur and the Chinese court of horses from Farghana against precious stones and paper money, from 1387 onwards. Embassies on a more important scale were exchanged under Shah Rukh in which several of the Timurid princes joined, notably Ulugh Beg and Baysunghur.

It has been suggested that many of the fifteenth century miniatures in the Istanbul albums may have been produced in Transoxiana or Herat about the middle of the fifteenth century, in circles where Turkish culture was an important element. But in view of the history of these areas and of the fact that the work of Herat under Shah Rukh is well known, it seems preferable to put forward the suggestion that it was rather among the Iranicized Turkmans that this hybrid art may have flourished, especially under Jahan Shah and then under the White Sheep Turkman Uzun Hasan for another decade.

There is in particular among the contents of the albums a series of drawings of extraordinary virtuosity, sometimes with hardly any colour added to the calligraphic penwork, but sometimes completed in brilliant colours. These include decorative features like leaves and flowers, occasionally arranged in complex designs (as on the engraved and inlaid metalwork which originated in Khurasan in the latter part of the twelfth century), but now developed into elaborate symplegmata of animal, fish, and bird forms incorporating also the dragon and phoenix of Chinese origin, not unlike those which we have noted in the Iskandar *Anthologies* of 1410, but far more elaborate. At other times we find animal studies which seem to be made from the life, a pair of horses or the head of a stag, and even a natural scene with bears, hares, and beasts of prey among trees. Such human figures as occur among this class of drawing are in costume of the first half of the fifteenth century, rather more squat than in the Herat manuscripts, less stiff and with freer movements. The few complete compositions which seem to go with these

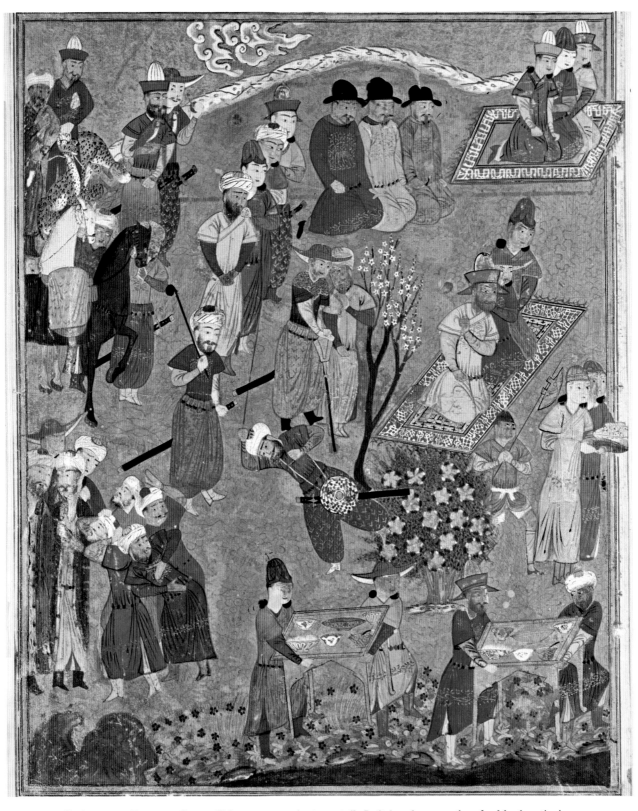

Shah-nama: Banquet Scene. Shiraz, c. 1444. (14¾×10¾″) Left-hand page of a double frontispiece.
No. 56.10, John L. Severance Collection, The Cleveland Museum of Art.

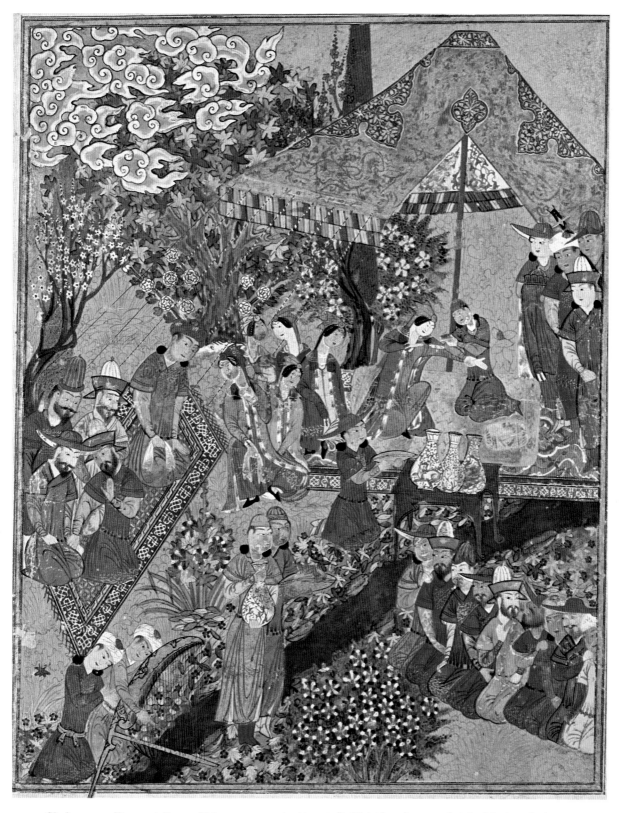

Shah-nama: Banquet Scene. Shiraz, c. 1444. (14¾×10¾″) Right-hand page of a double frontispiece.
No. 45.169, J. H. Wade Collection, The Cleveland Museum of Art.

sketches retain something of the large feeling of the fourteenth century, but their greater realism and Timurid landscape settings make their later date certain. A much larger proportion of the contents of these albums is of a stranger and more exotic kind. These are low-toned coloured drawings of grotesque-faced bearded men, in heavily quilted clothes, leading a nomadic life, with their skinny horses and asses; or of demons in similar colouring, shown dancing, fighting, or carrying off a horse, playing a guitar or humbly acting as porters.

These figures are related to a class of Chinese demon picture of Taoist origin, and their connections are certainly with the lands between Persia and China. The clothes suggest Mongolia rather than Turkestan, but the element of caricature in the drawing rules out that they should actually be Central Asian work, quite apart from the stylistic links with the other groups which we have been considering. Details forbid a date earlier than 1400, and draughtsmanship one after 1485. Once again one is driven to attribute these drawings to a circle in touch with the Far East and also with the Timurid school. The painter Ghiyath al-Din who accompanied the embassy of Shah Rukh to China in 1419-1422, as the agent of Baysunghur, left an account of all that he saw there and on the way, incorporated by Abdul Razzaq in his *History*. He describes the wall-paintings which he saw *en route* in Khotan and which at this period would have included Taoist as well as Buddhist work. He was also deeply impressed by the accomplishments of Chinese painting. These classes of drawing in the Istanbul albums seem to reflect this taste for the exotic rather than the native work of a Central Asian school, whether Turkish or Mongol. But it is important to recall that the patrons for whom these painters worked, whether Timurid or Turkman, were of Central Asian stock and recently leading nomadic lives. Many of them would have been addicted to the astrological and superstitious beliefs of their heathen past and only partly assimilated to the Islamic comity. Hence this disconcerting union of ferocious subjects with refined execution. It seems best to reserve the term "Turkman school" for this special type of painting rather than to apply it to the various styles current in the whole of western Persia by 1453 when they occupied Shiraz.

And so we return to the school of Shiraz in the middle of the fifteenth century. In the Museum of Fine Arts, Boston, are twenty-six miniatures from a *Shah-nama* manuscript which are dated by the Museum to about 1470. They are nearly square, and have features reminiscent of the Herat school of Baysunghur, but the colouring is the stronger range of Shiraz and they have the large tailed clouds characteristic of that centre. The horses wear the surcoats which Robinson believes to be a sure sign of Shiraz, and the compositions tend to be on a diagonal axis, and the landscape conceptual. Nothing now remains of the perspective science of the previous century, except the high view-point which enables the artist to manage a scene with many people.

With a conceptual landscape the tendency is to revert to the basic Persian inclination to symmetry and to decoration. This is most clearly seen in a richly illustrated manuscript of the *Khawar-nama* of Ibn Husam, an epic life of the Shi'a Imam Ali, the son-in-law of the Prophet Muhammad, composed in 1426, the last of the imitations of the *Shah-nama*.

Illustrations pages 105-107

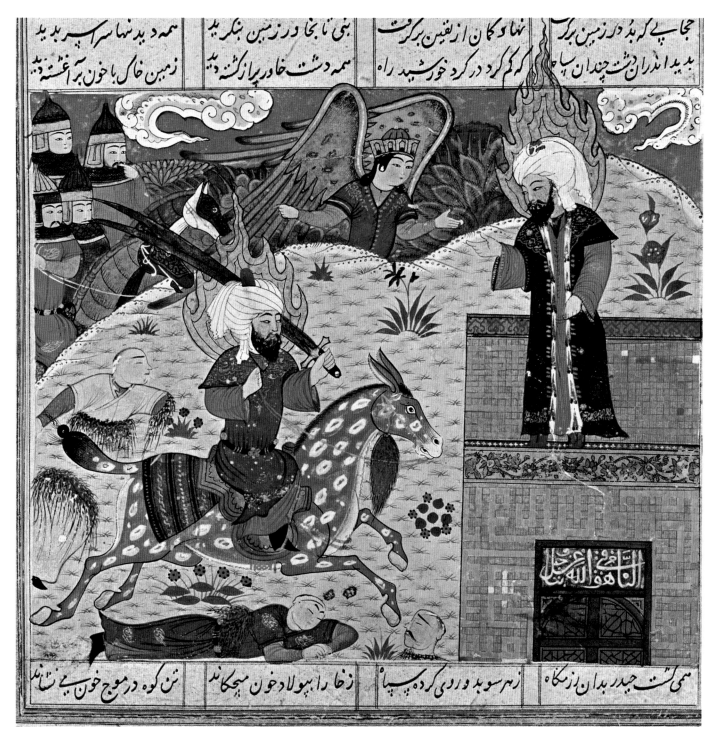

Khawar-nama of Ibn Husam: Gabriel shows the Prowess of Ali to the Prophet Muhammad. Shiraz, c. 1480. (8⅜×8⅝") Folio 112, Museum of Decorative Arts, Tehran.

This manuscript was broken up not long ago and many miniatures are now in collections in America and the Chester Beatty Library, but the greater part has found a permanent home in the Museum of Decorative Arts recently founded in Tehran by the

Iranian government. The colophon is unfortunately missing, but a few of the miniatures bear dates (between 1476 and 1487) and artists' names written very small in one corner, but these do not appear very convincing in spite of being plausible for the period of execution, which must be about 1480. They show what could be accomplished in this provincial centre by the use of bold colours to build up tapestry-like miniatures in which the principal figures stand out in epic splendour. It may be supposed that the circle for which it was produced was fervently Shi'a in sympathy and this is reflected in the fervid compositions. Clouds are quite unnaturalistic in colour as well as shape, gold and

Khawar-nama of Ibn Husam: Ali removes a Pillar placed by Solomon in a Cave and releases a Supply of Good Water. Shiraz, c. 1480. (6⅝×8¾″) Folio 211, Museum of Decorative Arts, Tehran.

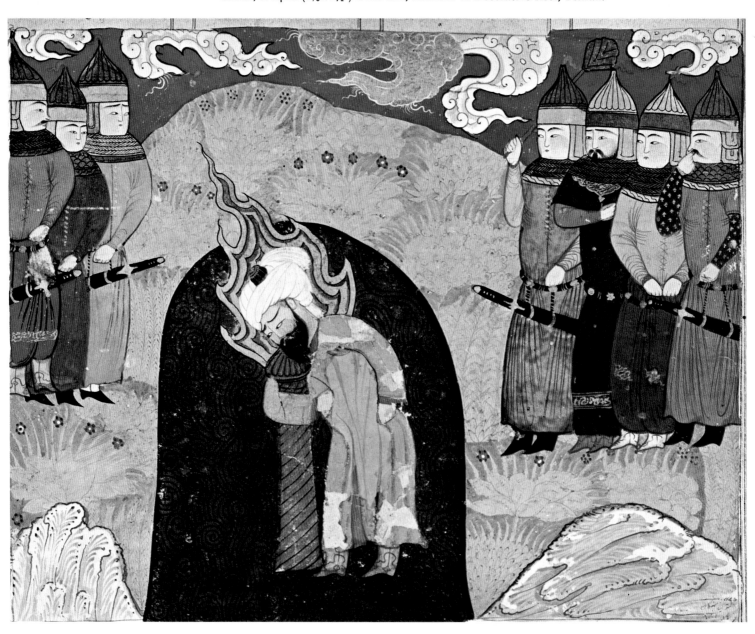

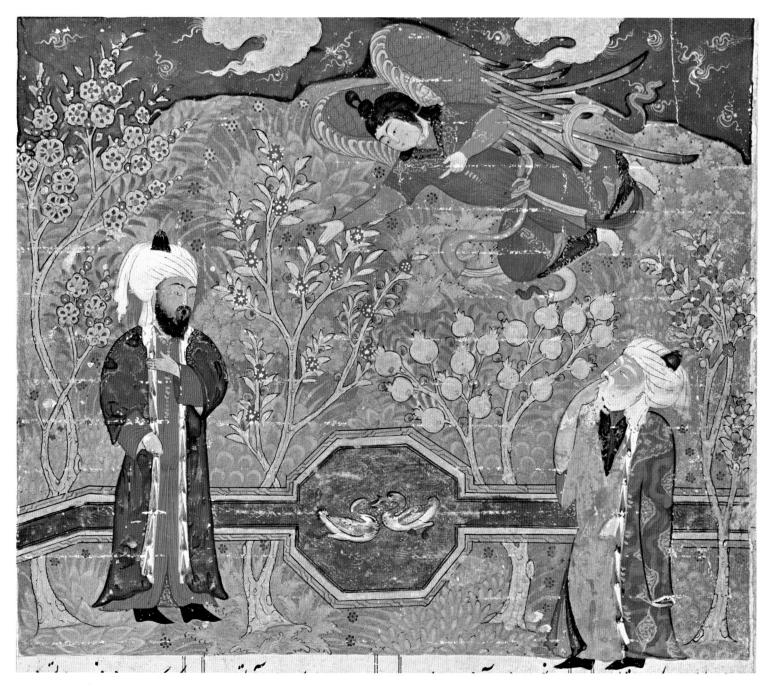

Khawar-nama of Ibn Husam: Gabriel announces the Apotheosis of Ali.
Shiraz, c. 1480. (7¼×8⅝″) Private Collection, U.S.A.

blue in a slate-blue sky, for instance; and the picture plane is as opaque as in a tapestry. Illustration page 107
In the garden scene illustrated the arrangement is purely formal and decorative. The
water-course is superimposed on the trees and the figures on top of all, but the resulting
scene is satisfactory as illustration as well as splendidly decorative. The danger of this
method comes where the problems set the painter have all been solved already and all

that he has to do is to copy some earlier miniature of the same subject. In the later fifteenth century *Shah-nama* manuscripts the figures are too often reduced to puppets playing a well-known part before a repeated conventional landscape. The miniature depends entirely on the subject for any charm that it may have, and instead of heightening the romance as it had done in earlier times, it reduces it to the level of the fairy story.

Of course not all late fifteenth century manuscripts illuminated at Shiraz were like this. Connected with the *Khawar-nama* miniatures by its conceptual character is a painting of magic quality, the *Rustam sleeping saved by his Horse Rakhsh from a Lion*, now in the British Museum. It shows pre-eminently the tapestry-like surface, and even the same unnaturalistic blue clouds on a gold ground. This is a page long ago separated from its manuscript, which may never have been completed, for it is unmarginated. There is a profusion and energy of natural life which go beyond any other Persian miniature, thus being the ideal example of the Sufi spirit.

6

AFTER the period of puritan domination, Herat was slow to recover the élan of its previous style. For the time of Abu Sa'id i Gurkan (1452-1468), there is nothing to bear witness except an *Anthology* of three love-poems now in the Chester Beatty Library, on which M. Minovi has found a faint dedication in his name. There are six miniatures of small size and simple composition in a style which preserves the externals of the Baysunghuri miniatures of the Sa'di of 1427, or the *Anthology* of the same year in the Berenson Collection; but they are comparatively lifeless. In 1468 he was succeeded by Sultan Husayn Bayqara, who was to rule from Herat for thirty-eight years, and make it once more a centre of letters and art. But ten years seem to have passed before there was any appreciable change in the quality of painting. A copy of the *History* of Tabari in the Chester Beatty Library, dated 1469, is illustrated by miniatures directly dependent on work of forty years earlier. A *Shah-nama* in the same collection, dated 1480, is no better in invention, but has a flatter look and is more mechanical. Even a *Bustan* of Sa'di which has been proposed as a juvenile work of the master Bihzad, and dated 1478, is inept in its handling of composition, although there is a feeling of spring in the air in the new way that the trees spread out in the margins.

With this period there begins to be more literary record of the names and careers of artists, from sources so nearly contemporary that they must be accepted as at least approximately true. But these names remain for the most part mere shadows without any authentic paintings to attach to them. These particulars do show however that the school of Herat proceeded without a break, the first master under Sultan Husayn being the son of the court artist of Abu Sa'id, Mansur. This painter, Shah Muzaffar, who was highly praised for his skill, died at the age of twenty-four, and no work by him is known today. Still better known was Master Mirak the painter, a Sayyid or descendant of the Prophet, who was also a monumental calligrapher and an illuminator, before becoming a miniature painter. He became chief of the library of Sultan Husayn and just survived his master's fall, dying soon after the seizure of Herat by the Uzbek, Shaibani Khan, in 1507. But his greatest claim to our attention is that he brought up the future master Bihzad, who had been left an orphan in childhood. He was presumably active from the beginning of the reign, but no attribution to him can be made of any work

earlier than 1485, in which year is dated a manuscript of the *Khamsa* of Amir Khusrau of Delhi in the Chester Beatty Library (P. 163), containing thirteen miniatures, which appear to be by a man of his generation, but to foreshadow in some respects the style of Bihzad. It is certainly a Herati manuscript and shows the direction in which the school there was moving by its disinterest in architectural perspective, compared with the placing of the figures in relations which are both psychological and significant in the whole composition. Although the figures are not particularly graceful, they form a harmonious pattern of an advanced complexity. This is one of the most striking characteristics of the accepted work of Bihzad, who adds his own innate sense of graceful gesture, and achieves thus a lively or moving harmony of unusual perfection.

By this date Bihzad would have been already from thirty to thirty-five years old, and if he had really been brought up from childhood by a painter and had himself the natural gifts with which he is universally credited, it is obvious that he must already have executed a considerable œuvre. But the earliest surviving work now attributed to him is of this period, one or two miniatures in a manuscript of the *Gulistan* of Sa'di in the Rothschild Collection in Paris, date 1486, and a double-page conversation piece in the *Gulistan* album in Tehran showing Sultan Husayn in his garden-harem, which actually bears a signature or at least a contemporary attribution in the field of the right leaf, and must date from about 1485, judging from the age of the principal figure. The *Gulistan* also contains a portrait which is recognizably the same person, in the guise of a prince watching a wrestling match, but inferior in vitality and drawing. The garden scene is daringly composed in the wide angle of the screen enclosing the harem, which ties the two halves together. A carpet in each part is the only other rectangle, and indeed the only other straight line; for the figures who dot the rest of the surface are seemingly carelessly arranged but actually form an *enchaînement*, made musical by the colour-play of the costumes, in which red is a dominant to the blues, greens and yellows.

Here we should pause to consider how Bihzad, while remaining within the idiom of imaginative composition developed by the Persian painters during the preceding century, found the means of strengthening the structural form of his miniatures, and thus of heightening the emotional tension; which is also underlined by a far more scientific use of colour than anything which is to be seen from earlier hands. For this purpose it is best to start with the *Bustan* of Sa'di with miniatures of 1488-1489 in the Egyptian Library in Cairo, a royal manuscript prepared for Sultan Husayn who is represented in the double frontispiece. This and the four other miniatures are almost universally admitted as the autograph works of Bihzad, and they are well preserved.

An examination of this frontispiece is instructive, in comparison with the conventional scene to be found at the beginning of so many manuscripts of the first half of the century. The prince had usually been shown seated among his courtiers with flowering trees beyond and often with a picnic meal being prepared on the opposite leaf. In spite of the informality which this lent to the scene, the picture retained a formal and grave character which had come down from the even earlier type of enthroned monarch to be seen in the Baghdad books and reflecting the hieratic sense of Sassanian prototypes.

Here in the *Bustan* Bihzad kept all the ingredients but has increased the naturalism by drawing the court as it might have been seen any day at Herat, with the prince holding a flower, a favourite page seated on his carpet, to whom an older man is whispering something, while on the opposite leaf, servants hurry in with fresh provisions and a drunken youth is helped out; a frequent event at this pleasure-loving ruler's entertainments. A touch of stronger action is given in the little scene in the corner in which a door-keeper vigorously raises his stick to drive away some importunate caller, who crouches half in and half out of the margin line. More than thirty figures are included in the two pages, in groups whose naturalism conceals the skill of the internal rhythms which tie the whole into an inevitable pattern, no detail in which could be altered without loss. The dignity of the prince is preserved by his placing a little apart, beneath a double canopy, a domed umbrella of imposing size under a square awning, which rises above the upper margin. On the facing page we find the conventional flowering trees beyond the red paling, which had been common for fifty years and more, but in addition a genre scene—the water carrier talking with an old woman by the cistern which is housed in a tower which also rises above the margin and is in perspective to the entrance tower in the foreground. Both the towers in the court are enriched with monumental inscriptions, a feature of which Bihzad was fond. This inscription formerly ended with the name of the artist but this has been effaced. There is no doubt that it is by Bihzad, like the others in this manuscript, and it is notable that he should have been able to sign his name so prominently. He·must therefore by this date already have become painter in chief to Sultan Husayn, though it was in the employ of his famous minister, Mir Ali Shir Nawa'i, that he first won fame. But his work at that time has not yet been identified.

Three of the other miniatures in the Cairo *Bustan* are exercises in architectural composition, two showing mosque interiors, and the third Pharaoh's palace, as setting for the attempted beguilement of Yusuf by Zulaikha. The mosque courts are seen strictly frontally, but the elevation is alleviated by recession indicated by planes introduced diagonally to the picture surface and ingeniously picked up by the text which is arranged in stepped diagonals also. The figures are once more placed with absolute assurance so as to enlarge the recession, while their psychological relation to one another is elegantly shown in their gestures. Bihzad was praised by the early Persian critics for his powers of draughtsmanship and composition, and these are the most obvious qualities of these pages. Pharaoh's palace is more daring in its use of similar devices to secure recession within a frontal view. This is not so much an elevation as an isometric perspective cross-section in which a staircase zigzags up three flights to the floor on which the action takes place in a room exposed to view by the removal of the front wall, but leaving half of the external inscriptional frieze, and showing an overhanging look-out balcony from which Zulaikha has just rushed into the house to detain Yusuf who is seeking to escape. Fifty years earlier, in the Baysunghur *Shah-nama* and in the Paris *Jami' al-Tawarikh*, elaborate architectural perspective had been attempted but, like the aerial views of the Ka'ba, these were no more than stage sets of cardboard thickness and not really related in scale to the figures.

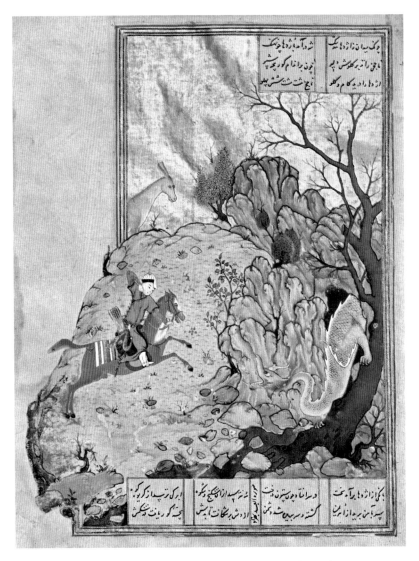

Khamsa of Nizami: Bahram Gur slaying the Dragon. Painted by Bihzad, Herat, c. 1493. (5⅛×3⁹/₁₆″)
Add. 25 900, folio 161, British Museum, London.

We have insisted at some length on the formal innovations of Bihzad, but this should not imply that he was outside the main tradition of Persian miniature painting; on the contrary he preserved the integrity of vision which was their unique heritage. His use of colour was thoroughly traditional, flat pure colours being juxtaposed, as they were in the West only in the mediaeval arts of enamel and stained glass. But the range and subtlety of the effects obtained far surpassed anything that could be done in them. Bihzad's favourite scheme shows a predominance of blues and greens with frequent areas of low-toned browns and earth yellows as a foil, and occasional touches of bright red, generally a vermilion. He seems to have preferred the old-fashioned gold sky, but without the conventional cloud-forms which had usually accompanied it in earlier paintings. Within a decade, however, he had developed a rather different palette.

There are two wonderful manuscripts of the *Khamsa* of Nizami in the British Museum, each containing some miniatures which are generally accepted as the work of Bihzad. The earlier of these are contained in an older manuscript originally copied in 1442, and only now illuminated with twelve additional miniatures, of which three bear signatures of Bihzad written small between the columns of the text. These little paintings (the page of this manuscript, Add. 25 900, measures only 7½ by 4¾ in.) can be assigned to the year 1493, in accordance with a date on one of the miniatures. The most famous of them shows the *Battle of the Clans of Laila and Majnun* watched from behind a neighbouring hill by the distracted Majnun. It is to be compared with the fifth miniature in the 1488 *Bustan*, in which King Dara rides into the pastures where his steward is keeping the herd of horses of the king, who fails to recognize him, and is scolded for it by the brave servant. Here the pastoral scene demands quiet rhythms and light coats of the horses against the deep green or pink of the hillside; whereas in the fight the camels are seen in excited action, sharply silhouetted against the desert sand, which is nearly white. The colouring of both camels and the clothes of their riders is more subtly varied than in the earlier book, there being three different greens, three blues and three purples in the dresses; and every shade from chestnut to near white in the hides of the camels. The internal rhythms of the camel fight have an almost hypnotic effect, so enticing to the eye are the reciprocal movements of arms and weapons. The composition here is circular while in the second battle in the same book it is horizontal. Here there are a much larger number of horsemen engaged with a couple only of drum-bearing camels; the movement is almost wholly from right to left. It is interesting to compare it with the battle mêlée of fifty years earlier in the *Shah-nama* of Muhammad Juki. There the two armies are Illustration page 89 ranged to right and left, and joined in the centre in reciprocal action. Here on the contrary we see one side pursuing the other who are offering vain resistance and falling from their horses, mortally wounded. The composition is more open, thus allowing the attitudes of men and horses to be more effectively seen. One would say that there was greater realism, but the illusion of an army fighting is achieved by only five actual combats, skilfully varied. One is aware of seeing only part of a greater action, which is cut off by the margin edge. If there is not here the emotional tension of the last miniature, at least there is plenty of room for the imagination to work. The integrity of vision is again preserved and there is no playing up to the spectator as in so many Western battle pictures. This is not the epic drama of the earlier periods, but it is romantic still.

The third miniature is the most romantic of the three; it represents the feat of Illustration page 112 Bahram Gur in slaying a dragon. The composition is not much changed from the illustration of the same subject in the 1411 *Anthology* of the British Museum, but the change is significant, if not vital. Instead of bringing down his sword on the dragon's head, Bahram shoots an arrow from a distance while his horse rears in fright. The landscape is wilder, and the dragon poised to spring crouches against the tree, no easy victim. Behind on the horizon instead of two casual spectators there is only a wild ass, which certainly intensifies the solitary feat of the king. The varied hues in the purple rocks are shaded naturalistically, and the scene is intensely felt. It happens that the subject is treated

once more by Bihzad in the other Nizami manuscript in the British Museum (Or. 6810), which is dated 1494. Here there has been a further change; although at first sight the composition looks so similar. The miniatures in this manuscript are for the most part notable for their rationalism and even their realism, compared with anything which went before. Of the twenty-one miniatures which it contains, sixteen were attributed by the Mughal emperor Jahangir to the hand of Bihzad, and his name has been written beside fourteen of them, but at a late date. It is therefore only on style that it is possible to attribute any of them to the master. Critical opinion has differed, but several miniatures are now generally accepted as his work, while a further number are close to him and presumably the work of his pupils. The Bahram Gur is a subject less suited to realistic treatment than most, but, by introducing the girl who played the harp to him on his hunting expeditions, the artist has reduced the combat to just that level; and the dragon has become no more than a target for the king's arrow. Characteristic of this manuscript is the low tone of this page, and this is repeated in two unusual pictures in it which are also almost certainly by Bihzad; the *Turkish Bath visited by the Caliph Ma'mun*, and the *Construction of the Castle of Khawarnaq*. Both are genre scenes, and full of movement; there is little imaginative content, and the interest of the compositions is largely formal. For all the activity of the numerous figures, it is the hanging blue towels in the first, and the ladder and scaffolding in the second, which are the keys to the curiously square pictures. For all their apparent realism these pages are as near abstract flat pattern as anything in Persian painting.

Illustration page 117
Illustration page 116

Again, as in the three miniatures of the Add. 25 900, the figures are so arranged that there is plenty of space for the internal rhythms in the comparatively open composition. Bihzad shows his genius for characterization in the way that he has invented here so many poses and groupings that were to become the stock-in-trade of the Persian school during almost a hundred years. In the construction scene most of the figures form pairs in reciprocal action, thus producing a dynamic pattern of movement which is all contained within the margins and thus built up into a complex of intense energy. Whereas in the bath scene the movement is slower, but again built up into a closely knit internal rhythm, the more modern in pattern because of the unusual shape of the picture space. The doorway placed in the margin on the right leads the eye inside at this point, where it is at once carried up to the hanging towels by the diagonal line of the pole held by the attendant just inside the door. The clothes-line then directs attention downwards to the left towards the principal figure of the Caliph, whose head is being shaved by a barber in the inner bath chamber. In front of him two boys carrying water buckets form a strong, nearly symmetrical unit; while in the outer room on the right the positions of the figures are equally calculated to make a reciprocity of movement. In these compositions the silhouettes of the figures and especially the gestures of the arms, generally clear of the body, present a striking contrast with the usual practice during the earlier part of the Timurid period, when the arms were generally held close to the body so that the outline of the whole figure was compact, and the emphasis was on the elegant line of the silhouette.

It must now be mentioned that this is one of several miniatures in this manuscript which bear the name of Mirak, written very small in the margins, as well as that of Bihzad written on a rather larger scale in this case but not in all; but these are not signatures. Controversy has raged over the weight to be attached to these attributions, which naturally depends upon the date at which they were supplied. Even if it is accepted that they were already there in the time when the manuscript was in the Mughal library and the Emperor Jahangir noted attributions to both Bihzad and Mirak, that would not give these attributions great authority, more than one hundred years after they were painted. The situation is further complicated by the fact that another artist's name, that of Qasim Ali, is found written between the text on four of the pages. All three artists, as well as Abd'ul Razzaq, whose name occurs on one page in the margin, are known from independent texts to have flourished about this time at Herat. The best known was Mirak, who is indeed said by Qadi Ahmad to have been the librarian of Sultan Husayn Mirza, and to have acted as foster father to Bihzad, when he was left an orphan. He was thus of an older generation than Bihzad, and therefore not likely to be associated with the stylistic changes which we have seen to be the feature of a group of miniatures in this manuscript. If he had indeed any share in it, it is to be seen in the more old-fashioned pages which are certainly by a different hand. Moreover the manuscript was not produced for his royal patron, but for a certain Mirza Ali Farsi Barlas, who has been identified with one of Sultan Husayn's Amirs mentioned by Babur in his Memoirs as a judge of poetry, gay-hearted and elegant.

In fact the miniature on which this dedication occurs is one of the more old-fashioned, which would certainly not be attributed to Bihzad. The date of 900 (1494 A.D.) is found on another page, where it is likewise introduced into the architecture, and is therefore hardly likely to be a later addition. The subject of this page is Iskandar in session with the Seven Sages, and this subject is attributed to Bihzad by Stchoukine and Pinder-Wilson. The former considers that this date belongs only to the later miniatures and not to the manuscript, which is not otherwise dated but which he believes to have been illustrated over a considerable period. Obviously this is a possibility which should be allowed for, but it seems an unnecessary complication to introduce, when the stylistic differences can be explained quite well by the presence of the work of artists of different generations working side by side. On these grounds alone, this miniature seems rather to be connected with some miniatures illustrating a manuscript of the *Khamsa* of Mir Ali Illustration page 119 Shir Nawa'i's Persian poems, now divided between the Bodleian Library and the John Rylands Library at Manchester. The date is 1485, and the book was prepared for Badi' al-Zaman, the son of Sultan Husayn. It is therefore likely to have been illustrated by some of the leading painters of the day. Stchoukine and Robinson think that they can see the hand of Bihzad in one or two of them. These are the first and last in the whole book, as it once was, which were both reproduced in colour by Sir Thomas Arnold thirty years ago. Both subjects are religious discussions, one in a mosque and the other in the open air, under a moon-lit night sky; and both therefore do not lend themselves to the energetic movement which we have seen to be a characteristic of Bihzad's work in the Illustrations pages 116-117

Khamsa of Nizami: Construction of the Castle of Khawarnaq. Painted by Bihzad, Herat, 1494. (7×5¼″)
Or. 6810, folio 154 verso, British Museum, London.

Khamsa of Nizami: Turkish Bath visited by the Caliph Ma'mun. Painted by Bihzad, Herat, 1494. (7×6")
Or. 6810, folio 27 verso, British Museum, London.

British Museum Nizami of 1494. They may more fairly be compared with the miniatures in the Cairo *Bustan* of Sa'di of 1488, to which they are also nearer in date. But there is no sign in either of them of the interest in opening up the composition which we have seen to be characteristic of these paintings, by either zigzagging the text, or by making a coulisse in the back wall, which in the Nawa'i closes the mosque scene with a straight façade, while the landscape of the other page has a unified hillside for background, in the conventional gold which is found with the deep blue of the night sky. For this reason it seems that these two miniatures of the Nawa'i, as well as the remaining eleven illustrations to these poems, belong to an earlier group of artists still uninfluenced by Bihzad, whose style in any case was not fully formed by this date. The last miniature carries a "signature" of Qasim Ali written in red between the columns, but this can hardly be accepted, as the late J. V. S. Wilkinson thought, since this artist was a pupil of Bihzad's. His name has also been written in the similar position on four pages of British Museum Or. 6810, apparently after the time of Jahangir, and therefore presumably in India. But the Nawa'i *Khamsa* was acquired by its former owner Sir Gore Ouseley during his embassy in Persia between 1810 and 1812. If the attributions were not made at the same time on these two manuscripts, it is difficult to see where and when this can have been. This is an enigma which is best ignored for the present until the surviving material is more fully published. The *Iskandar and the Seven Sages* of the Nizami of 1494 has some connexion with the Nawa'i of 1485, especially in the drawing of the seated figures, but it shows some sign of Bihzad's influence, in the daring articulation of the wall in the background, an upper window in which is cantilevered forward over the doorway, and at the same time this whole face of the building is at an angle with the right part, thus intending to indicate the corner of a tower. It must be admitted that this architecture is even less lucid in conception than usual. Another sign of the new freedom of composition is to be seen in the figures in the foreground outside the discussion circle and therefore freer in movement. It is here that one might perhaps see the possibility of recognizing the hand of Bihzad himself. Whether at this time artists were accustomed to collaborate in a single composition is unknown, but it would conform with later practice if they did and must be borne in mind as a possibility.

In attributing the miniatures in the Nawa'i of 1485 to an earlier group, there was no intention to belittle their particular charm. The author was the centre of literary and artistic life in Herat, the first patron of Bihzad and also of another painter, Shah Muzaffar. Moreover, in addition to being a royal manuscript, this is a very early copy of the *Khamsa*, completed in the year that the fifth poem was finished. It is therefore likely that its author may have had a hand in its illustration, so that, if we cannot recognize the work of Bihzad in it, there might be a case for attributing the best miniatures to Shah Muzaffar, but for the record already mentioned that he died at the age of twenty-four, and had been the son of the master Mansur, a painter at the court of Abu Sa'id, so that his death probably occurred in about 1480, twelve years after the death of Abu Sa'id, and when Ali Shir was forty; but he may have survived a further five years or so. The most original miniature in the *Khamsa* represents the great poet

and mystical writer Iraqi (d. 1289). Shaykh Iraqi is shown as a thin old man who has Illustration page 119 fallen on his knees overcome with emotion at parting from a friend as he starts on a journey. Since love was the theme of all his writing and he saw, like all Persian mystics, the ties of human love as the mirror of the search for the divine in which the soul is constantly involved, this subject would be naturally a favourite in any circle where Sufism was rife. The composition differs fundamentally from what we have seen to be

Khamsa of Mir Ali Shir Nawa'i: Shaykh Iraqi overcome with Emotion at parting from a Friend. Attributed to Shah Muzaffar, Herat, 1485. (5½×4⅛″) Elliot 287, folio 34, Bodleian Library, Oxford.

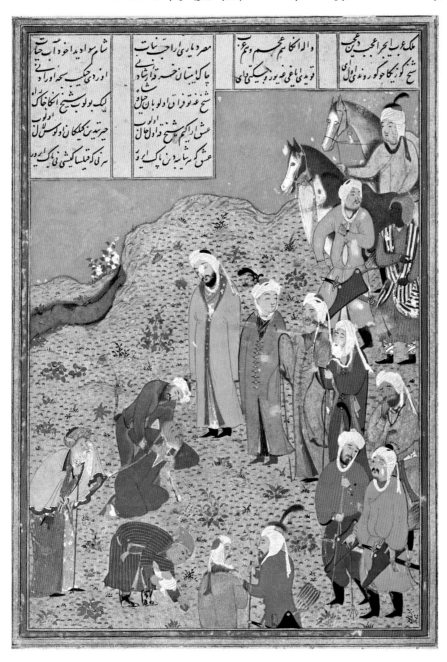

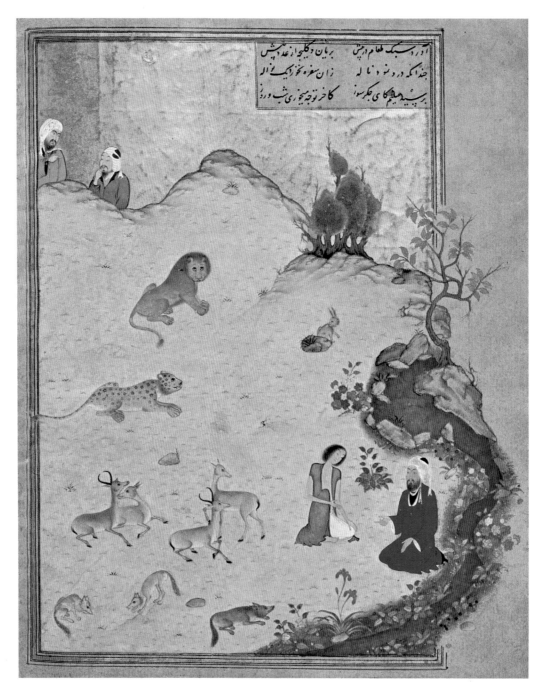

Khamsa of Nizami: Salim visiting Majnun in the Desert. Painted by a pupil of Bihzad, Herat, 1494. (6¾×5¼″)
Or. 6810, folio 128 verso, British Museum, London.

Bihzad's general practice, for instead of a formal pattern based on internal rhythms, here we see a double triangle based on the two sides of the miniature, and touching in the centre: but with more weight on the right, so that the triangle on the left which includes the figure of the Shaykh is incomplete, having its upper side missing. The effect is to emphasize the three crouching figures on this side as against the erect figures grouped

opposite. The pattern is not emphasized by open gestures in the way that Bihzad liked, but by the subtlest indications of sympathy among the bystanders, who turn very slightly towards each other. This might be thought to correspond with what we learn from Muhammad Haydar Dughlat about Shah Muzaffar, that he was "a master of group pictures."

As in the night scene of *Mystics in a Garden*, the background of the *Shaykh Iraqi* Illustration page 119 *parting from a Friend* consists of a golden hillside, cut by a conventional stream and dotted with plants in old-fashioned taste. This is however suited to the emotionally charged subject of the foreground, and in effect different from anything else in the volumes. One may well regret that it cannot be paralleled.

Of the two miniatures illustrating the *Laila and Majnun*, which is the portion of the work now in the Rylands Library, first published in 1954 by B. W. Robinson, that depicting the visit of Salim to Majnun in the desert, where he lived among the wild animals on terms of friendship, is the more interesting. The space is well contrived, but too many trees are introduced to suit the desert scene, and the figures, though formally related, lack psychological interest. The version of this subject in the Nizami of 1494 Illustration page 120 much better shows the growing sympathy between the two men, so different in appearance, and the affection of the deer for Majnun. Robinson has suggested that the artist who drew this must have had before him the earlier version, because he has borrowed the curve of the stream which encloses the seated figures. If so he has altered the character of the setting by omitting all the vegetation except that immediately by the stream, and so made it a true desert oasis. The space has been opened up in a Bihzadian way, but the two surprised onlookers behind the background hill do not seem in keeping with his tightly interlocked composing, and it seems more likely this may be the work of a pupil or assistant. The same hand may be responsible for the other miniature of Majnun in the desert, in which he lies in distraction among the beasts, while in the background Laila sits in her tent inaccessible to him. It is a fine open composition, but rather spoilt by the gaucherie of some of the figures, and especially by the introduction of two similar spectators among the rocks.

It is impossible to discuss all the miniatures in this famous manuscript but one other calls for special mention, the *Mourning for the Death of Laila's Husband*. It is Illustration page 122 remarkable for the natural and even free movement of the mourners, and for the low tone of their clothes, and it may well be called an advanced painting, which it would be hard to parallel. Stchoukine has pointed out some similarities with the figures in the 1488 *Bustan*, which clearly indicate the relation to Bihzad, but these are not ordinary borrowings, for the figures are arranged in a different kind of pattern, more closely linked than anything in that manuscript. It seems that this may be the early work of one of Bihzad's ablest pupils, possibly Shaykh Zadeh, who achieves a similar expression of strong emotion in his only signed work, the moving *Sermon* of the Hafiz of 1533, which will be fully discussed in the next chapter.

Closely connected with Bihzad are the six pairs of miniatures on opposing pages which illustrate a manuscript of the life of Timur, the *Zafar-nama* by Sharaf al-Din

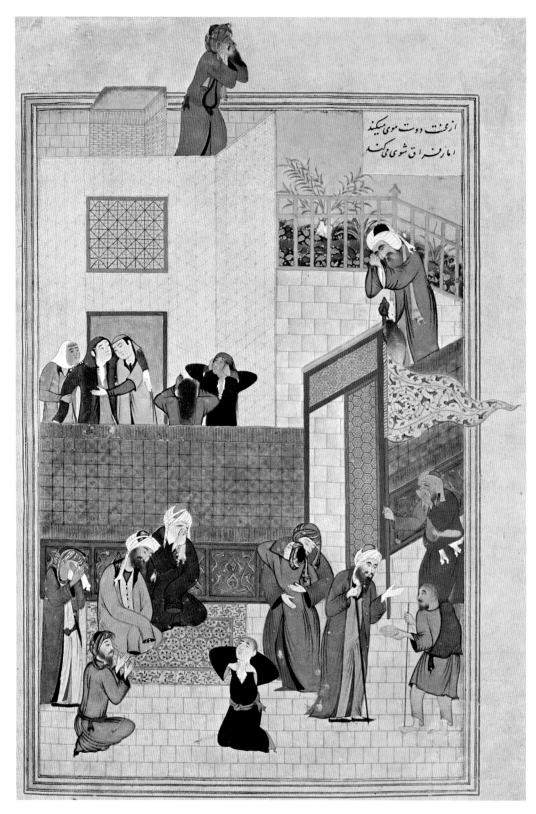

از محنت دوست موی میکند
اما رفاق شوی می کند

Khamsa of Nizami: Mourning for the Death of Laila's Husband. Painted by Bihzad or his pupil Shaykh Zadeh, Herat, 1494. (8⅜×6″) Or. 6810, folio 135 verso, British Museum, London.

Khamsa of Nizami: Laila and Majnun at School. Painted by Bihzad, Herat, 1494. (8⅝×5½″)
Or. 6810, folio 106 verso, British Museum, London.

Ali Yazdi, copied by Shir Ali, a well-known calligrapher, in 1467 for the library of Sultan Husayn, and subsequently for a long period in the Imperial Mughal library. Certainly by the beginning of the reign, in 1605, of Jahangir, and probably already in that of his father, Akbar the Great, these paintings were believed to be the work of Bihzad, and apparently accepted as being of the same period as the date in the colophon. The miniatures are however more advanced in style than is possible at that early date, as has been generally recognized; and as Stchoukine has pointed out, they contain figures and groups which clearly derive from some of the most securely given to Bihzad of all the work which we have been considering.

The question how much later than the manuscript these illustrations should be considered to be, is limited by the fact that the Conqueror is represented in more than one of them in the guise of his descendant Sultan Husayn, and they must have been painted before his death in 1506.

The proportions of these double-page compositions are thus unlike those of the normal Persian miniature; and these allow or demand a more complex scheme. Instead of the circular rhythm which is favoured in the earlier work of Bihzad, here diagonals are emphasized; ropes, lances, trumpets, rafts, drawbridges or planks are all turned to this good use. Foreshortened horses had been found before, but they now become more frequent, and there is a notable preference for a kneeling pose. A sense of movement is even stronger in these pages but the open placing of the figures as silhouettes is much less marked, and has given place to complex overlapping, especially in the several battle scenes. The colouring is on the whole not so pure or well-chosen, and the best hypothesis at present seems to be to suppose that Bihzad made the designs but that they were afterwards worked up by his pupils, who were responsible for most of the colouring. The compositions remain closely knit and have little of the diffusion which became marked in the sixteenth century Safavi school.

It is clear from the two Nizami manuscripts in the British Museum of 1493 and 1494, that already by this time Bihzad had pupils able to imitate his style fairly closely, and there are a number of miniatures known which approach him but which do not carry conviction as autograph work. Less forward-looking are the copies after Bihzad's work, of which there are a number of varying quality. Some of the more deceptive are to be seen in two manuscripts in Leningrad, a Nizami of 1481, copied by Darvish Muhammad Taqi (State Library, No. 338) and an Amir Khusrau copied by Sultan Muhammad al-Harawi as well as two separate miniatures in an album in the same collection. The first and last of these are by pupils, the second probably an early sixteenth century copy. Other designs are preserved in the manuscripts of the Bukhara school which was supported by the Uzbek rulers of the house of Shaibani, who captured Herat from the son of Sultan Husayn in 1507, and were in this sense the heirs of the last of the Timurids. This school must be discussed in a later chapter. There is another type of painting and drawing which is found frequently attributed to Bihzad and sometimes in an early-looking calligraphic inscription. These are the portraits of rulers like Sultan Husayn and Shaibani Khan or of prisoners with their right arm in the cagne used by the Mongols

to incapacitate their prisoners without preventing them from riding and keeping up with a moving horde. Some of these drawings are of fine quality and coloured with a sense of decorative values. Some look like figures from the manuscripts enlarged and isolated, and have plain clothes of unpatterned stuffs: others have elaborately decorated collars in floral arabesques or all-over small repeat designs of ducks or flower sprays. Stchoukine has rejected all these portraits completely from Bihzad's work and attributed them to a much later date. But we do know that portraits were being made before the end of the fifteenth century at least in Istanbul, which was visited by several Italian painters at the invitation of the Sultan, Mehmet the Conqueror, including Gentile Bellini and Costanzo da Ferrara, who were at the court in 1479-1481. The only earlier portraits known in Persia are the historical ones which were introduced into the Mongol historical works of the Il-Khanid period but these were not imitated. It may well be that the fashion for miniature portraits spread to Persia from Venice, either directly or via Turkey. A copy of the portrait of a prince drawing, in the Gardner Museum, Boston, is extremely delicate and skilful, but it has nothing in common with the known work of Bihzad in the manuscripts, and it is more natural to think that this is actually by some Persian or Turkish pupil of Bellini working at Istanbul.

The Safavi School under Shah Tahmasp

7

S HAH ISMA'IL, the first Safavi Shah, destroyed the power of the Uzbeks in Khurasan in 1510, but this proved only a temporary check to their capacity for nuisance to his House. His barbarous treatment of the corpse of his enemy Shaibani Khan whose skull he had mounted to serve as his drinking cup, illustrates one side of his character. Another is described by the Italian merchant who saw him when he was thirty-one, and called him "as amiable as a girl," and "as lively as a fawn." All agree in praising his courage, and he must have possessed great personal charm; but he was so continuously occupied with war that it is not surprising that there is little which can be attributed to his library atelier, to the control and direction of which Bihzad was appointed in the year 1522. Since he is said to have found Sultan Muhammad already engaged in teaching the Shah's son, Tahmasp, drawing when he arrived in the royal library, it is not likely that this can have been before about 1521, in which year the prince was seven years old. Presumably he must have stayed quietly meanwhile in his native Herat during the eleven years after the death of Shaibani. We know nothing of his activity at this time, but those who believe him to have executed a considerable number of separate figure-drawings would be inclined to attribute them to this period of unemployment, when he would have been free to accept private commissions. It would appear that his reputation remained at the highest at the end of the period, so that he must be presumed to have continued to produce fine work.

When the new reign of Shah Tahmasp opened in 1524, the influence of Bihzad was still decisive at Tabriz, as may be seen from the Nizami of 1525 in the Metropolitan Museum, in which the first thirteen miniatures continue the old tradition of Herat. The date occurs on the tenth of these miniatures, and the fourteenth and last may be an addition of a few years later.

The *Khusrau seeing Shirin bathing* and *Shirin on Horseback watching the Labours of Farhad* are obviously still in the Herat style, but the figure-drawing in these and the other old-fashioned miniatures has become much stiffer than at the end of the previous century, and it cannot be suggested that any of these could be by Bihzad himself. Nevertheless the connection with him is close, as can be seen by comparing the battle scene of Iskandar against Dara with the miniature in the British Museum Nizami manuscript

Illustration page 128

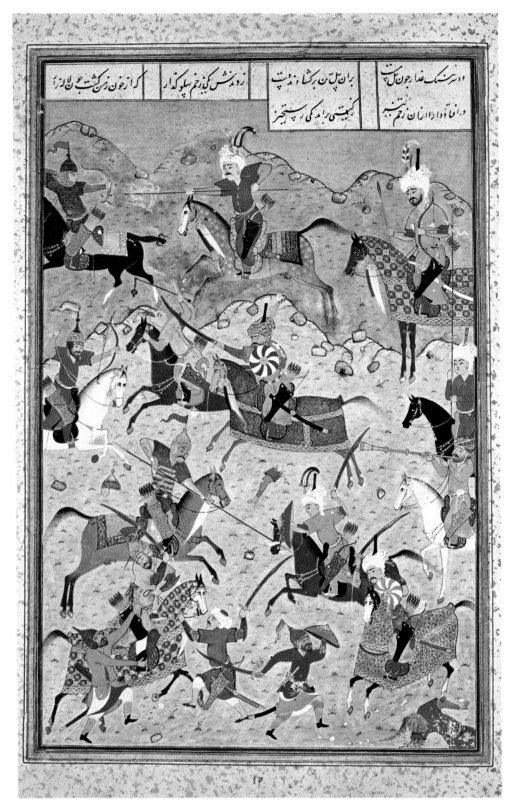

Khamsa of Nizami: Battle between Iskandar and Dara. Tabriz, 1525. (12¾×8¾″) Jackson & Yohannan 8, folio 279, Courtesy of The Metropolitan Museum of Art, New York. Gift of Alexander Smith Cochran, 1913.

of 1442 (Add. 25 900), which has been accepted as the work of Bihzad of about 1493. Illustration page 112 The foreground group of figures and horses is exactly repeated from this miniature; but instead of the curved line of the advancing army which is so effective in this composition, here there is nothing but three static horsemen, while a bowman on the left, entering the picture at this point, quite spoils the effect of the strong movement in the other direction of the two central fighting pairs. This manuscript may be praised for the mastery of its well-preserved colours, but it is dead in feeling. Consequently it is hard to accept the attribution to the hand of Shaykh Zadeh which has been proposed by Kuehnel and Stchoukine for these thirteen miniatures. For the only fully authenticated miniature by his hand is the vivid and even vivacious miniature of the moving *Sermon*; one of the three signed miniatures in the Hafiz, formerly in the Cartier Collection and now divided between the Fogg Art Museum, Cambridge, and the Cary Welch Collection. The illustrations to this book show a greater mastery of composition, with extremely subtle relations between the figures, both spatially and psychologically. Shaykh Zadeh, in particular, was not afraid to show faces in profile (there are five in this preaching scene), nor figures from behind; but every figure has personality and each contributes something to the effect of religious exaltation or absorption which the artist has sought to convey. There is nothing of this kind in the Nizami of 1525, where the treatment is relaxed and decorative, even in a scene like the meeting of Farhad and Shirin at the conduit which he has built for her, where a certain romantic heightening of the situation would have been appropriate.

So too with the miniatures of the *Diwan* of Mir Ali Shir in the Bibliothèque Nationale, dated 1526, four of which are also attributed to Shaykh Zadeh by Stchoukine. These are indeed much more lively, at least the *Battle Scene of Iskandar and Dara* and *Iskandar shooting Duck from a Boat*, but they have a decorative or formal beauty of quite another kind, with a minimum of indication of depth in the tapestry-like filling of the space. Both are of the new period which had now opened in their preference for light colours and rhythmic movement. The lyrical note so strong in this manuscript has superseded the dramatic which had been the main tradition of the Timurid school, even while Bihzad had emphasized the formal qualities of design. The science with which he had shown figures could be placed was not lost, but the tension of the design was now reduced, and there is no longer a tight internal rhythm. Instead there is a flow of line which can be called musical in its passage from one figure to another, a succession of notes which set up a harmony which the eye enjoys as it passes to and fro over the composition. The hunting scene of *Bahram and his Court* is an admirable example of this felicitous composing. Every scene in this manuscript has its spectator, even the *Bahram Gur in the Pavilion of the Princess of the Black Hall*.

The greatest novelty is the illustration of the voyage of Iskandar in the Western Illustration page 131 ocean. The world conqueror is seen absorbed in duck shooting, drawing his bow with a fine gesture of accomplished skill, as the arrow pierces the duck in flight. He is enthroned in a boat that is hardly large enough to contain his dais with its canopy, and which has no apparent means of propulsion or steering. In the foreground are two other boats,

filled with his soldiers, one with a long paddle to propel it; the other with a large square sail. These soldiers are more concerned with the marvels of this new world than with their king's doings and their attitudes suggest astonished wonder, which would come naturally to a Persian at Tabriz who had probably never seen the sea. The value of the composition lies in the gentle rhythm of the high-prowed ships against the dark oxidized silver of the water; and the restrained movements of the men in their crowded places. Again the note is lyrical, conveying a sense of enchantment, as of men contemplating a strange new world for the first time.

A manuscript with many miniatures in a relaxed but accomplished style, copied by the same scribe as the Nizami of 1525 in the Metropolitan, is the *Zafar-nama* describing the victories of Timur, in the Gulistan Library, Tehran, dated 1529. The colouring is in the same cool range, with low-toned blues and yellows predominating, as in the last miniature in that book, but the figures are on a much smaller scale, while the landscape

Illustration page 133

encircles the compositions with a softly contoured piling up of rounded rocks that was to be characteristic of the style of Tahmasp's capital. Here the decorative value of architecture and of various forms of outdoor canopy is exploited to the full; the guide-ropes

Illustration page 132

of the tents making an amusing pattern of white lines in the foreground of the picture. But the most distinctive feature of Safavi painting in this phase is to be found in the elegant posing of the figures, whether sitting or standing, generally inclined out of deference, partiality or confidence towards one another; the angle of the head being the more marked on account of the tall Safavi head-dress, with the twelve-fold coil of the turban cloth, in memory of the twelve Shi'a Imams, wrapped around the red cap with its spike that gave the Sufi followers of the house of Shaykh Safi' the name of Qizilbash. Another feature of the miniatures of this manuscript and one which was to recur during the next thirty years, was the preference for architecture formed of hexagons or parts of hexagons; and another the introduction of a curious cloud convention, the tightly curled snail-like form which seems to be based on a Chinese decorative motif. But this last is only an occasional variant.

Undoubtedly the masterpieces of this early Safavi school are the five miniatures of the Hafiz of Sam Mirza. This prince, a younger son of Shah Isma'il, was born in 1517 and was to be a notable patron of the arts until his imprisonment by Tahmasp in 1561. This volume belongs to his early years, the date being fixed by Stchoukine as about 1533 in accordance with the appearance of the enthroned prince beneath an arch on which his name and titles appear, which he takes to be a portrait of the patron of the book. This miniature also carries a signature of the painter Sultan Muhammad, who was at this time the leading painter at the Safavi court at Tabriz, according to his contemporary Dust Muhammad, who praises him for his skill in minute detail such as the spots in a leopard's coat. This court scene is remarkable for much besides the skilled brushwork. Around the prince's throne in a spiral curve are seated the courtiers, whose turbaned heads incline in different directions like flowers in a breeze, which seems to ruffle their charming variety. Indeed in the background they merge with a rose hedge; and the flower motif is picked up again by the floral carpet which covers the whole of the court.

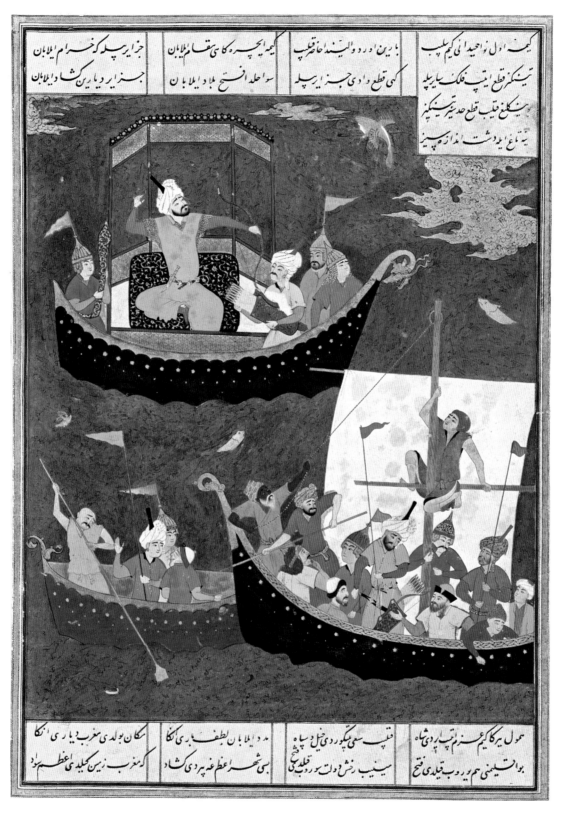

Diwan of Mir Ali Shir Nawa'i: Iskandar shooting Duck from a Boat. Tabriz, 1526. (15×10⅜″)
Sup. Turc 316, folio 447 verso, Bibliothèque Nationale, Paris.

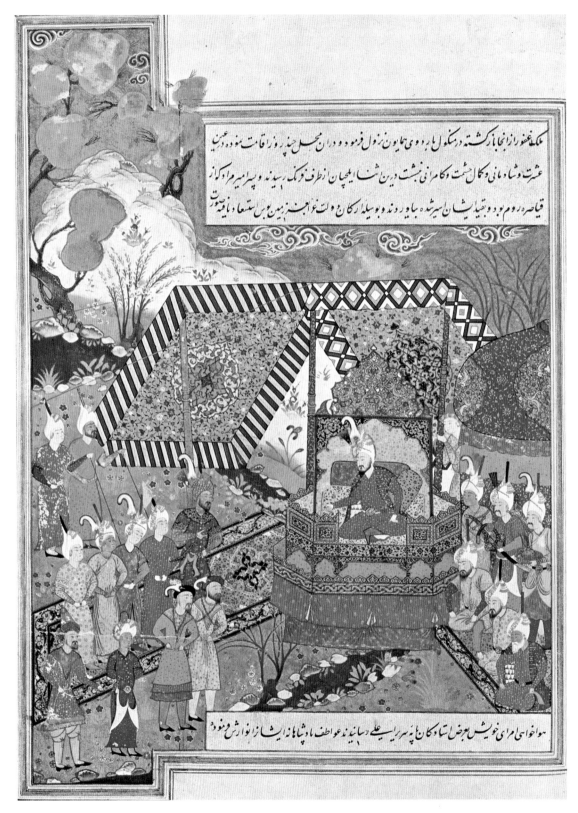

Zafar-nama (Life of Timur) of Sharaf al-Din Ali Yazdi: The European Envoys present the Son of the Ottoman Sultan Murad I. Tabriz, 1529. (11×7⅞″) Folio 520, Gulistan Palace Library, Tehran.

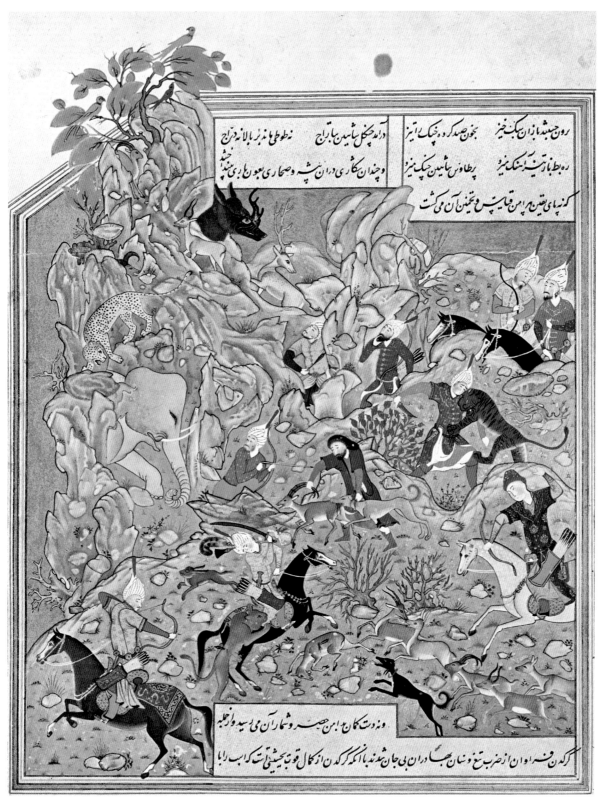

Zafar-nama (Life of Timur) of Sharaf al-Din Ali Yazdi: Hunting Scene. Tabriz, 1529. (10⅛×8″)
Folio 484, Gulistan Palace Library, Tehran.

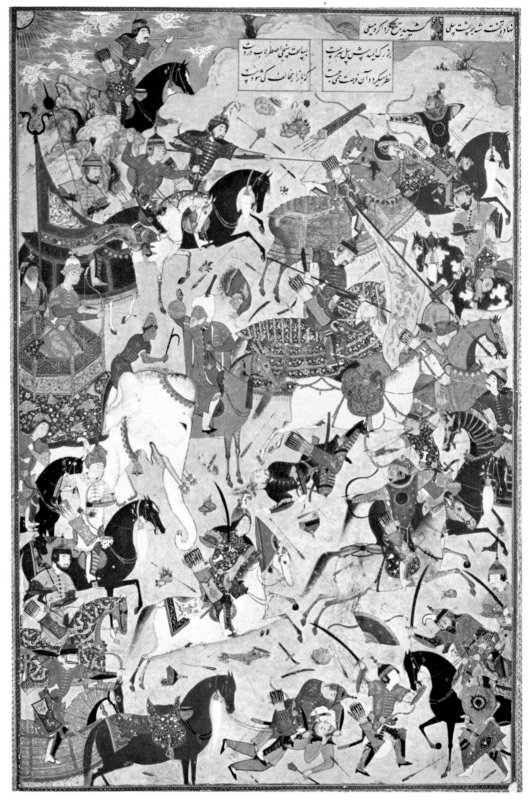

Khusrau and Shirin of Nizami: Battle between Bahram Chubina and Khusrau Parwiz, c. 1540. (15¾×10¼")
Detached page, Royal Scottish Museum, Edinburgh.

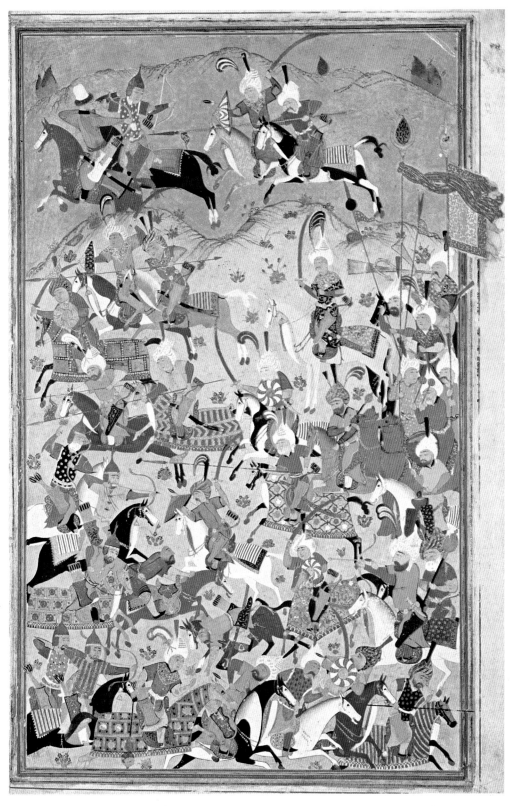

Battle Scene. Attributed to Mahmud Musavvir, c. 1530. ($12^{11}/_{16} \times 8^{1}/_{8}"$)
No. 54.4, Courtesy of the Smithsonian Institution, Freer Gallery of Art, Washington, D.C.

Illustration page 137

A group of four musicians on the left are expressively handled, and the party on the roof are perhaps pointing to the rising moon in the cool clear sky. The whole is poetically felt, a true lyrical work. A second portrait of Sam Mirza may be seen in a page of very different character depicting a prince seated with a girl on a carpet set in a flowering garden, where they are entertained by musicians and dancers, and enjoy a cup of wine poured for them by a page. They are shaded by an exceedingly elegant canopy, and are in a sentimental mood. The *clou* to the picture lies however in the pair of girls who sway towards one another as they work their castanets, silhouetted against the dark green grass. At first sight the composition is deceptively simple, and the flowering trees resemble those of a hundred years earlier. But every figure and plant is carefully placed, so as to build up a *fête champêtre* as rhythmical as the other more crowded scenes in this manuscript; while the simple conventions for hillside and clouds close this enchanted vision more suitably than a more naturalistic view could have done. This page seems not to be by the same hand as the signed miniature by Sultan Muhammad, nor as the other miniatures of this book.

Two of the other miniatures carry signatures, which have generally been accepted as genuine, and with good reason. The first is a scene of drinking and abandoned dancing, with the signature of Sultan Muhammad enclosed in an arabesque panel in the wall of the background pavilion, on the roof of which winged Peri are exchanging drinks with one another. This should be sufficient indication of the allegorical meaning of the scene, quite apart from the poems which it illustrates and from the fact that three of the musicians are dervishes in skins with shaven heads; no doubt the dance is one of intoxication with more than wine. In the background a bearded man reclines reading a volume which by its shape must be poetical.

There remains the last miniature to be discussed, the *Sermon in a Mosque*, which has already been mentioned as bearing the signature of the painter Shaykh Zadeh, who is not recorded in any of the few Persian sources which we have, but only in Turkish records of less authority. Nevertheless there is no need to doubt this signature for this very reason, although it is written on one of the floor tiles in the centre foreground, and not in an architectural setting, like the two signatures of Sultan Muhammad. It is true of the whole of the illustration of this manuscript that there is a remarkable intensive unity, in both composition and feeling.

In these respects this manuscript is unique; the masterly arrangement of large crowds was a lesson learnt, but the tendency towards the decorative and the subordination of feeling to refinements of detail proved far the strongest current during the rest of the period of Shah Tahmasp's patronage of the book. This was not in any case very long; for it is known that he suffered a revulsion from aesthetic interest about 1545, in favour of greater attention to affairs of state. Earlier still he had given up his youthful addiction to wine, which he is said to have renounced for good in 1532-1533. But there are two sumptuous manuscripts which were prepared for the Shah in these years from 1537 to 1543. The first, a *Shah-nama* formerly in the Edmond de Rothschild Collection, contains more than two hundred and fifty miniatures, and is said to have been finished

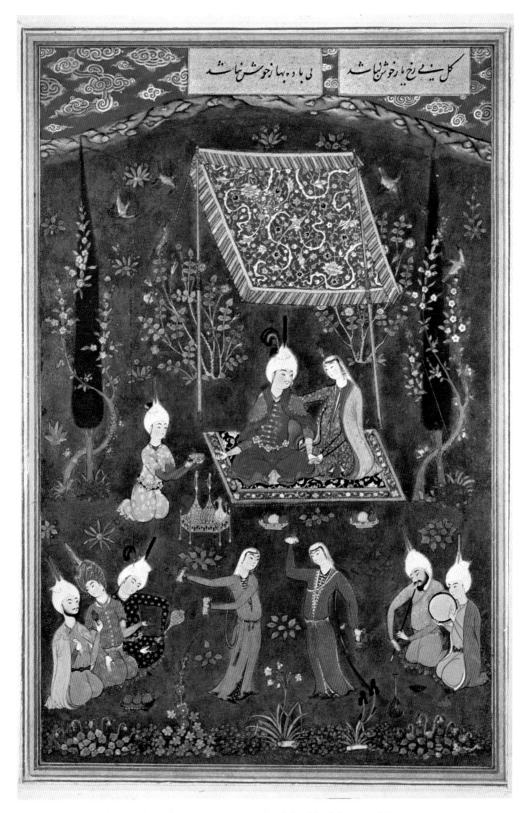

Diwan of Hafiz: Lovers entertained by Musicians and Dancers.
Painted for Sam Mirza, c. 1533. (11⅜×7¼″) Private Collection, U.S.A.

in 1537. The second is the celebrated Nizami in the British Museum (Or. 2265), which was copied between 1539 and 1543, and contains seventeen miniatures, of which four were added in the next century. It was written by the royal scribe, Shah Mahmud of Nishapur, who was so peerless a master that he quite eclipsed his own uncle, Maulana 'Abdi, who was the best calligrapher at the court in the early days of the Shah. He seems in fact to have worked exclusively for the Shah, and received from him the title of "Zarin-qalam," or Golden Pen.

When Shah Tahmasp lost interest in the preparation of fine books, Shah Mahmud retired to the holy city of Meshhed. It is recorded that he wrote a copy of the *Khamsa* of Nizami for Tahmasp in minute script, and that this was illustrated by Bihzad. This cannot refer to the British Museum volume which is written in a rather large script and contains no miniatures which could be attributed to the hand of Bihzad. The richness of its illumination has above all set this book apart from all others, for every page is painted in the wide margins with freely drawn pictorial subjects in gold, with occasional details in silver, generally of animals; natural and mythical being mixed on each page, and Chinese influence apparent in the very oriental *chi-lins* (unicorns), dragons, phoenixes and winged lions. There are however strong reasons for thinking that these margin paintings are not fully contemporary, because several of the miniatures show extensions into the margins which have been cut out and remounted, but which retain not only their old background, which can be seen to be a deeper coloured paper than that of the margins, but also slight traces of an earlier margin-painting in gold, beyond the edge of the painting. Moreover the illumination which is found round the colophons of each of the five poems is of a different character; an arabesque in a different gold, and with a heavier black outline. The *unwans* or opening pages of the several poems also have apparently been extended into the new margins at the top of the page. Decorative margin-painting in gold became the normal fashion for larger manuscripts in the second half of the century, and we will be mentioning an example completed in 1565, but this is in a far simpler style than the Tahmasp Nizami.

Of the miniatures the *Majnun in Chains brought by a Beggar Woman to Laila's Tent,* which bears the librarian's attribution to Mir Sayyid Ali, is the most advanced both in spirit and in composition. Built up on diagonals from the four corners, this is really a pastoral scene rather than a strict illustration of the subject, which occupies only a corner of it; though the small boys casting stones at the beggar and the dog with henna-dyed feet which is barking at him, serve to connect the Majnun with all the background activities of the nomad settlement, of which however only the two distant tents show the black felt characteristic of the desert. This kind of idealized pastoral scene was to be taken up into favour in the second half of the century, when the artists, freed from work in the royal library, began to produce separate drawings, presumably for sale to less noble patrons.

A similar mastery of a diffused country scene is to be found in the famous painting on cotton of the ancestors of the House of Timur of the Imperial Mughal family, now preserved in the British Museum. One pair of figures in this large picture corresponds

closely to the signed drawing of a young Safavi chamberlain in the same collection, by Mir Musavvir, and this connection would serve to strengthen the stylistic argument for attributing the *Princes of the House of Timur* to his son Mir Sayyid Ali.

We have the contemporary evidence of Dust Muhammad that Aqa Mirak was not only without equal as painter and portraitist, but also the confidant of the Shah himself. This was written in 1544, the year before that in which it seems that the Shah turned against the arts, and just after the conclusion of the Nizami. Consequently, when the author goes on to say that the two Sayyids, Aqa Mirak and Mir Musavvir, painted in the royal library a *Shah-nama* and a *Khamsa* of Nizami so beautiful that the pen is inadequate to describe their merits, it is natural to guess that this is the *Khamsa* which we are now describing. If so we would be justified in looking in it for the work of Aqa Mirak. We find that there are attributions of five of the miniatures to his hand, made by more than one librarian. Three of these are court scenes with garden backgrounds and one is specifically dedicated to the Shah by an inscription on the frieze above the *iwan* arch beneath which the young Khusrau is enthroned, which is the finest part of the miniature. The figure drawing in all these miniatures is rather stiff and heavy, but the effect is sumptuous. The only miniatures given to the master Sultan Muhammad himself by the librarian are two, the *Bahram hunting the Lion* and *Khusrau seeing Shirin bathing*, which may be said to be two of the more old-fashioned miniatures in this book, but not of a quality to suggest the artist of the Hafiz of Sam Mirza. Shirin's face is indeed more personal than is usual in this book, or indeed at all for girls' faces; she is of Mongoloid features, although in the poem she is an Armenian princess. Another thing which shows genius is that her horse Shabdia is depicted as turning back its head and whinnying to warn the princess of the presence of the stranger, or in greeting to Khusrau's stallion. The hunting scene is a more ordinary composition, enlivened only by the whim of making the bear join in the hunt of the leopard by throwing down a large rock at him; but we remember that Sultan Muhammad was believed to have excelled in drawing the skins of leopards. Perhaps that may explain the attribution of this miniature which shows skill rather than high artistic power.

There is indeed only one miniature in this book which rises above the level of great accomplishment, and that is the *Ascension* (or rather *Night Ride*) of the prophet Muhammad; a subject often treated before, but never with such a sense of the immensity of the night sky, and the presence of ministering angels far above the little earth. The layer of clouds below and the glory of flaming tongues which surround the principal figure and the archangel Gabriel who precedes him are imaginatively conceived and not mere decoration, as was usual in this scene.

There are some other separate miniatures which must be given to the royal artists of the period of Tahmasp, as for instance a very large double-page hunting scene in the Leningrad Public Library, in which there are a row of beaters holding hands and executing an awkward dance to celebrate the end of the battue. They are treated with humour such as we shall find in the leading artist of the next reign, Muhammadi. But otherwise this huge composition retains the heavy impasto which is characteristic of the miniatures

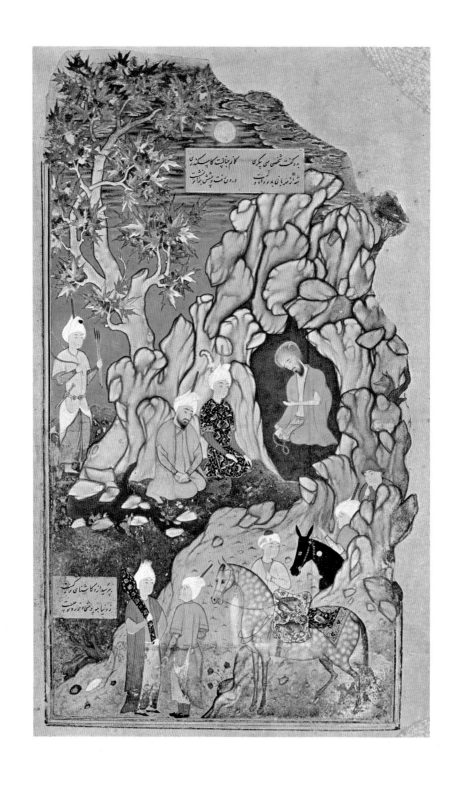

Khamsa of Nizami: Iskandar visiting a Hermit. Attributed to Mir Musavvir, 1535-1540. (7⅛×4″)
Add. 25 900, folio 250, British Museum, London.

in the royal Tahmasp Nizami. It is likely that the five Safavi miniatures added to the British Museum Nizami, dated 1442 (Add. 25 900), were executed in the royal library about this time; for although within the tradition of Bihzad, the landscape in them dominates the figures in a way that it never does in Bihzad's time. Both clouds and trees have become more decorative, and it is even possible that the drawing of one, the *Iskandar visiting a Hermit*, is fine enough for it to be by Mir Musavvir. More advanced Illustration page 140 are two detached pages in Leningrad, one representing a prince resting under a tree in the country and enjoying some fruit while his groom holds his horse and two falconers wait for him to start hunting; the other of a hunt on horseback, with a groom holding camels behind and a cheetah on the crupper of one of the horses. Both have moved further towards a Baroque style, the trees have become more agitated and the frozen calm of the big royal manuscripts has been broken. Yet, judging from colouring and costume, they can hardly be much later than the five Safavi miniatures of the British Museum. But the irregular extension of the Leningrad miniatures into the margins on three sides was to become more common in the third quarter of the century.

Two other detached miniatures, both representing battle scenes, are of a quality Illustrations pages 134-135 justifying an attribution to the royal atelier. The earlier, of about 1530, is attributed to Mahmud Musavvir, who later worked under the Shaibani at Bukhara. A good colourist and draughtsman, he may well be the master of this decorative page, beautiful in its parts, but somewhat confused as a whole composition. In the Royal Scottish Museum is an even finer page, showing a stronger sense of structure and of the sway of battle. The rayed sun and knotted clouds indicate a date about 1540.

There is no doubt that the painters of Tahmasp's court were occupied for the most part with the illumination of manuscripts, but we hear of some other commissions, such as the decoration of the walls of a pleasure house "of mirrors" by the royal artists Aqa Mirak and Mir Musavvir, and a number of the leading painters are recorded as excelling in portraiture. It seems likely that the earliest separate portraits may have been made under Sultan Husayn at Herat, in the last decade or so of the fifteenth century. One of the earliest to survive may be the portrait of Mir Ali Shir as an old man which bears a signature of Mahmud Muzahhib. The famous minister and patron died in 1500, and the style of the portrait is consistent with this date; but Mahmud, as we shall see, was working at Bukhara as late as about 1550, so that this is likely to be either a posthumous portrait or a copy by Mahmud of an earlier miniature, or it may be necessary to reject the attribution; for it must be admitted that the work does not much resemble the later work of this artist. In any case it may be accepted as evidence that portraiture was practised at Herat at the end of the fifteenth century. There are also portraits of Shaibani Khan who was killed in 1510; and several portraits of Safavi princes which appear from a comparison with figures in the miniatures to date from the reign of Tahmasp and probably from before 1545.

During the fifteen years succeeding 1545 Sam Mirza must to some extent have supplied the patronage at this time withdrawn by his uncle, the Shah, Tahmasp. But there is little which can be attributed to his atelier and it may well be that there had

already been a further exodus of painters at this time to Bukhara, as well as to the Mughal court. Certainly some of the best Bukhara manuscripts were produced between about 1544 and 1556, as we shall see.

After the fall of Sam Mirza in 1561, the principal royal patron of the Safavi house must have been his nephew Ibrahim Mirza, the son of Bahram Mirza (who had died long before in 1549), who seems to have remained a favourite of Tahmasp, perhaps because he was without political ambitions. At the age of thirteen (1556) he was given the Shah's daughter Gauhar Sultan in marriage and nominated governor of Meshhed, with which he was already associated as a home of his father, who was buried there. He took with him to his post the renowned master of calligraphy, Maulana Malik, as his personal instructor in this art, and as first head of his library staff. After three or four years however Malik was recalled by the Shah to Qazwin where he was required to write the inscription on the new government buildings then under construction. This was not later than 1561, but he had meanwhile set going one of the most famous surviving achievements of the period, the manuscript of the *Haft Aurang* of Jami, now in the Freer Gallery in Washington. With its twenty-eight miniatures this took nine years to complete, and the copying was completed by his successor in charge of the library, Muhibb Ali, his father Rustam Ali (who had previously worked for the prince's father, Bahram Mirza), Ayshi of Herat and Shah Mahmud, the most famous of them all. These scribes are all mentioned with high praise by Qadi Ahmad, who was brought up in Meshhed where his father was a wazir for ten years, apparently just at the time of the preparation of this sumptuous manuscript. Consequently the account which he gives of the leading painters who were then working in the prince's library is likely to be accurate and inclusive. It is therefore to these hands that its twenty-eight miniatures must be attributed: Shaykh Muhammad, Ali Asghar, and Abdullah. The first-named was a pupil of a certain Dust i-Divana, a pupil of Bihzad who is said to have sought his fortune in India, presumably with Humayun who returned there in 1549. After working in Ibrahim Mirza's library, he entered the royal library under Isma'il II and remained there under Shah Abbas I. But he is likely to have stayed with Ibrahim during the rest of the reign of Tahmasp, and it should be possible to identify other work from his hand from this time. The other leading painters of Ibrahim Mirza's library staff were Ali Asghar and Abdullah; the first is said to have been a fine colourist and to have excelled in the rendering of streets and trees, the second in ornamental gilding. Might he have been responsible for the decorative margin painting which is found on every page of this book? This was, as we have seen, an established feature of Safavi book production, but is here freer in the development of the stylized foliage, the idea of which may have been inspired by Chinese blue and white porcelain decoration, but was now completely Persianized, though its origin is more apparent in the *Haft Aurang* than in the pictorial margin painting of the royal Nizami of Shah Tahmasp of 1539-1543. One mannerism common to both is the occurrence of a broken spray which falls across other foliage in a counterpoint movement.

Looking through the *Haft Aurang*, there is little at first sight to recall Chinese painting; except that on some pages the cloud-forms go beyond the stock knotted symbols

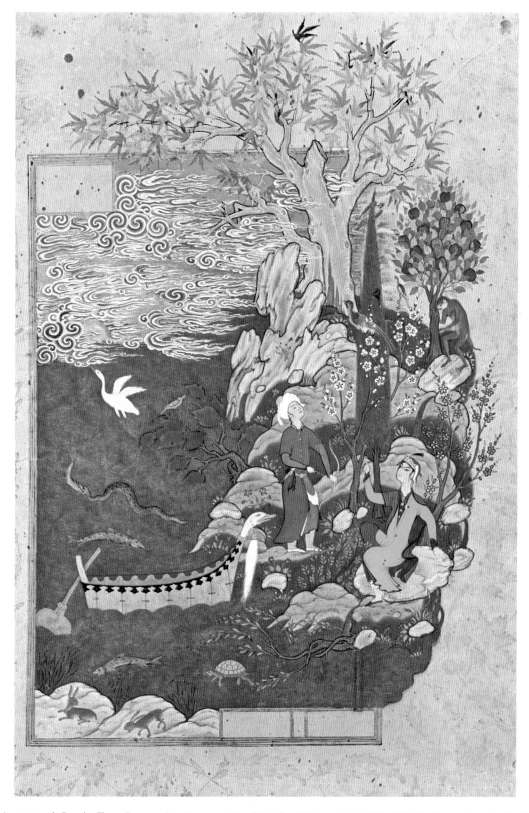

Haft Aurang of Jami: Two Lovers landing on the Island of Terrestrial Bliss. Meshhed, 1556-1565. (13½×9⅛″)
No. 46.12, folio 147, Courtesy of the Smithsonian Institution, Freer Gallery of Art, Washington, D.C.

Yusuf and Zulaikha of Jami: Yusuf on the Market-place. Meshhed, c. 1570. (15¾ × 10¼")
Or. 4122, folio 76 verso, British Museum, London.

which had been in use for nearly two hundred years, and are in fact near to the curdled convolutions with comet-like tails which form the background to the dragon robes of official Chinese dress under the Ming dynasty. This is most notable on folio 147 (46.12) where the two lovers are shown landing on the island of terrestrial bliss, and the clouds Illustration page 143 even coil round the tree-trunk. Other features in this miniature are quite different; the sharply contoured figures here, and still more on the crowded page showing *Majnun before Laila's Tent* (folio 253), do suggest that the artist may have seen and been interested by some Flemish or French illuminated manuscript, with all-over tapestry effect. On this second page the features are quite unpleasantly realistic; while the first is much to be preferred on account of its delightfully sympathetic animal drawing. In this respect it recalls a manuscript in the Chester Beatty Library, *The Wonders of Creation* by Illustration page 150 Qazwini (P. 212), copied by Murshid al-Shirazi in 1545. This is a Shiraz manuscript and therefore not likely to have been illuminated by any of the same artists, although it is clear that at this period there may have been more than ordinary circulation of artists. The landscape backgrounds are however quite different in this manuscript, far less realistic and without the illusion of recession.

The *Haft Aurang* manuscript was finished in 1565, and since Ibrahim survived for another twelve years there must have been much else produced for him which it is not now easy to identify. Another Jami manuscript copied by Shah Mahmud of Meshhed, and now in the British Museum, containing only the *Yusuf and Zulaikha* on large paper Illustration page 144 (15¾ by 10¼ in.) with twelve full-page miniatures shows a similar interest in complicated street scenes with many figures; but the more stylized landscapes explain Stchoukine's attribution of these pages to Shiraz. If it is compared with a manuscript like the *Nigaristan* of Ghaffari in the Walters Art Gallery in Baltimore, which is dated 1569 and is an undoubted Shiraz manuscript, we find a much greater interest in the structure of buildings, and in their relation to one another. This is most simply explained if the manuscript is attributed to Meshhed, where the scribe is stated to have remained for twenty years, following the change of heart of his old patron Shah Tahmasp, until his death there in 1564-1565. These miniatures may have been finished during the next five years or so by Ibrahim's staff.

8

WE have spoken already of the Uzbeks as opponents of the Safavi, and of their temporary occupation and subsequent sacking of Herat which had been the great art centre of the later fifteenth century. These wars and the ferocious hatred between the Shi'a and the Sunni which added so much to their destructive effects, dissipated the greater part of that heritage; so that Khurasan ceased to hold its old position of cultural leadership. One of the heirs of that tradition became the Uzbek capital of Bukhara, which kept alive the Timurid style of painting almost until the end of the century. The exact date of the foundation of this school is uncertain, for it seems that Herat remained a centre for some years after its capture by the Safavi Isma'il in 1510. For instance, the calligrapher Mir Ali al-Husaini, known as al-Harawi on account of his birth at Herat of a family of Sayyids, moved for a time in 1506 to Meshhed, but soon returned to Herat, and remained there, until in 1528 'Ubayd Khan Uzbek captured the city and took him to Bukhara, where he worked until his death, which was not before 1544 and probably even later. While still at Herat he copied in 1519 a *Bustan* of Sa'di now in the Turkish and Islamic Museum in Istanbul, containing two old-fashioned miniatures, showing the Bihzadian figures in simple open compositions, but with the men wearing the Safavi *kulah*. This manuscript seems to belong to the Herat school rather than that of Tabriz to which it is assigned by Robinson. The earliest manuscript which is assigned by the colophon to Bukhara is the romantic poem by Assar recounting the loves of Mihr and Mushtari, which was copied there in 1523. The four miniatures, now in the Freer Gallery, Washington, are in the full Herat style but are probably not versions of earlier paintings. They suggest that by this date one or two skilled painters had already migrated to Bukhara; but it is only some twenty years later that Bukhara manuscripts become frequent.

The *Mihr and Mushtari* miniatures retain the old-fashioned dumpy figures, the strictly frontal buildings, and the division into simple planes, of which there are generally not more than two, which had been the tradition at Herat; but the colouring has already begun to be confined to the strong primary colours which were to be so vivid a feature of later Bukhara painting. One of the scenes shows the favourite night sky of the school of Bihzad, with crescent moon and many stars; another, one of those school-scenes

Illustration page 149

Illustration page 149

which had been so typical of the late Timurids; but the finest is no doubt the landscape with Mihr hunting a lion, in which the spacing of the figures is masterly and daring, as those in the second plane move down into a fold in the ground; while the horse on which Mihr is mounted forms with the lion a chain stretching almost across the page. The sensitively painted frieze of foliage in the foreground saves the scene from rigidity, while at the same time setting it at a certain distance from the spectator. Structural clarity is still the rule, rather than the all-over richness aimed at in the Mir Ali Shir

Illustration page 131

of 1526 (Sup. Turc 316, Bibliothèque Nationale, Paris), discussed in the last chapter, which although written at Herat was surely illuminated at the Safavi capital.

The *Bustan* of 1524 (Vever Collection) retains the clarity of Herat, but the landscape reveals the new decorative sense of the Safavi, so that though there are no Safavi *kulah*, it seems likely that the manuscript was illuminated, as well as written, in Herat. However, as we have seen, by then the Bukhara school already existed, under the patronage of 'Ubayd Allah, who took up his residence there in 1512. His resources were increased when he succeeded as Khan in 1533. In 1528, and again in 1536, he seized Herat and sought out for slaughter the prominent Shi'a notables there; but craftsmen and artists he tried to persuade to return with him to Bukhara. Although some manuscripts survive written at Bukhara in his time, the miniatures which they contain seem all to be of later date. Perhaps he was too much occupied by his constant campaigns to be able to give his attention to such matters.

How early the painter Mahmud Muzahhib was working in Bukhara it is impossible to say, for the only dated miniatures by his hand are of 1546 and 1548, though both of the manuscripts in which they were painted were copied earlier; in one case nine years, in the other five. Sakisian identified him with a well-known calligrapher who was working at Bukhara though a native of Herat; but this is not possible, for his *nisbah* was al-Shihabi and he excelled in the *nastal'iq* script which he was taught by the master Mir Ali al-Harawi. Curiously both manuscripts, which contain the dated work by Mahmud, were written by Mir Ali al-Harawi: the earlier a *Makhzan al-Asrar* of 1537 (Bibliothèque Nationale, Sup. Pers. 985), the later a *Bustan* of Sa'di of 1543 (Gulbenkian Foundation); this contains seven double-page miniatures of which the third is signed by Mahmud and dated, and also the sixth. There is also signed work by Abdullah in it. Mahmud's signature is also written on the tambourine held by a dancer in a double-page miniature which is contained in a *Tuhfat al-Ahrar* of Jami' in the Bibliothèque Nationale (Sup. Pers. 1416), which was copied in 1499, but this miniature is obviously a work of fifty years later. All this work is in typical Bukhara style of the mid-century, that is, of rich but simple colouring, the old-fashioned figures seen against a simpler landscape than was then current in Safavi painting; with a curious mannerism in the drawing of the female figures, who are shown with their heads nearly at a right angle to the axis of their bodies. This feature serves to connect them with a group of detached figure subjects, of which two in the Meshhed shrine collection are signed Mahmud. These are in gayer colours but silhouetted against a plain ground, which makes the same impression of simplicity as the manuscript illustrations.

Mihr and Mushtari of Assar: Prince Mihr cutting off a Lion's Head at one Blow. Bukhara, 1523. (7⁷/₁₆×5″)
No. 32.6, Courtesy of the Smithsonian Institution, Freer Gallery of Art, Washington, D.C.

The Wonders of Creation (Aja'ib al-Makhluqat) of Qazwini: Rhinoceros, Buffalo and Tree-Dwellers. Shiraz, 1545. (12½ × 7⅜″) P. 212, folio 109b, Chester Beatty Library, Dublin.

It is this simplification which gives its distinctive and attractive character to the later work of the Bukhara school, which is frequently based on compositions of Bihzad or his school, but simplified both in the number of figures and also in the colour range. Still when one has seen two or three manuscripts of this kind they become monotonous.

The best period of the school seems to have been under Abd al-Aziz (1540-1549) and Yar Muhammad (1550-1557), for whom the *Bustan* of Sa'di in the Bibliothèque Nationale dated 1556 (Sup. Pers. 1187) and two volumes of the poems of Mir Ali Shir in the Bodleian Library were written in 1553. Of the nineteen miniatures in these three volumes at least four can be traced as simplified copies of miniatures in four different manuscripts of the Herat school under Husayn Bayqara executed in the 1480s. Judged by the standard of that period they are inept, especially in their incompetence in spatial composition; but they have their own quality as decorative work. Better quality work is to be seen in a manuscript of the *Bustan*, now in the Gulistan Palace Library, containing four miniatures, of which the first is another derivative from the Bihzad *Dara and the Herdsman* of the 1488 *Bustan* in Cairo. The colophon gives the name of the calligrapher Mir Husayn Sultani and the date 1553 at Bukhara, but one of the miniatures is dated the previous year and dedicated to Abdullah Munshi Kitabdar. Such dedicatory inscriptions are rather frequently found on Bukhara miniatures, combined with fine arabesque. The almond eyes in the flat faces and the flat pure colours with preference for gold skies give them some of the rich and romantic charm of stained glass, and their very simplicity preserves more of the essential character of the Persian miniature than do the more illusionistic miniatures of the Safavi royal manuscripts.

This richness in intensity of colour, rather than in refinement of line or elaboration of detail, is even more characteristic of the separate figure subjects of the last Bukhara painter Abdullah, who was working at least as late as 1575. Once more it is the colour which saves his work from triviality, and his disarming simplicity places no great burden on the vehicle in which he shows the mastery of a real talent and a personal style which is at once recognizable.

Apart from Bukhara the most conservative school of importance in the sixteenth century was that of Shiraz. We parted from this school in 1503. We have now to look more closely at the large production of these decades in Shiraz. One of the most active calligraphers in the city was Mun'im al-Din al-Awhadi, whose earliest surviving work seems to be the copying in 1504 of a manuscript of Nizami now in the Bodleian Library. From the year 1513 is a *Gulistan* of Sa'di in the British Museum (Or. 11 847), with twelve miniatures in the new style of Safavi Shiraz, which is as conceptual as the old, yet has made some concession to the taste for decoration of the new period, but none at all to its naturalism. This was to be the character of Shiraz painting for some time to come; concentration on the main theme of the subject and decorative arrangement of the rest, including especially the background landscape and architecture. The colouring was decorative rather than naturalistic, with a choice of bold touches of strong colour and a generally blond tone. That this was regarded as a setting, like a conventional stage drop, is revealed by the way that the figures often overlap the margination with an arm

or a lance, or even with a whole leg, as in the case of the *Lassoing of a Div* in a Nizami of 1537 (also copied by Mun'im al-Din al-Awhadi, and now in the Morgan Library, M. 471).

Another leading calligrapher of Shiraz at this period was Murshid, surnamed al-Attar, who was active at least from 1523 to 1552. That he may have died or retired in that year is suggested by the colophon of a copy of the *Zafar-nama*, the life of Timur, made by him, but finished by another scribe, Hasan al-Sharif in 1552. The twelve miniatures are in the style typical of Shiraz in the mid-century, decorative and romantic, perfectly controlled within the convention of manuscript illustration which had been established. The colouring is gay, the rich costumes being foiled by the pale backgrounds of hillside usually framed by friezes or purple-edged rocks, and under an azure or gold sky. A favourite device of the painters at this time was to show a row of men, troops or grooms, silhouetted against the horizon, half-hidden behind the rocky frieze, and indeed the figures as a rule of both men and horses are drawn in silhouette like superimposed images coined from a restricted mould. The success of these illustrations is indeed due to the strict limits observed in them, of scale and colour and of intimate association with the text, which is almost invariably found above and below a part of the composition.

Illustration page 150 This same scribe Murshid was responsible for the copying of a thick manuscript in the Chester Beatty Library (P. 212) of the *Wonders of Creation* of Qazwini, in 1545, which is filled with a treasury of animal drawings that show the school of Shiraz in another mood altogether. Here the generalization of the landscape background makes the perfect setting for the animals which inhabit it. The very simplicity of the repeated flower and tree conventions allows the reader an easy entry into this other world in which the animal creation is at home. The long history of animal representation in Persia lies behind these sympathetic drawings of monkeys, of the bird which sings all night, or which changes its colouring like the chameleon. But the imaginative range of the artists was greater than this, and extends into the supernatural world as well, to talking apes, winged men or others who live in trees. Here the text is completely enclosed by the painting, into which it opens like a window. The blond colouring seems particularly well-suited to this fairy world and its very density not to require any sky or distance. It is hard to think of any art which so well suits the level of the marvellous, because this conceptual manner of composing suits the imaginary world just as well as the real, and the artists can carry the reader with them, just as in the same way though less perfectly the strip cartoon designer can create a fresh world with a different focus and scale and tempo. Only, the Persian artist did not need to introduce a make-believe air because he and his audience had not lost the capacity to see the marvellous in the world as it is. It rather seems that from about 1560 the Shiraz school began to rely overmuch on the pictorial repertory which it had developed for trees, rocks, clouds, flowering plants, and even human figures, whether on horseback or standing or seated. What little sky remained was coloured a flat blue or gold, and tiny wisps of cloud put in as an all-over pattern. The trees are like botanical specimens, with the leaves drawn individually, and water is more rigorously patterned. In fact pattern is carried so far that it is frequently impossible to analyse the structure of a scene.

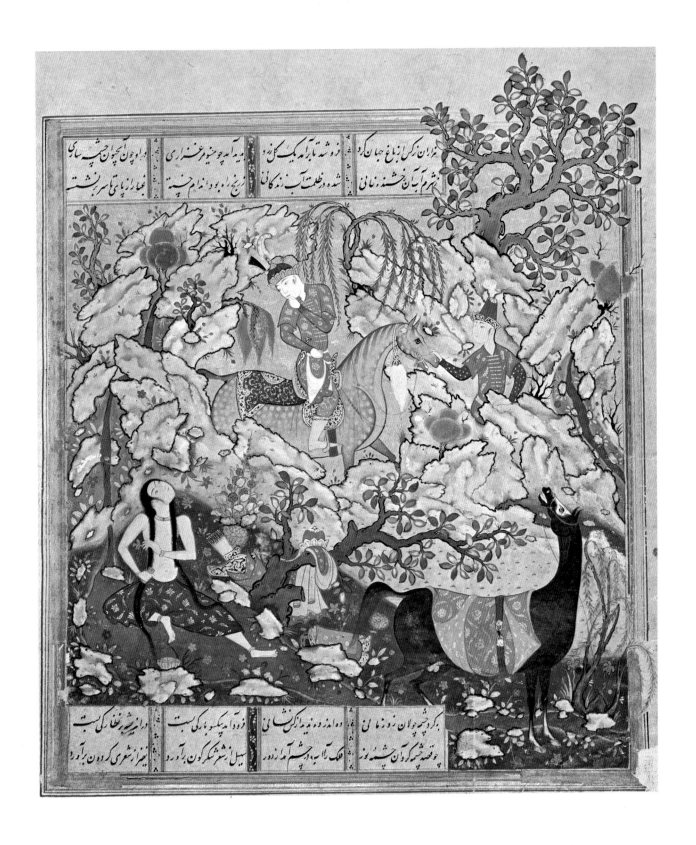

Khamsa of Nizami: Khusrau's First Sight of Shirin bathing. Shiraz, 1584. (14⁹/₁₆ × 10⁵/₈″)
Miniature No. 3, NE. P. 33, The University Museum, Philadelphia.

Another good example of this tendency to imprisonment within the terms of conventional picture-making can be seen in the richly illustrated copy of the *Khamsa* of Nizami dated 1584, now in the University of Pennsylvania Museum at Philadelphia, where the individually graceful figures are as if cut out in cardboard and combined to make up an attractive pattern. They serve successively in the spacious interiors of the seven pavilions in which Bahram spent the seven days of the week, in a different colour for each day. The black pavilion of the Indian princess, for instance, provides an admirable background for the silhouettes of the dancing girl, the musicians and the waiting maids, each wearing the new-fashioned wimple with a little point at the back of the head. But the whole idea of structure is negated by this building of unrelated rectangles, relieved only by a ridiculously small dome balanced on the roof, while the four quatrains introduced into the composition are neither behind nor before the picture surface.

Illustration page 153 In the landscape scenes such as the *Khusrau's First Sight of Shirin*, the figures of the king and his groom (mistakenly introduced in this scene) are seen in a frame of rocks which can be no thicker than pasteboard, through the holes in which trees or streams proceed. Now the reader will allow a good deal of licence to the artist in scale or perspective, but he does expect to be given some room to exercise his imagination if the result is to be more than pattern. The relationship of the miniature to the page of the book is lost if it is an all-over flat pattern on the surface.

9

THE second part of the reign of the Shah Tahmasp saw manuscript painting everywhere in Persia declining into stereotype repetition, not only in Qazwin and Tabriz, but also in Shiraz and Bukhara. The best late Tahmaspi work, such as the eight illustrations to the *Hadiqat al-Uns* dated 1573, in the Museum of Fine Arts, Boston, is attractive in colour and sensitively drawn; but the composition is so relaxed that these pages seem purely decorative. On blue paper, they show conventional scalloped horizon-lines against a gold sky, and three of them use the conceit of composing an animal (in these cases, a horse, an elephant and a camel) of many human figures, a decadent device which spread to the Mughal school in India. Moreover this anti-realism leaves these pages emptier than they would otherwise be, by the complexity of this one part of them. It is therefore strange that just at this time there was at least one artist working at the Safavi court who revivified his art by studying from nature without any radical break with tradition. This was Muhammadi, whose signed pastoral drawing in Paris, dated 1578, shows the way to a fresh and charming style. From the few unfinished miniatures which have survived in manuscripts we can see that the basis had always been a fine line-drawing; here this drawing was only tinted and left without the opaque covering of the usual pigments. It is a rural scene without reference to any text, so far as one can tell. The central group shows a plough drawn by two oxen, whose herdsman turns back to speak to a dervish seated under a tree. In the foreground a shepherd is piping to his flock of goats, while by a stream women are engaged in household pursuits in two tents; and behind a boy draws water from it in a pitcher.

All the elements in this drawing might have been found in work of the circle round Sultan Muhammad thirty years earlier; but they are here combined to form a pastoral landscape, instead of the background to the illustration to a well-known story. It is curious to notice how the substitution of the oxen for the horses as the centre of the composition has affected the rhythm, giving a long sweeping line to the most prominent silhouette. The other change to be noted is the greater naturalism of the principal figures, especially the bearded herdsman whose spare body leans forward with the energy of his playing, as he smiles beneath his fur-edged hat. It is this figure which has connected with the name of Muhammadi the several drawings of dervishes dancing, in different

collections, of which some are certainly of a later date. Lastly the delicate sense of colour in the tinting has led to the attribution to his hand of another country scene in the British Museum, in which the fine outlines are drawn in several different coloured pigments. But the far simpler manner of composing and the absence of any touch of humour, such as the piping shepherd, here point to another hand and perhaps a slightly earlier date. There are some coloured drawings however which should be considered as perhaps being by Muhammadi. Among them the first to be mentioned is the *Self-Portrait* in the Boston Museum, a bearded man standing and looking down at a drawing of a flower which he holds in his hand, on plain ground, and not very well preserved, but signed by the artist. The head is remarkably like that of the man at the plough in the Louvre drawing of 1578, and the line is equally firm. The pose suggests a close connection with the old school of Herat; but we have no sure reason for saying that Muhammadi was a pupil, still less a son of Sultan Muhammad. Indeed the one nearly contemporary source which mentions him does so only incidentally, as an excellent painter who flourished in the time of Isma'il II, who reigned for no more than a year after the death of his father Tahmasp in 1576. It is possible that the accident of the survival of the Louvre masterpiece may have given Muhammadi a greater œuvre than he was in fact entitled to. Both the *Self-Portrait* and the *Hadiqat al-Uns* were afterwards in the collection of Shah Abbas I and bear his seal impression. The palm-tree which is the central feature of the British Museum *Country Scene* resembles another in one of the *Hadiqat al-Uns* miniatures, so that 1575 might be a date for it.

This whole group of pastoral scenes used to be attributed to the school of Sultan Muhammad, if not to the master himself; and the pastoral scene in the background of the Mir Sayyid Ali *Majnun brought to Laila's Tent* in the royal Nizami of 1539-1543 is cited in support. That is however to disregard the great increase in the naturalism of the group; whereby the goats really inhabit the landscape, and the shepherd is not just reclining against a rock but really pipes to his flock and the boy stoops to fill his can, instead of sitting looking the other way, like the girl in the Mir Sayyid Ali. With not very different means quite a different effect has been achieved: here is an idyllic pastoral peace instead of a splendid setting for a lyrical romance. The only earlier instance of the revelation of Illustration page 49 the quality of Persian draughtsmanship is that unique manuscript of the *Diwan* of Sultan Ahmad Jala'ir in the Freer Gallery more than a hundred and fifty years before. Those margin drawings were under the strong influence of Chinese draughtsmanship, whereas here there is the essence of Persian calligraphy, perfectly controlled penmanship, a sweet and subtle line.

As has been suggested above, Muhammadi's own line was more accented than that of the group which we have been considering, and there is a certain whimsicality in it which enables him to add a touch of humour that had been completely absent from previous Persian work. One or two drawings of dervishes dancing, of which the best are in Leningrad, exemplify this humorous style. The poses of the dancers in their high pointed hats or completely covered by a goatskin disguise, remind one of the Commedia dell'Arte; and the perambulating musicians show the abandon of religious inspiration.

Drinking Party in the Mountains. Attributed to Muhammadi, c. 1590. (8⅞ × 5½″)
No. 14.649, Courtesy of The Museum of Fine Arts, Boston.

Hawking Party in the Mountains, c. 1585. (14¾×9¾″) Half of a double-page composition.
No. 14.624, Courtesy of The Museum of Fine Arts, Boston. (Formerly Goloubev Collection)

Several such drawings in the India Office Library in London have signatures or ascriptions to Muhammadi, so that some connection must be recognized between him and work of this kind. For all the actuality of these drawings there is no sign of the realism which is marked in yet another type of drawing attributed, probably without justification, to Muhammadi. This may be illustrated by the masterly *Drinking Party* in the Boston Illustration page 157 Museum of Fine Arts, in which the landscape has been completely dissolved and the figures entirely hold the stage. These too are probably all dervishes seeking religious ecstasy through the release of drink. They are seated in front of an old gnarled tree, with large bowls of rice before them and smaller bowls of wine which are filled from a huge jar in the foreground. All these are decorated in the floral arabesque scroll-work which was imitated from Chinese blue and white porcelain during the reign of Shah Abbas I (1587-1629), to the earlier part of whose reign this drawing should be assigned. The realism of some of the faces has suggested to Schroeder that this might be a Mughal work, but this is the realism of sympathetic observation rather than the scientifically organized perspective and modelling of the Mughal school, with its debt to Western influence. The organization of this composition is typically Persian, and there is nothing unusual in the intensely observed cat and flowers, nor in the sympathetically felt expressions. Only now, with the increased virtuosity of the drawing, these are more actualized than ever before. The realism is in fact innate and not external to the subject.

There is only one double-page fully coloured miniature which has been attributed to Muhammadi, and this is now divided between the Metropolitan Museum and the Boston Museum of Fine Arts. It shows a pause for refreshment during a princely hawking Illustration page 158 party in the mountains, and is remarkable for the brilliance of the colouring, with gold sky, dark green grass and purple rocks; against which the gay dresses of the party emphasize the elegant figures of the young men. Both halves of the composition extend beyond the margination, so that the foliage of the trees merges into the decorative painting in gold and silver which surrounds both of them on all four sides, and is thus evidently by the same hand as the main composition. It is a mannered, expressionist hand, accenting the line of cheek and chin, proliferating boughs of trees. In the margin drawing he depicts the animals in a frenzy of movement; lions and hyenas going after deer, an eagle pursuing stork, all, even hares which do not seem to be much threatened, wide-eyed with fright or venom. This is in complete contrast to the gentle wiry line of Muhammadi. Who the artist was is not known, but the fashion is that of the 1580s, before the introduction of the large loosely tied turban of the next decade. Already the painter is more concerned to express his own personality than to convey the charm of rural life, or the lyrical spirit of a romantic poem; in other words, the intention is to exploit the possibilities of elegant gestures and stance in making an interesting pattern. Such an overriding emphasis on personal handling was henceforth to be characteristic of Persian painting to the end of the Safavi period.

The first of such personalities to be considered is Aqa Riza, son of Maulana 'Ali Asghar of Kashan, a painter who had worked at the court of prince Ibrahim Mirza while he was governor of Meshhed, from about 1556 to 1577. He was therefore brought up at

the best centre of this period for the appreciation of the arts. The writer Qadi Ahmad was of similar origin, being the son of the *Munshi* of this same prince, and what he tells us about Aqa Riza is therefore reliable. According to him, then, as a young man he won fame by the virtuosity of his drawing, especially in portraits. And this brought him preferment at the court of Shah Abbas, presumably in the early 1590s. But the Shah was occupied with repelling invasions of his territories in the early years of his reign and probably could not give much personal attention to the arts until the removal of the capital from Qazwin to Isfahan in 1597-1598. Some of the surviving work of Aqa Riza is no doubt earlier than this, for the first edition of Qadi Ahmad's book was completed by that year, and by then his fame was clearly established; whereas in the later version, which is assigned by Professor Minorsky to about 1606-1608, his nature is said to have quite altered through keeping bad company, and he was then spending his time watching wrestling. The work known to us which can be attributed to Aqa Riza, as argued by

Young Prince playing the Mandolin. Safavi School, c. 1585-1590. (5⅛×5⅛″)
Or. 1373, folio 23, British Museum, London.

Eric Schroeder, can all be given to the years 1589 to 1600. It is marked by a beautiful flowing line, sensitive to different textures and slightly accented where the brush is lifted from the paper. He enjoyed rendering transparent passages, muslin sleeves or curling hair or beards; and above all the folds of waist sash or turban. Signed figures of a court page and of a smartly dressed girl, in the Fogg Art Museum and the Freer Gallery respectively, both of which bear impressions of the Shah's personal seal, can serve as criteria for attributing other drawings of figure subjects, such as several in an album in the Morgan Library (M. 386). These two figures show the beginning of a curious fashion which was to become a tiresome mannerism in the next century, of leaning forward and slightly bending the knee, so as to make a full curve in the line of the thigh and a corresponding double curve in the line of the back. This with the fuller contour of the cheek, and the chin, indicates a change in the modish figure from the type favoured under Tahmasp. The shoulders are more sloping, the body fuller and the waist less marked. Partly this is no doubt due to the continued growth of naturalism; for certainly these figures are less stiff and posed, and seem indeed to be about to move forward; but there is also undoubtedly a psychological change from the tense and tightly buttoned figures of the mid-century to these relaxed and self-absorbed persons of its end. The lips are now generally parted in a half-smile, instead of being pursed together.

Two of the Morgan Library drawings, also in bright colours, show turbans of even more extreme elegance, and with the end forming a crest on the top. These are both seated figures of young courtiers or princes, one speaking to his hawk which is perched

Court Page in a Blue Cloak. Painted by Aqa Riza, c. 1590. (6¾ × 2⅞″) No. 1936.27, Courtesy of the Fogg Art Museum, Harvard University. Sarah C. Sears Collection.

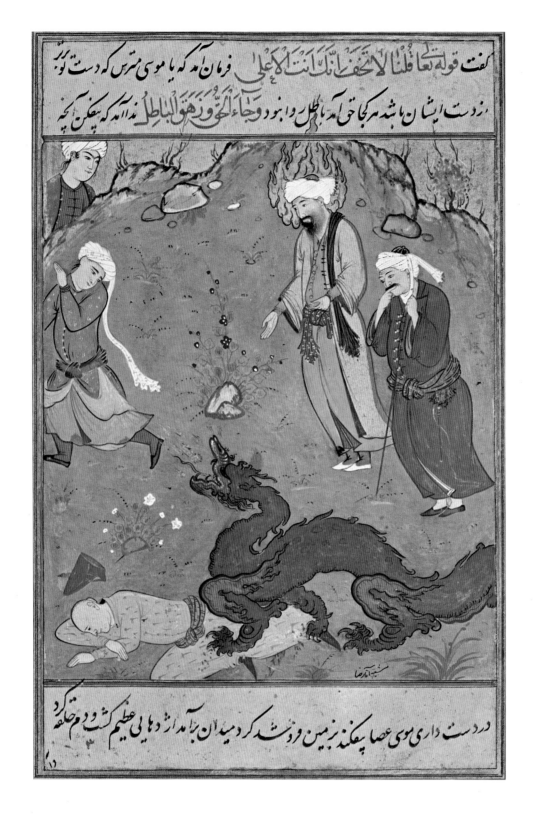

Qisas al-Anbiya (History of the Prophets) of Nishapuri: Moses and Aaron conjuring up a Dragon which attacks the Magician Servants of Pharaoh. Painted by Aqa Riza, c. 1590-1600. (5½×4⅞″) Sup. Pers. 1313, folio 79 verso, Bibliothèque Nationale, Paris.

on his knee, the other hammering a horse-shoe on a diminutive anvil. If not actually by Aqa Riza they are very near to him. The first shows the same sort of gold-decorated floral background with conventional clouds as the Fogg court page; and the second only a carpet in the position of greatest visibility, as it was drawn by Aqa Riza in one of the miniatures of the only manuscript illustration which can be connected with him—the *Qisas al-Anbiya* of Nishapuri in the Bibliothèque Nationale (Sup. Pers. 1313). This *History of the Prophets* is prefixed by a defaced royal dedication, which can hardly have been to any prince but Shah Abbas I, and the style of the miniatures suggests a date between 1590 and 1600. Only one is signed, the scene here reproduced in which Moses Illustration page 162 and Aaron have conjured up a dragon which is attacking the magician servants of Pharaoh. It bears the signature of Riza, and it seems likely that most, if not all of the others, are also from his hand. The figures are inclined in the same way as in the separate drawings, and there is the same interest in beards and turban ends which we have seen on them. The drawing is rather coarser, as is needed for a wider setting; and the naturalism greater than we have seen in any earlier manuscript illumination.

The naturalism of the figures combined with a conventional landscape is well seen in some other miniatures in this manuscript; representing the *Seven Sleepers of Ephesus* with their dog in a cave, and *Cain fleeing from the Corpse of the Murdered Abel*. The trees are shapeless shrubs and other detail is reduced to the minimum, while the figures are such as might have been seen any day then, after a drinking party, leaning against one another in abandon. There could be no clearer indication of the subordinate position taken by manuscript illustration at this time compared with portraiture or separate genre pictures. And in the figure drawing line is of greater importance than colouring.

Another fine figure drawing of this period is of a *Falconer* holding the jessed bird on his gloved left hand, and wearing on his head the peculiar hat of this office, with a stiff peak shielding the eyes and a purple veil over the top of the crest. His short black beard and frizzled hair are as carefully rendered as in the signed Aqa Riza figures, but the drawing is more linear and less indicative of volume, the folds being scribbled in a way that was to be commoner in the next century. The tone of the colouring is different, the turquoise of the dress with its purple trimmings against the warm orange brown of the ground, which is however still filled by gold drawn plants. Similar indication of folds is to be seen in the *Sleeping Page* in the Cleveland Museum of Art, but the tree and landscape behind are not of the quality of this fine figure drawing; and this once more suggests that Aqa Riza's landscapes were not comparable with his figure drawings in quality. Yet it may well be that both this and the *Falconer*, which passed to the British Museum with the Bernard Eckstein bequest in 1948, are by Aqa Riza from a later period in his career than the signed work executed for the Shah. There is no other hand to which they can be attributed, and he must have continued to work, even after his fall from royal favour.

In general the illustration of manuscripts does not present much of interest during the rest of the reign of Shah Abbas I and it is more and more dominated by the figure drawing. Background landscape is in a lower tone than the rich costumes of these

Shah-nama of Shah Abbas I: Kay Khusrau offering the Crown to Luhrasp, 1614. (14½×7¾″)
Folio 580, Spencer Collection, The New York Public Library.

Book of the Wonders of Creation (Aja'ib al-Makhluqat) of Qazwini: Mongoose in a Tree. Herat, 1613. (9½×6⅜″)
w. 652, folio 147 verso, The Walters Art Gallery, Baltimore.

figures, and where, as often, they project beyond the margins, they are little more than tinted drawings. In fact the finest work is found not in the direct landscape but in the wall-paintings now so frequently represented on the buildings depicted. These are generally drawn in blue and sanguine on the white wall, and are in the tradition established in the sixteenth century for the decoration of the margins of the finer manuscripts. They are therefore all-over patterns but with a coherent ascent from trees below to a sky filled with birds and clouds. Clouds are drawn in the margins of these manuscripts in the same style, often in gold with blue edges or vice versa, as in a fine poetical manuscript

Illustration page 165

in the Walters Art Gallery, Baltimore (652), copied in Herat in 1613, with thirteen miniatures of varying quality. The animal drawing is sympathetic and the trees decorative; but the compositions are disorganized and the figures too large. Still compared with the ordinary *Shah-nama* illustrations of this period, of which a number survive, such as those in a manuscript of 1614 in the British Museum, or one of 1618-1619 in the Walters Art Gallery, these miniatures are elegant and ornaments to the volumes in which they are painted; whereas the others seem mechanical repetitions of earlier compositions, and even when tolerably drawn, lack that imaginative penetration which had been the quality of the whole school in the earlier centuries.

Illustration page 164

A sumptuously illustrated manuscript of the *Shah-nama*, prepared for Shah Abbas I in 1614, and now in the New York Public Library (Spencer Collection), is a curious exception to this rule; not that it is not copied from an earlier model, but that the copying is so much more faithful as to amount to plagiarism of a very high order. For the thirty-nine miniatures are pastiches of the famous Baysunghur *Shah-nama* in the Gulistan Palace in Tehran, described above. The whole allure of this sumptuous manuscript is successfully imitated in colouring which seldom betrays its late date, with lavish use of gold and lapis blue. A careful comparison shows that twenty-two of the compositions are closely repeated with occasional simplification by omission of one or two figures, and more regularly by the addition of more foreground rocks and more background trees. A general difference is that the text of the epic is in four columns instead of six, and that passages of the text are enclosed within the miniatures, in accord with the practice of the time, thus involving the displacement of some of the figures. In two or three cases small groups have been transferred from one composition to another, as on folio 223, where the figure of Baysunghur is taken out of the frontispiece and used in this polo scene; or in the battle scene on folio 766, where several figures are omitted from the corresponding page in the 1430 book, and one group actually transferred to a different miniature on folio 126. On folio 287 in the scene of Jamshid and the artisans to whom he has first taught the crafts, the various pictorial elements have been rearranged and in one case at least the direction reversed, which strongly suggests the use of tracing.

Much more remarkable is the fact that there are seventeen miniatures in this volume which do not occur in the prototype as it is known to us, and the question to be decided is whether they were in fact copied from some other and possibly even more sumptuous version of the Baysunghur *Shah-nama*, or whether the artists were capable of so far entering into the style of the Herat school of the early fifteenth century as to succeed in

inventing new pictures which are deceptive to a like degree. An argument in favour of this last solution is to be found in their undoubted power of adaptation as can be seen in the *Kay Khusrau offering the Crown to Luhrasp*, on folio 580, the right-hand page Illustration page 164 of a double-page miniature, which is ingeniously derived from the *Faramurz mourning over the Coffins of his Father Rustam and his Brother Zawara* in the 1430 book. The whole foreground and framework of these two miniatures are the same, while the building has been converted from a mosque into a palace and a throne introduced instead of a coffin; but the poverty of real invention is shown by the fact that the hands outstretched in prayer have here received the crown which is offered to Luhrasp.

What appears to be a completely new subject is the *Rescue of Bizhan from the Well* on folio 432, where the landscape is quite chaotic, and the figure in the well is entirely seventeenth century in costume and facial type. All these new illustrations have gold skies, which are never found in the original book; and the fifteenth century rock-forms are multiplied to excess.

Still, it is a shock to discover that at so late a date the royal library was capable of producing something as deceptive at first sight as this; and one asks oneself if this is an isolated freak; inspired by a deliberate wish to preserve the compositions of a famous manuscript, which was presumably still in the royal library at this time, as it has remained ever since. A manuscript in the Malek Library, Tehran, actually written for Baysunghur, has a single miniature added in this same style of the early seventeenth century. It may be suggested that the 1580 Nizami in the Metropolitan Museum is also a pastiche of a later Timurid book. There are formidable deductions to be drawn from this discovery, which must take account of the thorough organization of the royal library as it is clearly revealed at a later date in the treatise translated by Professor Minorsky under the title *Tadhkirat al-Muluk* (1943), a manuscript of Safavid administration dating to about the year 1137 A.H. (1725 A.D.).

The monarchy of Shah Abbas I was an efficient bureaucracy, reflecting in all its departments the aims and taste of the Shah. His love of splendour and interest in architecture are reflected in the central area of the Meidan at Isfahan, surrounded by the tile-covered buildings of the mosques and the gates of the bazaars, and dominated by the tall palace of the Ali Qapu; from which he was accustomed to look down on the busy city set in ample gardens. Only the painted decoration of this building seems inadequate to the setting. There was no real tradition of wall-painting in Safavi Persia; but it might have been expected that the royal taste which directed the sumptuous brocade-weaving and tile-designing not to speak of the famous carpet-weaving in the royal factories might have required something more noble from his painters to decorate the private apartments of his palace. But these paintings of young pages and courtiers do represent the background to the Shah's own life, as we may see it so vividly depicted by the Italian traveller Pietro della Valle, in the extremely readable English summary in Wilfrid Blunt's account of his year's stay at the Persian court.

Such were the commissions given to the royal painters; and it is therefore not surprising that the leading painter of this age should have been Riza Abbasi, whose active

career seems to have extended from 1610 to 1640. Much later portraits of him by his pupil Mu'in give the year 1635 as that of his death, but this date is not reliable. It is obvious that many of the signatures of Riza Abbasi, which follow the style of his characteristic calligraphic hand, are not genuine; and there are several versions of some of them. But a nucleus of authentic pictures can be isolated to form a basis for judging his work. That he was a brilliant draughtsman may be seen from the famous Sarre sketchbook now in the Freer Gallery, Washington. And this fluent penmanship with thickened accent and spluttered termination underlies all his genuine work, much of which is fully coloured with flat enamelled pigment which takes a craquelure. These may be finished with gold brocade designs on dresses. What distinguishes him from his followers and imitators is his interest in pure design; the ample folds of a long scarf or a dervish's cloak, the ends of a page's sash are emphasized to a degree which gives them an abstract beauty, which is picked up in the gold painting of the background, in which the silhouettes of wine bottles or fruit are incorporated into the sprays of chenar foliage and the wisps of cloud to form an all-over pattern of expressive brushwork. The design is on the point of dissolving into free abstraction which might have led Persia to an art well suited to her long tradition of calligraphy and abstract design in the arts of illumination and carpet-making. That there was a connexion between the work of Shah Abbas' painters and his textile factories is in any case very probable, and we shall see that Shafi' the son of Riza was definitely a designer for textiles. Unfortunately the tendency to realism, which was competing with this abstract designing, gained the upper hand, perhaps mainly under the influence of European art in which the Shah took an interest for its own sake, and which represented the market which he was concerned to capture for the export of brocades. A contemporary of Riza named Muhammad Yusuf al-Husaini carried this movement towards a release from the flat designing of the traditional Persian figure drawing, as far as it ever

Illustration page 169 went. In a brilliant composition now preserved in the Morgan Library he makes of the relations of three figures, two kneeling young men and a standing lady of fashion whose waist one of them is embracing, an exercise in intersecting forms which for once is composed in depth. Her upraised arms coil about the turban which she has removed from her lover's head and is placing on her own, in a dance movement echoed by the streaming clouds and foliage against the deep blue sky. Little is known by this artist but his masterly draughtsmanship is illustrated in the Pozzi and Dawud Collections.

Riza's son Shafi' was a tight and careful draughtsman who seems to have specialized in bird and flower drawing, and to have worked as a designer for textiles. The period of his activity seems to have lain mainly within the reign of Shah Abbas II (1642-1667), but he probably survived until 1674, possibly in India, where he may have migrated to the Mughal court after the death of that Shah. There is a finished drawing of a goldfinch dedicated to the Shah in the year 1653, in the Bibliothèque Nationale, and in the same library is a manuscript (Sup. Pers. 769) prepared for this Shah which when acquired by the Swedish traveller J. Otter in the first half of the eighteenth century in Isfahan was stated to be illustrated by Shafi' Abbasi. Abbas II is known to have favoured Western artists, and it was under his reign that the famous Chihil Sutun palace in Isfahan had

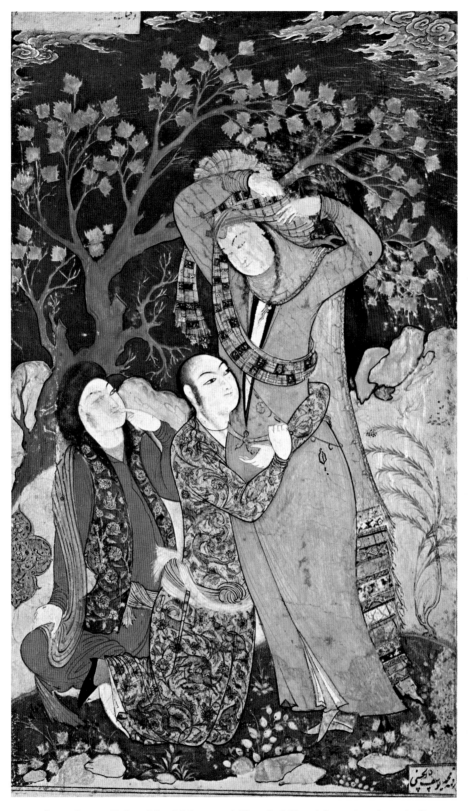

Love Scene. Painted by Muhammad Yusuf al-Husaini, c. 1630. (9¾×6¾")
M. 386, folio 15, Courtesy The Pierpont Morgan Library, New York.

its walls painted by Dutch painters and their Persian pupils. It was moreover Abbas II who sent the Persian painter Muhammad Zaman to Rome to study Western art. Muhammad Zaman returned to Persia by 1675 and continued to work in Isfahan at least as late as 1697.

The story preserved in the unreliable gossipy pages of a Venetian adventurer in Mughal India, Dr Nicolao Manucci, is that Zaman was converted to Christianity in Italy and received the name of Paolo, on which account he did not dare to return to Persia, but took service instead at the court of Shah Jahan, until presumably the growing fanaticism of his successor Aurangzeb hurried him on or back to Persia, where Shah Sulayman had succeeded in 1667. The only supporting evidence for this story, to be found in the work of Muhammad Zaman known to us, is the introduction into some of his miniatures of flights of birds in line, a frequent Mughal practice, and the existence of two Christian paintings by him of later date which imply familiarity with iconography as well as style. But even these are signed "Muhammad Zaman son of Hajji Yusuf," with no trace of Christian name. Royal patronage in Persia is proved by the commission to add three additional miniatures to the royal Nizami of Shah Tahmasp of 1543, and there seems little doubt that it is the Shah himself who is depicted in the guise of *Bahram Gur killing a Dragon*, signed and dated 1675-1676. It is curious that into this same year seems to have been crowded the greater part of his known work in manuscript illumination. In addition there are two large miniatures in a *Shah-nama* in the Chester Beatty Library and the first miniatures at least in a Nizami *Khamsa* in the Pierpont Morgan Library (M. 469) written in 1675-1677. All the paintings are in a heroic mood, bathed in the golden light of Italy, with cast shadows indicated. The relation to the text of the poems is however still preserved. The figures retain something of the Persian elegance of stance and gesture, and in the Nizami, the subject of *The Seljuq Sultan Sanjar listening to the Complaint of an Old Woman against one of his Soldiers* shows a subordinate figure in the old Persian attitude of astonishment with the finger raised to the lips. Here again the Sultan is surely the young reigning Shah, who was twenty-eight in 1675-1676, when this was painted. There is in the British Museum a drawing of a prince in exactly the same pose as this figure and with a similar elaborate turban, which bears in the sky an inscription *Ya Sahib al-Zaman* ("O lord of the times"), which has already been taken as a punning reference to the painter Zaman, and is now seen to be closely connected with signed work by him. This drawing is a portrait group of the Shah with a cup-bearer in European dress and a Mughal beside him in court dress, both most accurately depicted as he would have known how to do. Here there is no background landscape, and westernization is not so complete. Other pages in the Morgan Nizami are even more realistic in their execution. There follow the *Visitation* and *Flight into Egypt* dated 1679 and 1689, with formal signatures and not illustrating a manuscript; and then in 1697 a painted lacquer pen-box in the Hatoun Collection, showing the last Safavi Shah, Sultan Husayn (1694-1722), at a picnic.

It might be thought that this style was an exceptional exoticism, if it were possible to point to any indication of the survival of a less contaminated tradition of painting,

but even the young pages in their sumptuous gold or silver brocade dresses, and the dancing girls with their long scarves now have modelled faces, and the former calligraphic curves are broken up into careful naturalism, as in a highly finished drawing in the Boston Museum of Fine Arts (14.641). Decadence of the Safavi house was accompanied by decadence in the arts; neither the vigour of the Afghan invaders nor the revivalism of the Kajars in their new capital at Tehran brought any vitality to the art of manuscript illustration in Persia; in the nineteenth century the whole basis of the art was lost with the supersession of the hand-written book by the lithograph and the printing press.

Bibliography

A Select List of Western Authorities

General

F. R. Martin, *The Miniature Painting and Painters of Persia, India and Turkey*, 2 volumes, London 1912.

T. W. Arnold, *Painting in Islam*, Oxford 1928.

Armenag Bey Sakisian, *La miniature persane du XIIe au XVIIe siècle*, Paris and Brussels 1929.

L. Binyon, J. V. S. Wilkinson and Basil Gray, *Persian Miniature Painting*, London 1933.

Ernst Kuehnel, *History of Miniature Painting and Drawing*, in *A Survey of Persian Art*, vol. 3, Oxford 1939.

E. Schroeder, *Persian Miniatures in the Fogg Museum of Art*, Cambridge, Mass., 1942.

B. W. Robinson, *A Descriptive Catalogue of the Persian Paintings in the Bodleian Library*, Oxford 1958.

Ernst Kuehnel, *Persische Miniaturmalerei*, Berlin 1959.

A. J. Arberry, M. Minovi and E. Blochet, edited by J. V. S. Wilkinson, *The Chester Beatty Library*; a catalogue of the Persian manuscripts and miniatures, 2 volumes, Dublin 1959-1960.

CHAPTER I

E. Herzfeld, *Die Malereien von Samarra*, Berlin 1927.

G. Jerphanion, *Les miniatures du MS. syriaque No. 559 de la Bibliothèque vaticane*, in *Codices e vaticanis selecti*, No. 25, Vatican City 1940.

G. D. Guest, *Notes on Miniatures on a Thirteenth Century Beaker*, in *Ars Islamica*, vol. X, 1943.

Bishr Farés, *Une miniature religieuse de l'école arabe de Bagdad*, Cairo 1948.

D. Schlumberger, *Le palais ghaznévide de Lashkari Bazar*, in *Syria*, XXIX, 1952.

D. S. Rice, *The Aghani Miniatures and Religious Painting in Islam*, in *Burlington Magazine*, April 1953.

R. Ghirshman, *Bîchâpour*, vol. II, *Les Mosaïques sassanides*, Paris 1956.

R. Ettinghausen, *On Some Mongol Miniatures*, in *Kunst des Orients*, III, 1959.

E. Wellesz, *An Early al-Sûfî Manuscript in the Bodleian Library in Oxford*; a study in Islamic constellation images, in *Ars Orientalis*, III, 1959.

CHAPTERS II AND III

F. R. Martin, *Miniatures from the Period of Timur in a MS. of the Poems of Sultan Ahmed Jalair*, Vienna 1926.

I. Stchoukine, *La peinture iranienne sous les derniers Abbasides et les Il-Khâns*, Bruges 1936.

E. de Lorey, *Peinture musulmane ou peinture iranienne*, in *Revue des arts asiatiques*, XII, 1938.

D. Brian, *A Reconstruction of the Miniature Cycle in the Demotte Shah-namah*, in *Ars Islamica*, VI (2), 1939.

H. Massé, *Le Livre des Merveilles du Monde*, Paris 1944.

R. Ettinghausen, *Persian Ascension Miniatures of the 14th Century*, in *Ars Orientalis*, I, 1954.

D. S. Rice, *The Seasons and the Labors of the Months in Islamic Art*, in *Ars Orientalis*, I, 1954.

R. Ettinghausen, *Some Paintings in Four Istanbul Albums*, Accademia Nazionale dei Lincei, Rome 1957.

D. E. Barrett, *Persian Painting of the Fourteenth Century*, London 1952.

H. Stern, *Au sujet des images des mois dans l'art musulman*, in *Ars Orientalis*, II, 1957.

I. Stchoukine, *Les peintures du Shah-nameh Demotte*, in *Arts Asiatiques*, V (2), 1958.

CHAPTER IV

J. V. S. Wilkinson and L. Binyon, *The Shâh-nâmah of Firdausî*, with 24 illustrations from a 15th-century Persian MS. in the possession of the Royal Asiatic Society, Oxford 1931.

M. Aga Oglu, *The Landscape Miniatures of an Anthology Manuscript of the Year 1398 A.D.*, in *Ars Islamica*, III, 1936.

B. W. Robinson, *Unpublished Paintings from a 15th Century Book of Kings*, in *Apollo Miscellany*, 1951.

I. Stchoukine, *Les peintures des manuscrits tîmurides*, Paris 1954.

R. Ettinghausen, *An Illuminated Manuscript of Hâfiz i-Abrû in Istanbul*, in *Kunst des Orients*, II (3), 1956.

CHAPTER V

K. V. Zetterstein and C. J. Lamm, *Mohammed Asafî, The Story of Jamal and Jalâl, an illuminated MS. in the Library of Uppsala University*, Uppsala 1948.

M. S. Ipsiroglu and S. Eyüböglu, *Sur l'album du Conquérant*, Istanbul 1954.

B. W. Robinson, *Origin and Date of Three Famous Shah-nameh Illustrations*, in *Ars Orientalis*, vol. I, 1954.

Basil Gray, *The So-called Turkman School of Persian Miniature Painting*, in *Akten des vierundzwanzigsten internationalen Orientalisten-Kongresses*, Munich 1957.

M. S. Ipsiroglu and S. Eyüböglu, *Ein Beitrag zur türkischen Malerei im 15. Jahrhundert*, in *Du*, Zurich, June 1959.

Ernst Kuehnel, *Malernamen in den Berliner 'Saray'-Alben*, in *Kunst des Orients*, III, 1959.

CHAPTER VI

F. R. MARTIN, *Les miniatures de Behzad dans un manuscrit persan daté de 1485*, Munich 1912.

F. R. MARTIN and T. W. ARNOLD, *The Nizami Manuscript in the British Museum (Or. 6810)*, Vienna 1926.

T. W. ARNOLD, *Bihzâd and his Paintings in the Zafarnâmah MS.*, London 1930.

B. W. ROBINSON, *The John Rylands Laylâ wa Majnûn and the Bodleian Nawâ'i of 1485, a royal Timurid manuscript*, in *Bulletin of the John Rylands Library*, vol. 37, Manchester 1954.

Muhammad MUSTAFA, *The Work of Bihzad* (in Arabic), Cairo 1959.

R. PINDER-WILSON, *Bihzâd* (extract from vol. II of the *Enciclopedia Universale dell'Arte*), Rome 1960.

CHAPTERS VII AND VIII

F. R. MARTIN, *The Nizami MS. from the Library of the Shâh of Persia*, Vienna 1927.

Laurence BINYON, *The Poems of Nizami*, London 1928.

Qâdî AHMAD, *Calligraphers and Painters*, a treatise circa A.H. 1015/A.D. 1606, translated from the Persian by V. Minorsky with an introduction by B. N. Zakhoder, Washington 1959.

I. STCHOUKINE, *Les peintures des manuscrits Safavis de 1502 à 1587*, Paris 1959.

CHAPTER IX

F. SARRE and E. MITTWOCH, *Die Zeichnungen von Riza Abbasi*, Munich 1914.

Richard GOTTHEIL, *The Shahnameh in Persian, an illuminated and illustrated Manuscript in the Spencer Collection*, in *Bulletin of the New York Public Library*, vol. 36, no. 8, 1932.

Basil GRAY, *An Album of Designs for Persian Textiles*, in *Aus der Welt der islamischen Kunst*, Festschrift für Ernst Kuehnel, Berlin 1959.

Index of Manuscripts

General Index

List of Colour Plates

PUBLISHED MARCH 1977

PRINTED BY
IMPRIMERIE COURVOISIER
LA CHAUX-DE-FONDS

PHOTOGRAPHS BY

*Henry B. Beville, Washington (pages 20, 21, 28, 29, 32, 49, 54, 58, 59, 60, 61, 97, 102, 103,
107, 128, 135, 137, 143, 149, 153, 157, 158, 161, 164, 165, 169), Zoltán Wegner, London (pages 24,
25, 27, 46, 47, 66, 71, 73, 87, 89, 90, 91, 112, 116, 117, 120, 122, 123, 134, 140, 144, 150, 160),
Maurice Babey, Olten (pages 3, 35, 38, 39, 41, 42, 43, 63, 68, 82, 83, 84, 105, 106, 132, 133),
Hans Hinz, Basel (pages 74, 75, 76, 77, 79 and cover plate), Claudio Emmer, Milan (page 86),
and by the photographic services of the Bibliothèque Nationale, Paris (pages 45, 81, 131, 162),
and the Oxford University Press, Oxford (pages 50, 98, 100, 119).*

PRINTED IN SWITZERLAND